BEYOND

JENNIFER
BEBB

AUTO MODE

A Guide to Taking Control of Your Photography

WILEY

John Wiley & Sons, Inc.

Beyond Auto Mode

Published by
John Wiley & Sons, Inc.
10475 Crosspoint Boulevard
Indianapolis, IN 46256

Copyright © 2013 by John Wiley & Sons, Inc., Indianapolis, Indiana

Published simultaneously in Canada

ISBN: 978-1-118-17287-2

Manufactured in the United States of America

10 9 8 7 6 5 4 3 2 1

ABOUT THE AUTHOR

Sometimes witty, frequently sarcastic, always sincere … **Jennifer Bebb** combines humility with proficiency, and likability with determination.

Raised to believe hard work is all you need to succeed, Jennifer (call her Jen, folks, Jennifer is way too formal) has certainly modeled that. Content to put her head down and do the best job she could, Jen and her husband Steve soon reaped the rewards of that work. It took only seven years for them to become overnight successes as a result of *American Photo's* Top 10 Wedding Photographers list. Seven years.

As an author, Jen has always believed that putting pen to paper (or finger to keyboard) was the key to success. And yet, years of writing led her nowhere. Out of the blue, she was contacted by this publisher to write a non-fiction book—*Photo Fusion*. Producing that first title reminded Jen of her first creative love—writing. *Beyond Auto Mode* is a natural second title for Jen as it combines her two talents perfectly.

Along the way, Jen came to realize that she was not merely photographer or writer. Rather, she is a Creative, a person who thrives in a world full of interpretation and imagination. Despite living with one foot in the creative world, she remains firmly rooted in the life she has created with Steve and their two children. Learning to fly while rooted has been one of Jen's greatest successes.

Jen's belief in the importance of hard work never wavers. Nor does her belief that integrity, respect, and humor are the cornerstones of a good life.

No stranger to risk, this photographer/author/mom/wife/CEO is ready for the next big leap, knowing this might not work … *but what if it does?*

CREDITS

Acquisitions Editor
Courtney Allen

Editorial Program Coordinator
Carol Kessel

Project Editor
Jennifer Bowles

Technical Editor
Alan Hess

Editorial Director
Robyn Siesky

Business Manager
Amy Knies

Senior Marketing Manager
Sandy Smith

Vice President and Executive Group
Publisher
Richard Swadley

Vice President and Executive Publisher
Barry Pruett

Book Designer
Erik Powers

ACKNOWLEDGMENTS

To write a book is to be one part of a team. While the words and ideas may be mine, what is between these pages is the result of an incredible collaboration. Without Courtney, who brainstormed ideas with me, *Beyond Auto Mode* would not have come to be. Carol has been an integral part of getting us to publication. Alan kept my technical explanations accurate, while Erik came up with the perfect design. A special thanks must go to Jen Bowles, my project editor and copy editor, who helped me sound far more intelligent than I really am.

Beyond my Wiley team is my personal and professional support network. Without a doubt, my biggest fans and loudest cheerleaders are my boys, Logan and Ethan, and my husband, Steve. My extended network of friends generously let me pick their brains and quiz them about making their own images, and their struggles to do so. In fact, this book was written as an answer to many of my friends' photography questions.

A simple thank you never feels like enough and as a writer one would think I could find a more creative way to express my gratitude. But maybe, simple is best. So, thank you, each of you, for being on my team.

Nothing in life feels real until he knows about it ...
my husband, and inspiration, Steve Bebb ❖

BEYOND AUTO MODE
TABLE OF CONTENTS

BEYOND AUTO MODE
INTRODUCTION

> ❋ Photography is the preservation of memory.

> ❋ Photography is the means to recall the most important moments of our lives.

> ❋ Photography is the literal recording of a moment, as well as interpretive art.

> ❋ Photography is a way to bring people together, to record history, and to give perspective to events.

Photography is life,
life recalled in our images.

Everyone is a photographer to some degree, documenting their lives as they go. In fact, with smart phones, programs like Instagram, and the instant access we now have to imagery, we are living in the most visual era yet.

Eventually, many amateurs move on from their phones, to point-and-shoot cameras, to cameras with interchangeable lenses. That evolution of camera choices is often accompanied by a reliance on the camera's automatic settings that began with the smartphone.

Using your camera's automatic modes means giving up control of your photography. You push the shutter button to actually make the image but that just makes you a button-pusher, not an active participant in the process.

Photography, in its purest form, is a mix of art and science. As photographers we control the amount of light the camera uses to make the picture, and thus how the image looks. Each of us can be a "photographer" by taking control of our cameras and making images with intention.

Do you ever look at your photos and wonder why they are so dark or so light? Do you wonder why some images are blurry, but images made two frames later are not? Do you look at your images and wish you could do better?

Do you wonder all this and then get completely overwhelmed with how complicated photography seems? Have you tried to read your camera manual and become stuck on the jargon and technical terms?

Anyone can make an incredible picture—anyone. You just have to get beyond auto mode.

GETTING BEYOND AUTO MODE: MAKING BETTER PICTURES

Modern cameras are smart. Modern camera makers have made it easy for you to use expensive and complicated equipment without any technical know-how.

The camera, however, is merely the tool we use to create our images and, like any tool, needs input to be used most effectively. Setting a camera on a pre-determined mode, such as "portrait," is akin to a carpenter setting a saw to cut and walking away from the machine. The saw doesn't know what result the carpenter is looking for, it is merely one part of the process. The same is true with your camera—it cannot know what you want to do, it can merely guess based on the settings you choose.

That's where the frustration with DSLRs, or cameras with interchangeable lenses, comes from. We buy those cameras to make better images, and yet the trust we place in the camera itself is undermining our abilities to make compelling images. How often do your images look exactly the way you want them to? Do you blame the camera, or the lens? I often hear comments about how nice my camera is and how it must take good pictures. But just like a pen is controlled by the user, so is a camera—without input, it is merely a tool.

The camera makes decisions designed to best suit the way it's been programmed, not necessarily the best settings for the specific images you want to make. The camera doesn't care how your photograph looks, it simply uses a pre-determined formula that satisfies a set of criteria that likely has nothing to do with the photo you are creating.

Making better photographs is about taking control of your camera settings and deciding how you want your images to look. It's about moving beyond the automatic modes.

GETTING IT RIGHT IN THE CAMERA

I bet you have some version of Photoshop or other image editing software, don't you? You probably spend a lot of time trying to edit your image into something you want—cropping, playing with exposure adjustments, changing color settings, and more.

As you learn to move beyond auto mode on your camera, I'm also going to help you move beyond the "fix it in postproduction" mentality. Getting your image right when you actually shoot it is incredibly satisfying. If you want to polish it in postproduction, that's great, but if you get it right when you make the image, there is no need to spend hours trying to fix it.

In fact, we are going to treat your digital image making as though it was film—no second chances and no fixing it later. One of the goals of this book is to teach you

make images with intention, and manual settings. Photography is not about the digital "fixing" you can do later, it's about getting it right every time you push the shutter.

You will find yourself making better photographs straight out of camera almost right away. Simply learning why your camera does what it does, and how to change that for each image you want to make, will change everything about your pictures.

GUIDE TO USING THIS BOOK

The technical part of photography can be overwhelming. It's like learning a whole new language. That's why this book is different—it focuses on the practical while taking the time to explain difficult concepts in a variety of ways. Take your time and revisit chapters as you need to. Don't worry if you don't grasp everything at once. I've been a professional photographer for more than 13 years and I'm still learning.

As you read this book, you will get all the technical information you need to make the images you want, in non-technical language. Ideally, you'll read it from start to

finish, tackling each step one-by-one. Realistically, though, most of you will skip to the sections most relevant to you. Don't worry—I've got you covered regardless.

Each chapter in Part 1, "Understanding Exposure," deals with the basics of photography: the stuff you have to know and understand to use your camera effectively.

I take the mystery out of the technical jargon, saving that for the sidebars sprinkled throughout. Read each chapter and then when you want more technical details and explanations, read the sidebars or refer to the glossary. That way you're not bogged down with unfamiliar language and terminology as you are trying to grasp each concept.

If you read nothing else in this introductory section, read the following section, "The Quick Start Guide to Manual Mode." The foundation of image making is right there for

you. Once you have done that, you'll likely be more interested in reading the next few chapters on shutter speed, ISO, aperture, and more. These chapters take what you learn in the Quick Start Guide and build on your comprehension of each concept. These are your building blocks to understanding why your images look as they do, and how to change and improve them.

Part 2, "Semi-Auto and Manual Modes," enables you to gradually move from automatic to manual mode. This is not only a great transition for you, but some of these semi-auto modes are used by professional photographers when the situation warrants. The truth is, in semi-automatic modes you are in control—everything the camera does for you, you can override manually. In Chapter 9 I talk about manual mode, specifically, and how taking control of all your settings can help you make consistently better pictures.

Finally, we'll move into Part 3, "Going Beyond Auto Mode in the Real World." In this section, I talk about composing images and offer real-world, situational examples for you. If you are struggling with a certain image, like photographing a child's hockey game, I'll share how to do that. If you want to make better pictures of flowers, that's covered too. The section is finished off with information on using your flash and other gear questions you may have.

Finally, you'll find a glossary filled with all the technical terms used in the book. I've tried to keep the language simple, but I also want to make sure you are getting the correct information. If a term or concept ever stumps you, you can find a quick explanation in the glossary.

As a bonus, I've put together my thoughts on photography in general and a collection of some of my favorite images. You'll find these in the appendix, where I share the why and how of each image. When you get overwhelmed and need a break—head to the Appendix, "The Making of an Image." It's my favorite part of the book.

Each chapter and section stands alone. Once you have read the Quick Start Guide, you can pick and choose which chapter you want to explore next. When I was learning photography, I found some of the concepts overwhelming at first and needed to make some pictures and then go back and study the concepts. If that's how you learn, go for it. You will likely find yourself wanting to understand why an aperture does what it does or why changing your shutter speed gave you a result you didn't expect. All the information is waiting for you, when you're ready for it. ❖

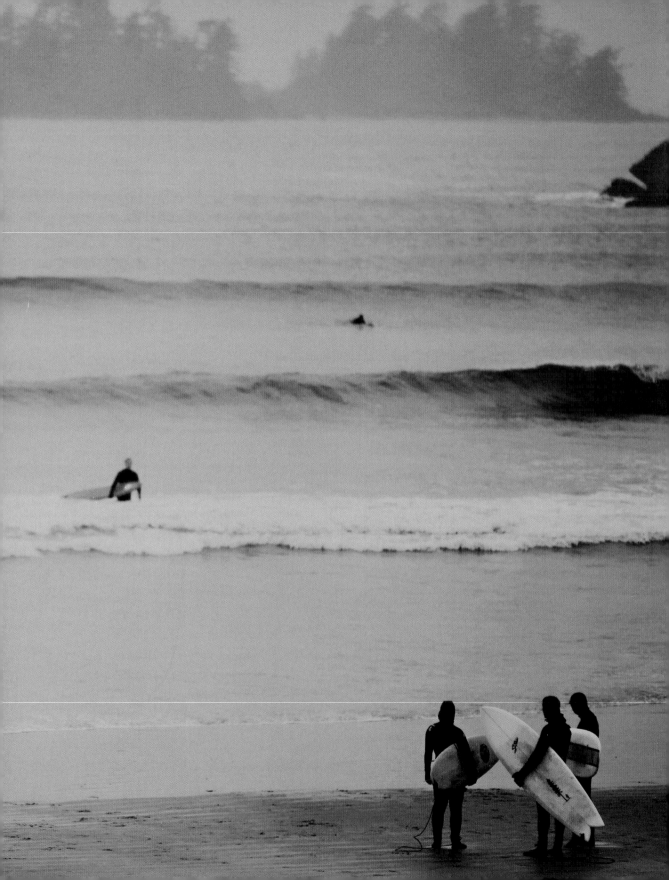

The Quick Start Guide to
TO MANUAL MODE

LET THERE BE LIGHT

When you make a photograph, you are literally drawing with light. Without light, you cannot make a photograph. When using automatic camera modes you give a black box the power to choose how to use light and how your photographs look. It makes no sense to give that control to a box that cannot see what you see or know what kind of photograph you wish to make.

In the next few chapters I use the word *light* frequently. The levels, quality, and color of light affect every decision a photographer makes. It's no different for you. You will find yourself looking for light and, once you find it, looking at it differently than before. It's just like learning any new skill—practice makes perfect.

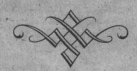

At this point, all you need to know is this: You need light to make a picture. Too much light and your picture is too bright; too little light and your picture is too dark. Making images is about controlling the amount of light your camera is using.

You will also read the word *exposure* a lot in this book. Without getting into too much detail right now, exposure is simply the total amount of light used to make an image. In other words, it's how light or dark your image is.

EXPOSURE TRIANGLE

There are three key ways light is managed by your camera, and these three elements together are known as the exposure triangle:

※ The **ISO** is the sensitivity of the digital sensor (also known as film speed).

※ The **shutter speed** controls how long the shutter is open, allowing light to reach the sensor.

※ The **aperture** is the size of the lens opening, which allows light to reach the sensor.

Let's look at this another way: Imagine exposure as a bucket being filled by a hose. The correct exposure is a full bucket. The ISO is the size of the bucket, shutter speed is how long you fill it for, and aperture is the width of the garden hose.

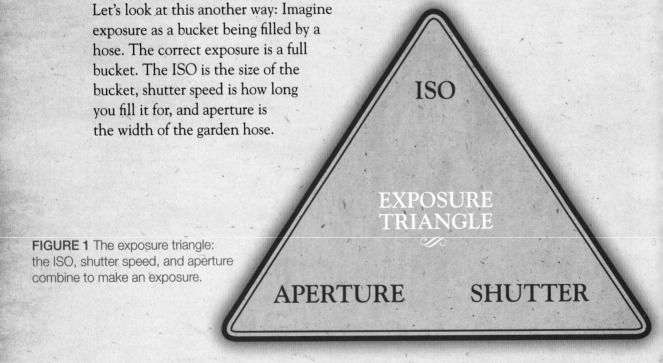

FIGURE 1 The exposure triangle: the ISO, shutter speed, and aperture combine to make an exposure.

In auto mode, your camera chooses all three of the exposure elements, in semi-auto mode your camera chooses one, and in manual mode you make all the choices. Each corner of the triangle works in partnership with the other two—and changing any of these affects how dark or light your image is.

One of the reasons we want to move beyond auto mode is because the camera likes to keep the exposure the same no matter what point of the triangle is changed. For example, if you are in P mode (where the camera chooses the settings, but you can override them) and you change your aperture to let in more light, your shutter speed will increase as well. When your shutter speed increases, less light is coming into the camera. More light is coming in through one source, so the other must let in less light. Make sense?

To use our bucket analogy, we have made the garden hose (aperture) wider, so more water is coming into the bucket. As a result, we need to shorten the amount of time we are filling the bucket.

The opposite holds true as well. If you change your aperture to let in less light (a narrower hose), your shutter speed will slow down (the hose will be turned on for longer) to let in more light. It's all about maintaining the balance between these points.

Your camera uses a pre-set formula to work out the exposure triangle. Although this is always balanced, it isn't always "right" for the image you want to make. Once you understand what affects exposure and how to make those decisions yourself, you will never need to use auto mode again.

FIGURE 2 In your camera's auto mode, when one point on the triangle shifts the others shift also. If your ISO stays the same and you increase the aperture to let in more light, the shutter speed will decrease.

ISO

EXPOSURE
TRIANGLE

APERTURE SHUTTER

When you are in manual mode, on the other hand, you determine each point of the triangle. You could, for example, let in so much light that the image is pure white (overexposed), or let in so little light that the image is black (underexposed). You could let the bucket overflow or leave it completely dry. Ideally, you will find the perfect combination of all three factors, letting in just the right amount of light to make the photograph you want.

Each element of the exposure triangle controls light, but also controls other ways your image looks. Aperture, for example, controls depth of field (how blurry or in focus your background and foreground is) while shutter speed controls motion blur (that blur you get when you are photographing a moving subject). Don't worry, we'll explain all of this in much more detail in the coming chapters, but Figure 3 shows what other areas each point of the triangle controls.

As we move into more detail with each chapter, always keep the exposure triangle in mind and remember that the three points work in relation to each other. In auto and semi-auto modes, the camera will always choose the "correct" exposure for its preset formula, attempting to override changes you make manually. Knowing what elements to change and what affect that will have on your final image is the balancing act that is the cornerstone of every image you make and one of main reasons to move beyond those auto modes.

The next few chapters focus on specific, individual points of the triangle (shutter speed, ISO, and aperture). These elements do not exist in isolation, however, but work in conjunction with the other two points of the triangle. As such, you will see overlapping information in Chapters 1 through 3 as we explore each point of the triangle in more detail.

FIGURE 3 The elements on the exposure triangle control more than just the amount of light.

ISO
grain/noise

EXPOSURE
TRIANGLE

depth of field
APERTURE

motion blur
SHUTTER

Exposure Latititude

Each camera sensor (or film) has a latitude for exposure, often called dynamic range. Basically this means there is a range within which a well-exposed image can be made. Too much light and the image is overexposed, too little and it is underexposed—the sensor (film) cannot record that information and it appears as very bright or very dark areas in the frame.

The following figures show images that are overexposed, well exposed, and underexposed. All images were made with the same aperture (f/2.8) and shutter speed (1/40), with the only variable being the ISO. Keeping the exposure triangle in mind, you can see how changing one part of the triangle without changing the other two affects the exposure.

Overexposed with ISO 1600. Note how overly bright the scene is and the loss of detail in the background and vase.

This is a well-exposed image with ISO 800.

Underexposed with ISO 100. Note how muddy the image looks.

Overexposure: We say an image is overexposed when too much light has been let in and there is a loss of highlight detail. In other words, the highlights are *blown* and the image itself looks overly bright. In extreme cases the image is all white.

Underexposure: An image in underexposed when there is not enough light and there is a loss of shadow detail. Often referred to as *blocked-up shadows* or *crushed blacks*, this means the image is too dark and looks muddy as a result. In extreme cases the image is all black.

Same Exposure, Different Effect (Aperture and Depth of Field)

Because exposure is simply a mathematical equation, albeit a complicated one, the same exposure value (EV) can be achieved with different aperture/shutter speed combinations (assuming ISO stays the same). It's just like fractions—1/2 can be indicated in a variety of ways, such as 2/4, 4/8, or 8/16. It's the same fraction, expressed differently—the value is the same.

For example, let's assume you are at f/8 (aperture) and 1/60 (shutter speed). You will get the same exposure at these settings:

* ※ *f/5.6 and 1/125*
* ※ *f/4 and 1/250*
* ※ *f/2.8 and 1/500*

Because the EV is exactly the same, the amount of light coming into the camera is the same. The only change is to the depth of field (see Chapter 3 for a discussion about this). As we open up our aperture (and the aperture number gets smaller) we get a shallower depth of field. Conversely, if we start at f/2.8 and 1/500 and move to f/8 and 1/60 our depth of field is less shallow (more of the background comes into focus).

[handwritten notes]
open up aperture : aperture # gets smaller = shallower depth of field. ex f.5.6
f/5.6 = 1/5.6 f/11 = 1/11
aperture # gets bigger = less shallow depth of field ex. f 11

STOPS AND F/STOPS

In addition to the words *light* and *exposure* you will also see the words *stop* and *f/stop* a lot. Always relating to exposure elements, *stop* and *f/stop* refer to the halving and doubling of light from one exposure choice to the next.

A *stop* is a relative change in the brightness or darkness of light. Specifically, a *stop* measures the doubling or halving of light. Imagine you have a series of light bulbs,

all exactly the same. If you have two turned on and then turn on two more you have doubled the amount of light, or increased your light by one stop. If you go back to those original two light bulbs again and turn one off, you have halved the amount of light or decreased it by one stop.

wider
f/2.8
vs
f/4
smaller

The term *f/stop* typically refers to aperture, which is expressed as an f/number—for example, f/2.8 or f/4. As I talk about aperture in more detail (Chapter 3) or refer to different aperture choices throughout the book, you will see that information written as an f/number. Whenever you see that, you will know we are talking about the aperture of your lens.

Keep an eye on the technical asides throughout the next few chapters as they offer more detail about stops and how they work together. If you're not quite ready for that much technical information yet, don't worry. All you need to remember is that a *stop* refers to the amount of light and an *f/stop* refers to aperture, specifically.

PUTTING IT ALL TOGETHER

sensitivity of digital sensor

You now know you need to make three decisions to make an image: ISO, shutter speed, and aperture. If you want to go out and try making images right now, go for it. Here is a cheat sheet for making images in manual mode.

STEP 1: CHOOSE YOUR ISO

This is the size of your bucket. Evaluate the light levels of your scene, following these guidelines for setting ISO:

* ISO 100—bright sunny day
* ISO 400—daylit room or overcast day
* ISO 800—dimly lit room
* ISO 1600—darker scene

STEP 2: CHOOSE YOUR APERTURE

This is the width of the hose. Consider the kind of image you want to make and choose your selections based on the following:

* F/2.8 to f/5.6—portraits
* F/8 to f/16—landscapes

1/2.8 to 1/5.6
1/8 to 1/16

STEP 3: CHOOSE YOUR SHUTTER SPEED

This is the amount of time the hose is on. Next, consider what your subject is doing and make general selections based on that:

⁂ 1/30 to 1/250—your subject is not moving. *longer*

⁂ 1/250 and above—your subject is moving. *shorter*

STEP 4: TAKE A TEST SHOT, EVALUATE, AND ADJUST

Make an image with your initial settings and then review it on your LCD screen. It will look too dark, too light, or just right. If it's just right—way to go! If it's too light or dark, here is what to do:

Too dark? Do one of the following:

⁂ Change your aperture to a smaller number (f/8 to f/4, for example). *let in more light*

⁂ Change your shutter speed to a bigger number (move from 1/250 to 1/125, for example). *shutter open longer*

⁂ Increase your ISO (400 to 800, for example). *sensitivity to light*

Too light? Do one of the following:

⁂ Change your aperture to a bigger number (f4 to f/8, for example). *narrows aperature*

⁂ Change your shutter speed to a smaller number (1/60 to 1/125, for example). *shorter time shutter is open*

⁂ Decrease your ISO (400 to 100, for example).

Handwritten margin note: f/4 = 1/4, f/16 = 1/16, larger #, smaller opening

STEP 5: BE PATIENT

There will be times you get your exposure correct on the first try and there will be times it feels like you'll never get it right. That's normal for everyone, especially as you are learning how all this works. Go back through the steps and try different combinations—there is a combination that will work. Learning more about the different elements, the other things that impact their selection, and how the different modes work will facilitate your success in making well exposed images. What are you waiting for? Go read the rest of the book! ❖

UNDERSTANDING EXPOSURE

It seems so simple at first—buy a camera and start taking pictures. The better the camera, so the assumption goes, the better the pictures. For something so popular, though, good photography requires much more than a good camera.

In the previous section, "The Quick Start Guide to Manual Mode," you learned about the exposure triangle—the three elements (ISO, shutter speed, and aperture) required to make a well-exposed photograph. You were also introduced to some technical terms like *stop* and *f/stop*, as well as *overexposure* and *underexposure*. It was a crash course in the basics of making images.

Just as with anything in life, though, the most basic information can take you only so far. The next few chapters provide the details to fill in the blanks and answer questions you may have after reading the Quick Start Guide. Chapters 1, 2, and 3 cover the points of the exposure triangle while Chapters 4 and 5 take you on a journey of how to see and use light.

At this point I want to encourage you to be patient with yourself. You'll grasp some of these concepts easily, while others will take you longer to master. Personally, I found the best way to understand each concept was to make pictures and study them. With your digital camera, you are able to check, and correct, your results immediately by viewing each image on your LCD screen.

If possible, keep your camera nearby while you read this book. As you work through each chapter, make images of what is in front of you, practicing each concept in turn. Before you know it, you will find yourself thinking of more than one element at a time, making exposure decisions more quickly and getting your exposure right more often.

There are so many considerations that go into the making of an image, so keep *sun* it simple right now. If you are reading Chapter 2, "ISO," focus on that element *behind* and make images that show you the effect of ISO on your exposure. If you are *you!* working through Chapters 4 and 5 on light, keep watch for how different lighting scenarios affect your exposure choices. You have plenty of time to put it all together as we move forward. For now, take one step at a time, knowing all the pieces you are learning individually will fit together seamlessly for you, very soon.

—ᨓ—

Chapter 1
SHUTTER SPEED

The amount of light coming into your camera determines whether your image is bright or dark. When you take a picture, you hear a *click* from your camera—that's your shutter in action.

The best way to learn about photography is with a camera in your hands, so go on, try it now—grab your camera and take a picture. It doesn't matter what you take a picture of, I want you to listen for that clicking noise. Hear it? Was it fast *(click)* or slow *(clu...click)*? If the click was fast you have a fast shutter speed, and if it was slow you have a slow shutter speed.

In most situations, you want to hear that fast *click*. Shooting fast is like freezing time, letting in just a moment. This is especially important if your subject is moving. Conversely, shooting slow lets in more light. Sometimes this causes blur if your subject is moving, but if everything is still it works well in a darker setting.

Be mindful of your shutter speed in low-light situations—sometimes you can be the cause of blur. If the shutter is too slow, you may not be able to hold the camera steady and that can result in a blurry, or soft, image.

FIGURE 1-1 In the exposure triangle, shutter speed controls motion blur.

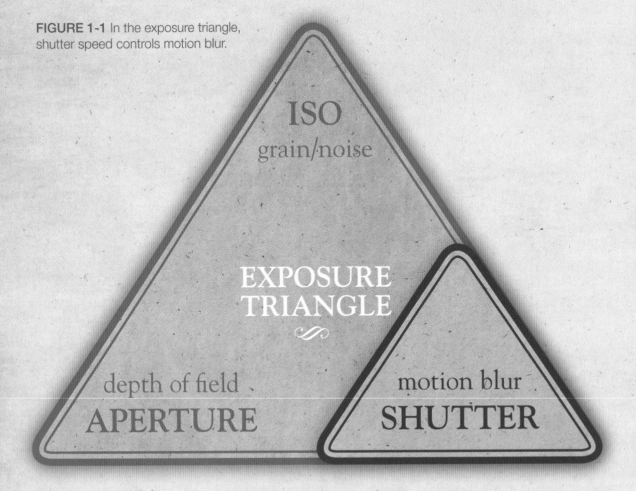

ISO
grain/noise

EXPOSURE
TRIANGLE

depth of field
APERTURE

motion blur
SHUTTER

WHAT SHUTTER SPEED MEANS

Simply put, the shutter speed is how fast your shutter opens and closes when you push the shutter button. A fast shutter speed means your shutter opens and closes quickly, letting in less light. A slower shutter speed means your shutter opens and closes slowly and, therefore, lets in more light.

We measure shutter speed in seconds. A faster shutter speed has a lower number, while a slower shutter speed has a higher number. This can be confusing at first because when we look at our cameras, often shutter speed is expressed as "30," "60," or "250" rather than the correct expression, which would be "1/30," "1/60," or "1/250."

For example, a fast shutter speed is measured as "1/1000" while a slow shutter speed is "1/60." The faster shutter speed (*click*) is actually letting in less light than the slower shutter speed (*clu...click*). In other words, the bigger the denominator (second number) in the fraction (and, therefore, the smaller the number), the shorter the time your shutter is open. That means the photo is made quicker, but can sometimes be too dark.

As you move from one stop to the next, it is referred to as "stopping up" or "stopping down" the shutter speed. A movement from 1/500 to 1/1000, for example, is stopping down (letting in less light) while a move from 1/500 to 1/250 is stopping up (letting in more light).

It's a balancing act to find the right shutter speed and ensure your image is sharp. This requires practice and taking the time to get to know what happens at each speed.

Stop and Shutter Speed

A stop is the halving or doubling of light. When you double the amount of light coming into your camera we say you increased it by a stop, or "stopped up." When you halve the amount of light, we say you decreased it by a stop or "stopped down" your exposure.

Shutter speeds go up in increments that double (longer time) or halve (shorter time) the amount of light. This scale indicates the increments of exposure speed expressed as seconds (s):

1/1000 s *high*
1/500 s
1/250 s
1/125 s
1/60 s
1/30 s
1/15 s *really slow*
1/2 s
1 s

It's obvious that a really slow shutter (such as 1/15 of a second) will likely result in blur, especially if your subject is moving or you're holding the camera in your hands. But it's what happens in the 1/60 to 1/250 range that you will struggle with the most. Within that range you can see motion blur, or you might make a perfectly sharp image. At 1/60, your shutter actually sounds fast, so you won't have the *clu…click* sound alerting you to the potential for blur. If your subject is moving, 1/60 is too slow, but if your subject is still and there is plenty of light, 1/60 will do the job. Keep a close eye on the light levels and the movement of your subject when you are working between 1/60 and 1/250— even with a shutter as fast as 1/250 you can get motion blur if your subject is moving quickly enough.

WHY SHUTTER SPEED MATTERS

When you move beyond auto mode, you will likely find that shutter speed is a relatively easy concept to understand and master. The relationship between shutter speed and

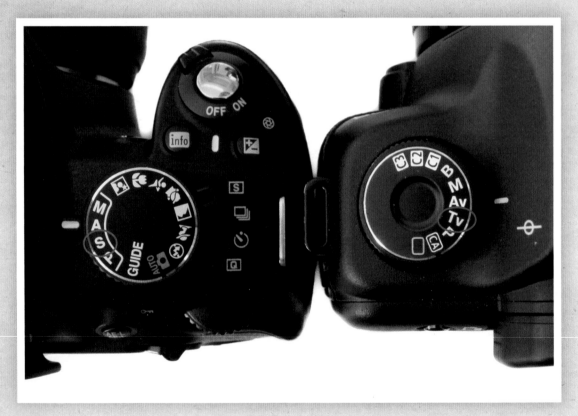

FIGURE 1-2 On a Nikon, shutter priority is labeled "S" and on a Canon, shutter priority is labeled "TV" (time value).

the amount of light makes sense—faster shutter speed means the shutter is open for a shorter amount of time, letting in less light. A slower shutter speed means the shutter is open longer. Obviously, when the shutter is open longer, more light can get in.

As a result, you can immediately change the look of an image simply by changing your shutter speed and nothing else. There is a semi-auto mode called "shutter priority" (Figure 1-2) that enables you to set the shutter speed while the camera chooses the aperture.

SHUTTER SPEED AND LIGHT

If you look around your scene and it is a bright, sunny day, you will want a fast shutter speed. If it is a darker scene like in an auditorium or house, you will want to let in more light by choosing a slower shutter speed.

Let's look at this another way. On a bright sunny day there is a lot of light. If your shutter is open for a long time, too much light will get into your sensor and make your image too bright or even completely white. You can see this on the back of your camera when reviewing the images you made. An overly bright, very white image is overexposed while a very dark, muddy looking image is underexposed.

Let's test this. Go to a really bright place (outside on a sunny day is ideal). Set your camera on manual mode with the following settings:

※ *ISO: 400* (high - must)

※ *Aperture: f/8* (depth of field)

※ *Shutter: 1/60*

Choose a subject facing the sun (the sun should be behind you as you make the picture). Make the picture.

What happened? Did your image look like mine in Figure 1-3—really, really bright and blown out? It looks that way because I left my shutter open too long and let in too much light.

Let's try it again with our shutter at 1/250 and see what happens. Was your image darker or brighter? It should be darker because less light came into

FIGURE 1-5 With a shutter speed of 1/250, this is image is too dark, or underexposed.

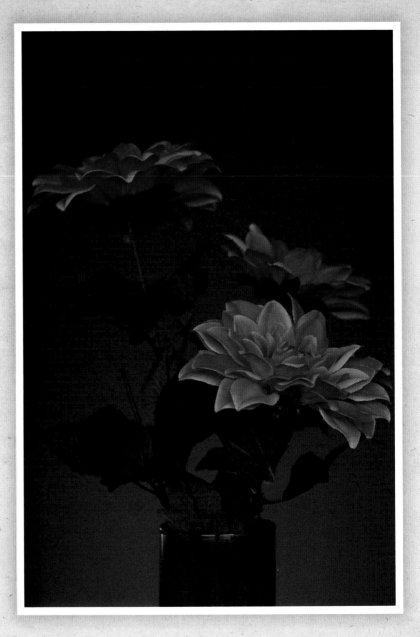

Let's try the same thing with a darker scene. Place your subject adjacent to a window so there is light coming into the scene. Let's start with the following settings and see what happens:

* *ISO: 400*
* *Aperture: f/4*
* *Shutter: 1/250, and then 1/60*

Which image looks better? Which is brighter and which is darker? Notice that changing the shutter speed had the same effect as Figures 1-3 and 1-4, but this time to get the correct exposure we needed the slower shutter speed. Simply controlling the speed of your shutter can dramatically change how your image looks.

In this example, the image with the slower shutter speed (Figure 1-6) has the better exposure. If your images are still very underexposed, slow down your shutter speed even more and see if that brightens up your scene. If that doesn't work, move your subject closer to your light source and try again.

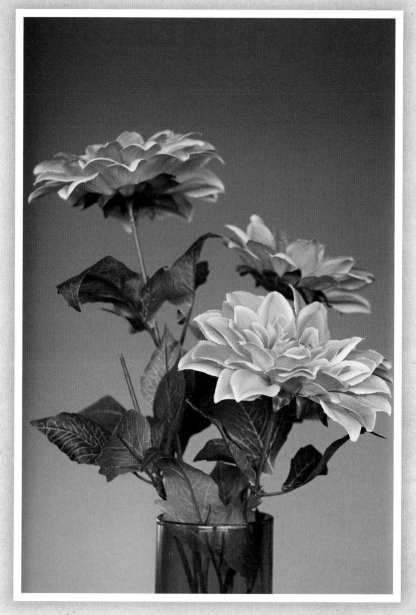

FIGURE 1-6 Changing the shutter speed to 1/60 created the correct exposure.

At this point we're not overly concerned about making the perfect exposure, but rather understanding how changing the shutter speed dramatically affects exposure.

Your shutter doesn't act alone and your camera has a maximum shutter speed. Remember the exposure triangle—if you have a high ISO (see Chapter 2 for more on ISO), which makes your camera more sensitive to light, and are using the fastest available shutter speed and your images are still too bright, you need to look at changing something other than your shutter speed (such as lowering the ISO or changing your aperture).

WHERE TO FIND THE CONTROL

On most DSLR cameras, the shutter button is located on the right side of the camera body within easy reach of your right index finger. (See Figure 1-7)

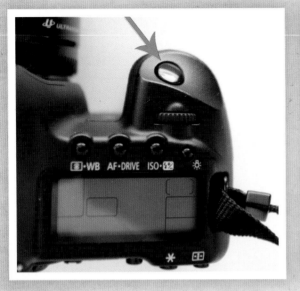

FIGURE 1-7 On most cameras, the shutter button is located here.

Shutter Speed with ISO and Aperture

Your shutter speed is only one way to control the amount of light coming into your camera. ISO and aperture affect shutter speed as well. For example, if you increase your ISO (making the sensor more sensitive to light) you can speed up the shutter to get the same exposure, keep the shutter speed the same to let in more light, or slow down the shutter to overexpose your scene considerably. It all depends on the effect you want to achieve.

With aperture and shutter speed, you can increase or decrease your aperture and shutter a corresponding amount to get the exact same exposure. But if you open up the aperture, letting in more light, and leave your shutter the same, the image will be brighter. If you speed up your shutter (more than one stop) the image will be darker.

A S
O slower

O faster

HOW LOW CAN YOU GO?

On sunny days or in well-lit environments, you need not worry about your shutter speed being too low. But, in dimly lit spaces you must keep a close eye on your shutter speed.

Have you ever taken a picture in which everything is in focus except what you were trying to photograph? Think of an ice hockey rink, for example. If your child is skating down the ice and your shutter speed is too slow, he or she will be blurry. Oftentimes people chalk this up to their lens not focusing, but it's most likely something called motion blur. See Figures 1-8 and 1-9 on the next page.

Motion blur typically happens when your shutter speed is 1/60 or slower—everything that is still is sharp, but anything moving has blur.

When your images are blurry because your subject is moving, and that is not something you want, check that your shutter speed is 1/250 or faster. Generally speaking, choosing a shutter speed of at least 1/250 minimizes the chance of motion blur in your images. If you still find your subject is blurry, try a faster shutter speed such as 1/320 or 1/500, ensuring you are still getting enough light to make a proper exposure. If your subject is now frozen, but your image is dark, increase your ISO or your aperture to let in more light.

In addition to motion blur, slower shutter speeds can cause blurry, or soft, images because of something called "camera shake." This happens when your shutter speed is too slow for you to hold the camera steady while the shutter is open. In other words, your shutter speed is slow enough that holding the camera in your hands, which are rarely perfectly still, is causing the camera to move while the shutter is open. This happens at very slow shutter speeds, but can also happen at higher shutter speeds if you are simply not very steady. A good rule of thumb is this: Your shutter speed should never drop below the focal length of the lens you are using.

Let's say you are using a 50mm lens. You will want to keep your shutter speed at 1/50 or higher. If you are using a 135mm lens, your shutter should be 1/160 or higher. When you are using a zoom lens, watch your zoom (your focal length) to ensure you are not causing motion blur with a slow shutter speed.

If you find yourself wanting to make images in the dark, a tripod or a solid surface will come in handy. Say, for example, you want to photograph your home at night. If you don't have a tripod, you can lay your camera on a table or the ground and use a very slow shutter speed. You may end up with a one- or two-second exposure.

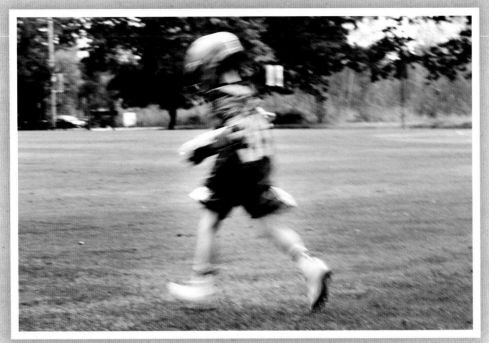

FIGURE 1-8 With a shutter speed of 1/30, this image of a running child shows motion blur.

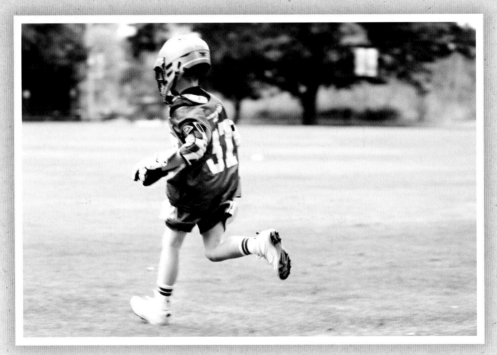

FIGURE 1-9 Here is the same scene as 1-8, made with a shutter speed of 1/250. Notice there is no motion blur.

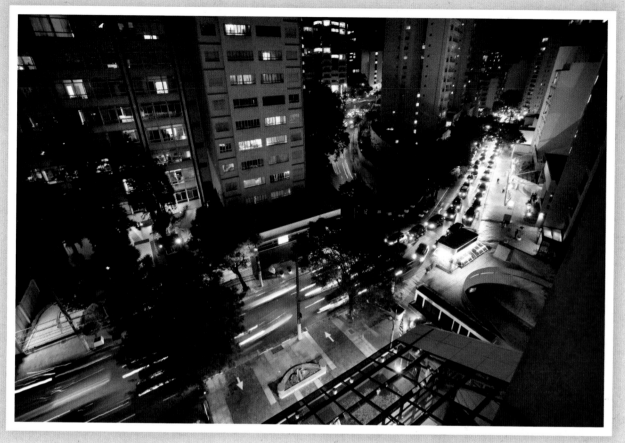

FIGURE 1-10 Motion blur can be used to great effect, especially in nighttime city scenes like this one from a hotel window in Sao Paolo, Brazil.

Another great example of motion blur created by using a slow shutter speed is an image made at night of a roadway or bridge. Using a tripod and a very long exposure creates those lines, or ribbons, of tail lights and headlights you see in those images. Go out and give that a try if you want to experiment with very slow shutter speeds. Keeping the image sharp while capturing movement is an incredibly satisfying result.

The shutter speed used to make is Figure 1-10 is very slow—1.2 seconds. To avoid camera shake, I rested the camera on the window sill and tilted it down toward the street. Ideally, a tripod should have been used, but we did not have one with us on our travels. To make the lights of the cars look like ribbons, a tripod and an even slower shutter speed are required.

YOUR TURN

Let's practice what we've learned about shutter speed so far. The best way to see how shutter speed affects your images is to make photographs using different camera settings and compare them.

This section walks you through three assignments:

1. Testing shutter speed in varying light conditions
2. Creating motion blur
3. Making images with a very slow shutter speed

Assignment 1-1: Changing Light

Get your camera and set it to aperture priority (AV/A) mode (see Figure 1-11). AV is a semi-auto mode that requires you to make two exposure choices while your camera determines the third point of the triangle—shutter speed, in this case. You will learn

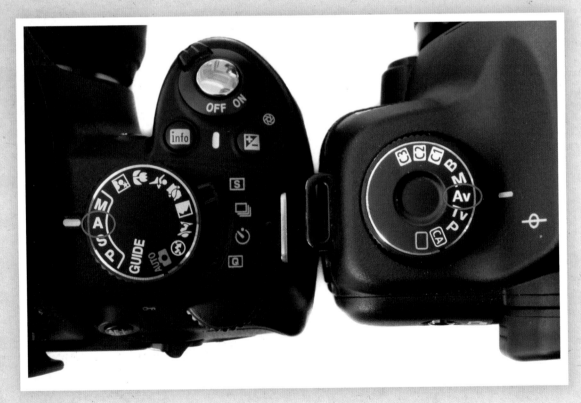

FIGURE 1-11 Aperture priority mode.

more about AV/A mode in Chapter 7, so don't worry if you're not sure exactly what you're doing at this point. AV/A mode keeps ISO and aperture constant, allowing you to see how changing shutter speed affects exposure.

For this assignment it doesn't matter what your subject is—this is simply an exercise for you to gain practical understanding of how shutter speed works.

Follow these steps:

1. Set your ISO to 400 and your aperture to f/4. Figure 1-12 shows you where to find your aperture and ISO settings. How, exactly, you set those will depend on your camera model, so if you are unsure check your camera manual.

2. Choose a fairly bright area near a light source (such as a window) and press the shutter button. What did your shutter sound like—*click*, or *clu...click*? If your camera is making the *clu...click* sound, change your ISO to 800.

3. Choose a darker area (maybe go into a room with no windows or lights) and take another photo. Listen to the sound of your shutter now. Was it *clu...click*? It should be.

4. Move to a bright area (outside on a sunny day, if possible) and press that shutter button again—*click*. If it isn't a sunny day, turn on a light and take a picture of the light itself.

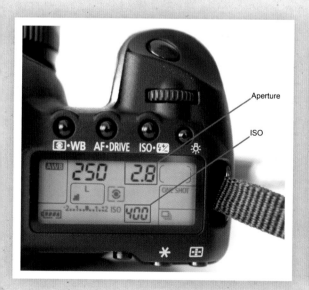

FIGURE 1-12 In AV/A mode you select ISO and aperture while the camera selects the shutter speed.

Now that you have made those three images, let's review them. Look at the images on the back of your camera and note how light or dark each is. You will want to review what shutter speed you used in each scene, so ensure you can see that information when reviewing your images.

Because ISO and aperture remained the same, and your lighting situation changed, the shutter speed was different for each image in this series. The first frame (taken near the window) is your reference point for seeing how shutter speed affects an image.

In the second frame (in a darker area), your shutter speed was much slower than in the first frame because there was less light in your scene. The only setting the camera could change to make the correct exposure was shutter speed, so it chose a much slower setting to let more light into your image. Your image is likely dark and muddy looking. It also might be a bit soft, or blurry, if your shutter speed was too slow to hand hold well.

In the third image (outside in the sun), your shutter speed was faster than the first and second images. When you moved into a brighter area your camera needed less light for the correct exposure, so it chose a much faster shutter speed. If you were at ISO 800 and moved into a bright sunny day, it's possible your image is extremely bright and overexposed. Each camera has a maximum shutter speed, and with ISO 800 and aperture f/4 on a bright day your camera might not have been able to select a high enough shutter speed to make the correct exposure. If your image is very bright or white, that is what happened.

Assignment 1-2: Motion Blur

Now that you have seen how light levels affect shutter speed, let's see how shutter speed can result in motion blur. For this assignment you will need to work with someone, or something, that is moving. If you don't have a willing subject, perhaps head outside and use moving cars.

The difference between motion blur and panning is this: With motion blur, typically our subject is still and other elements in the frame are moving. With panning, on the other hand, our subject is moving and we are moving the camera with it. Let's go outside and try this. I used my dog for these examples, having her run through the frame as I did this exercise.

To create motion blur, you will need a relatively slow shutter speed. You learned earlier that a shutter speed of 1/60 will likely be slow enough for motion blur, so let's test that.

Follow these steps:

1. Set your camera to shutter mode (see Figure 1-12). Choose a shutter speed of 1/60 and set your ISO to 400 (see Figure 1-13). If you are outside on a bright day, you will need to select an ISO of 100. With shutter speed and ISO set by you, the camera will determine the final point of the triangle—aperture.

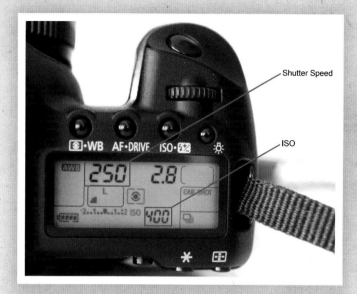

2. Choose a subject. In Figure 1-14, our subject is the woman (that's me!) throwing a stick for her dog. Focus on your subject and press the shutter button. Keep the camera steady as the moving elements travel through your frame. If those elements are moving quickly enough, they will appear blurry in your frame. At 1/60 the dog was blurry, but I wanted more blur and tried it again with a slower shutter speed of 1/25. The final exposure settings for Figure 1-14 were ISO 100, aperture f/16, and shutter speed 1/25.

FIGURE 1-13 In shutter priority mode, you choose shutter speed and ISO while the camera chooses aperture.

3. Another way to capture motion in an image is to pan with a moving subject. Instead of allowing elements to move through your frame, you are now going to focus on your subject and move with it. This takes a fair bit of practice, so don't get upset if you don't master this right away. When you pan with your subject, the foreground and background appear blurry while your subject is sharper.

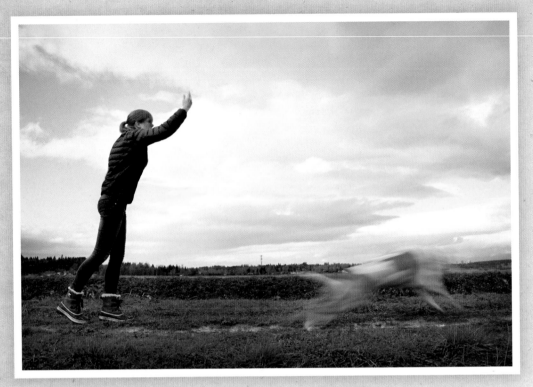

FIGURE 1-14 The subject is sharp, and the moving element is blurred.

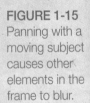

FIGURE 1-15
Panning with a moving subject causes other elements in the frame to blur.

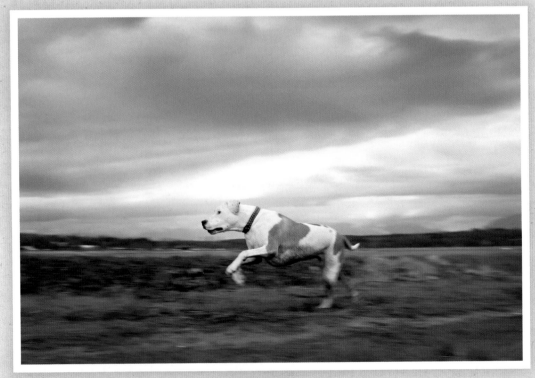

Look at Figure 1-15 and notice how everything in the frame, except our subject, is blurry. This is in real contrast to Figure 1-14, where the only thing blurry was the dog moving through the frame. Our final exposure settings in Figure 1-15 were ISO 100, aperture f/6.3, and shutter speed 1/125.

Assignment 1-3: Using a Very Slow Shutter Speed

You can use motion blur to create compelling images. Earlier in the chapter you saw the effect of a slow shutter speed on vehicle lights at night in Figure 1-10. Another way to use slow shutter speeds in your imagery is when you are photographing water. We will revisit this in Chapter 12, but let's go ahead and give it a try.

Whether you choose a nighttime scene or a water scene, the steps are essentially the same:

1. Keep your camera in shutter priority and choose an extremely slow shutter speed. On some cameras, shutter speeds of 1 second or slower are shown as 1.6 or 1"6. If you camera does not allow you to choose something this slow, you will have to switch to manual mode for this assignment. If that's the case, I encourage you to revisit this assignment after you have finished reading Parts 1 and 2.

2. Choose an ISO of 100 or 200.

3. If you have a tripod, now is the time to use it. If not, find a level and stable surface to rest your camera on. Your subject will be moving, and your camera must stay still.

4. Make the picture. You will hear *clu........click* when you press the shutter button. Everything in the frame that is moving will appear blurry in your image.

5. Does your image look something like Figure 1-16 or 1-17? If the water or vehicle lights look too blurry, speed up your shutter speed a little bit or change your composition.

Figures 1-16 and 1-17 were made at the same settings: ISO 100, aperture f/16, and shutter speed 2.5s. The water in Figure 1-16 is quite cloudy looking, while the water in Figure 1-17 is more in line with the look I wanted. The reason for this difference is there was more fast moving water in my composition with 1-16 than with 1-17, resulting in that almost cloud like looking flow of water in 1-16.

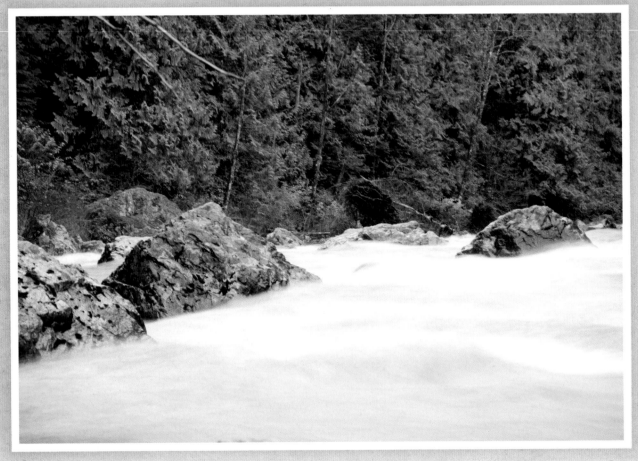

FIGURE 1-16 With fast moving water and a slow shutter speed, a cloudy effect is achieved.

Something to keep in mind when watching for the effect of shutter speed is the focal length of your lens (zoom) and what is included in your frame. Figures 1-16 and 1-17 were made with the camera in the same position and with the same camera settings. The only difference was focal lengths. Figure 1-16 was made at 105mm while Figure 1-17 was made at 24mm. You can clearly see how only showing fast moving water created a very cloudy effect, while the combination of fast and slow moving water in Figure 1-17 resulted in a very different look.

If you find there is not enough blur in your image, choose a slower shutter speed. Cameras do not offer shutter speeds below a certain level so if you cannot choose a slower setting, check your camera manual

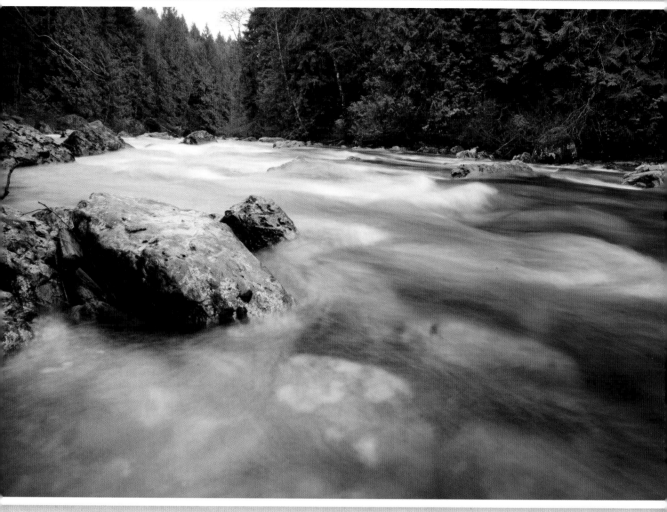

FIGURE 1-17 A slow shutter speed facilitates the look of movement in this image.

for more information on what your shutter speed range is. It is highly unlikely you will run out of effective shutter speeds at the slowest end of the scale but, depending on your camera model, it is something to be aware of.

When you can't slow your shutter speed down further, it is time to look at other settings such as your ISO and aperture. Choose a smaller ISO, (perhaps 100) or a smaller aperture (such as f/16 or f/22) and see if that solves the problem.

FIGURE 1-18 Images made in dark setting require a slow shutter speed and a stable way to keep your camera steady.

Although you can use a very slow shutter speed to great effect in making images with motion blur, there are other times you will find yourself in a dark setting, but wanting to make images without a moving subject. Let's give it a try:

1. Move into a dark room. Maybe turn on a table lamp, but keep the rest of the room dark.

2. Using AV/A mode, set your aperture to the largest aperture/smallest number possible and your ISO to 3200 if you can. Your challenge now is making an image that is sharp and well exposed.

3. Stabilize your camera using a tripod, a table, the floor, or some other surface. In Figure 1-18, the shutter speed was 1/13, which was much too slow to handhold, so I set the camera on a table. This is a dark room with only candles and tungsten lamps to light the space.

Shutter speed is relatively easy to understand and learn. As you choose a faster shutter speed, the shutter opens and closes quickly, letting in less light. Conversely, if you choose a slower shutter speed, the shutter remains open longer thereby allowing more light to enter the frame. Because shutter speed is expressed as a fraction, the second number, or denominator, gets bigger as the shutter speed gets faster. 1/250 then, is a faster shutter speed than 1/60. If you choose a very slow shutter speed of 1 second or longer, however, shutter speed is no longer expressed as a fraction, but rather as a decimal like 1.6 or 2.5.

Simply changing your shutter speed is an effective way to change your exposure. If your image is too dark choose a slower shutter speed, and if your image is too bright choose a faster shutter speed. As you move into the next two chapters on ISO and aperture you will see how changing one setting impacts the other two, and how the entire exposure triangle works together in the creation of your images. ❖

Chapter 2
ISO

In photography we use the term ISO to indicate how sensitive film or a digital camera is to light. If you use film, you choose a film speed (such as 400) based on the lighting conditions. Digital cameras are no different—you choose ISO based on the amount of light in the scene. The higher the ISO, the more sensitive your camera is to light; the lower the ISO, the less sensitive it is.

Put another way, the ISO refers to the amount of light the film or camera sensor will receive based on the setting you select. As you increase film speed or your ISO, the film/sensor is able to "absorb" more light. Essentially, more light is available for you to make your exposure. At ISO 50 less light is available, while at ISO 400 more light is available.

The term *ISO* refers to both film speed in analog cameras and light sensitivity in digital cameras.

With film, we must evaluate the light in our scene when choosing which film to use (ISO), and learning what film is best for each lighting scenario is necessary to make the appropriate choice. A sunny day, for example, might call for a film speed of 100, while a darker scene would find 1600 more appropriate. ISO 400 is a good catchall speed if you are unsure what your selection should be.

With a digital camera, the same principles apply. We choose a lower ISO of 100 in a very bright setting, and move to an ISO setting of 1600 or 3200 in much

FIGURE 2-1 In the exposure triangle, ISO controls grain/noise.

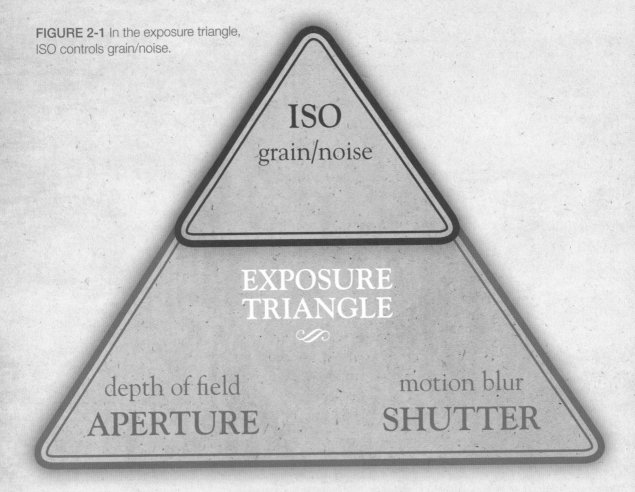

darker settings. As with film, ISO 400 is a neutral setting that works in a variety of lighting conditions.

Another factor in choosing your ISO is the level of noise (grain) you are comfortable with in your images. Have you ever looked at an image with lots of film grain? Just as with film speed, the higher the ISO, the more noise you will have in your images.

The newest cameras have extremely high ISO capabilities, but the trade-off to using those settings is the amount of noise in the image. Personally, I would rather make a great image with noise than miss the image altogether because I was worried about noise levels. Tolerance to noise is a personal thing, and as you are learning what your preferences are, choose a higher ISO if required for the correct exposure and don't worry a lot about noise.

ISO is an abbreviation for the International Organization of Standardization. This international group with headquarters in Europe works to provided standards for a variety of different measures. ISO is a universal measurement that enables digital photographers to make ISO choices just as film photographers choose their film speed.

With digital cameras, we no longer need to physically change our film and film speeds in changing lighting conditions as we did with analog cameras. As such, we can monitor each new scene and choose our ISO accordingly. This is, perhaps, one of the most convenient things about digital cameras—the fact that we can move from a bright scene and ISO 100 to a darker scene with ISO 400 to a very dark scene with an ISO of 1600 or more without pausing to physically change the film we are using.

WHY ISO MATTERS

As one corner of the exposure triangle, ISO helps control how bright or dark our images are. In other words, ISO controls the amount of light we need to make a proper exposure. If we use a low ISO, for example, we need to let in more light via our shutter and/or aperture settings. With a higher ISO we need less light via those settings.

Stops and ISO

The term *stop* is used when referring to shutter speed, aperture, and ISO. In Chapter 1 you learned that shutter speed goes up in increments that double or halve the amount of light; this is also called "stopping up or down."

A stop, in other words, refers to a doubling, or halving, relationship in exposure. If you want a stop more light, you want twice as much light; a stop less means half as much light.

The common range of ISOs (as stops) is this:

50, 100, 200, 400, 800, 1600, 3200, 6400, and so on.
Each of those numbers refers to a full stop interval.

The doubling and halving of these numbers is quite obvious. Where it gets confusing is when you see half or third-stop intervals when changing the ISO on your camera. Here are the third stop intervals you will see:

50, 64, 80, 100, 125, 160, 200, 250, 320, 400,
500, 640, 800, 1000, 1250, 1600, and so on.

Using these increments allows you to control both the sensitivity to light and the levels of noise in your images—rather than moving up a full stop to get more light, you may find you need to move up only one- or two-thirds of a stop.

When you change your ISO it impacts your aperture and shutter speed settings. If you move from ISO 100 to ISO 400, you are able to increase your shutter speed and/or decrease your aperture, assuming you want the same exposure.

Imagine you are in a setting where you have set your shutter speed and aperture to let in as much light as possible, but your images are still too dark. You know you need to let in more light to make your image brighter, but you don't want to change your shutter speed or aperture. Increase the ISO, allowing more light to reach your sensor, and your image will be brighter.

Explained another way, increasing your ISO by one stop (see the "Stops and ISO" aside on the previous page) has the same effect as increasing your aperture by a stop or decreasing your shutter speed by a stop—there is more light.

ISO AND LIGHT

When we are in bright situations we're going to choose a lower ISO (less light sensitivity) and in dark settings a higher ISO (more light sensitivity). Each lighting setting is unique, but there are some generalizations we can make with regard to choosing ISO. On a bright, sunny day, choose ISO 100. On an overcast day, choose ISO 400. Inside a dimly lit room, choose ISO 800. With the newest cameras, there is much less noise at higher ISOs so you could choose 1600, or even 3200, in dimly lit settings.

Because our cameras see light differently than we do (see Chapter 4 for more on this), what looks well lit to you might seem dark to your camera. At a wedding reception, for example, the lights are often dim but our eyes adjust and we are able to see what is happening around us, so it no longer feels as dark in the room. To the camera, the room is still dimly lit and we must increase our ISO to let in more light.

The trade-off for a higher ISO is the noise. Noise can make your image appear softer than it really is (or almost blurry), so it's important to evaluate the light carefully and choose the lowest ISO appropriate for the situation. Look at Figure 2-2b (on the following pages), for example. The image has a softer look to it than Figure 2-2a, which is, in part, the result of the noise in the image.

Many cameras offer an auto-ISO mode that will automatically change the ISO for you. But the only way to really experience the effects of changing the ISO is to do it yourself.

When you choose your ISO, consider the following:

※ **Light:** How much light is in the setting? Is it very bright, very dark, or somewhere in the middle?

※ **Movement:** Is your subject moving? A moving subject requires a higher shutter speed, and you may need to increase your ISO to allow for that.

Let's look at light first. Take your camera into a very bright space (outside in the sun is perfect). Use the following settings to take a picture:

※ *Aperture: f/8*

※ *Shutter speed: 1/250*

※ *ISO: 100*

FIGURE 2-2a

FIGURE 2-2c
Figure 2-2a was taken at ISO 125 while the image in Figure 2-2b was taken at ISO 3200. There is a distinct difference with regards to noise. This is particularly obvious when you zoom in 100% on both images.

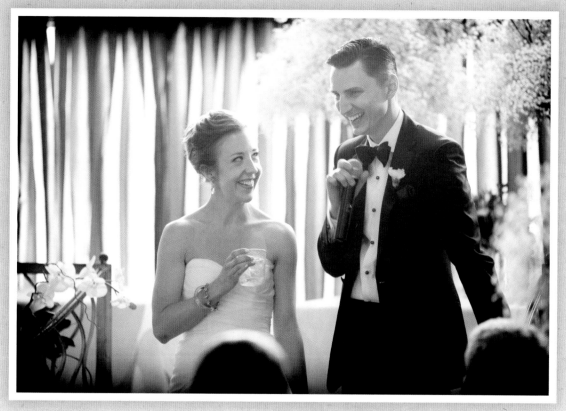

FIGURE 2-2b

What happened? Is your image too bright? Remember, we only want to see how changing ISO affects our exposure, so if your image is too bright, change the ISO to 50 and see what happens. Doing this means your camera has less light sensitivity and your exposure will become darker. If your image is too dark, try moving the ISO to 200. Doing that will increase the light sensitivity and your image will become brighter.

Now take your camera into a room in your home. Use the following settings to take a picture:

※ *Aperture: f/4*

※ *Shutter speed: 1/250*

※ *ISO: 800*

What happened? If the image is too dark, increase your ISO and let in more light; if it's too bright, decrease your ISO and let in less light. Experiment with how changing the ISO alone affects the exposure.

The Sunny 16

Also referred to as basic daylight exposure, the Sunny 16 rule states that your ISO and your shutter will always be the same when your aperture is set at f/16 on a bright sunny day. In other words, if your ISO is 200, your shutter will be 1/200. Or if your ISO is 100, your shutter will also be 1/100.

WHERE TO FIND THE CONTROL

On most cameras, there is a setting clearly marked "ISO." When you press this button, use your dial (see Figure 2-3) to change the ISO.

AUTO ISO: THE PROS AND CONS

As mentioned earlier, many cameras now offer the option of auto ISO. This means the camera changes the ISO for you depending on your other settings. As you are in changing lighting conditions, the camera automatically moves the ISO up or down to ensure that the exposure remains the same.

Obviously, if you don't want to think about ISO, this is a convenient feature. You choose your aperture and shutter speed, and the camera controls the ISO. But therein lies the problem—the camera chooses the ISO and will not always choose the ISO that lends itself to the image you want to make. While it can be tempting to rely on the camera to make this exposure decision for you, it does not work in manual mode. Since our goal is to move beyond reliance on our camera in exposure decisions, I suggest turning this feature off and choosing your ISO manually.

ISO is probably the easiest point of the exposure triangle to understand—increase ISO for more light sensitivity and decrease it for less. In darker settings, choose a higher ISO and in bright settings choose a lower ISO.

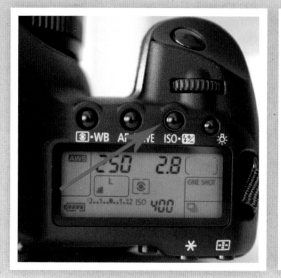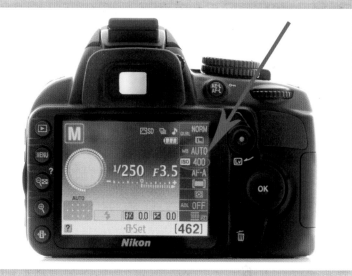

FIGURE 2-3 Look for the ISO button on the front or back of your camera. On some cameras, ISO is controlled from the menu via the LCD.

The other component of ISO, noise, has been mentioned several times in this chapter. In the earliest digital cameras, noise was a real problem at higher ISOs. In recent years, however, camera manufacturers have made the issue of noise almost negligible until you reach the highest ISOs. In my own work, I regularly use ISO settings of 1600 and 3200 to capture moments like the first dance at a wedding. Missing an important moment because you don't want noise in your image doesn't make sense. In fact, professionals photographing news events or live sports often work at ISO 1600. When looking at images you make at ISO 1600, 3200, or possibly even 6400 (depending on your camera model) you won't notice the noise, but rather the moment in the picture.

YOUR TURN

Let's practice what we've learned about ISO so far. Grab your camera and let's experiment to see how ISO affects your images and what noise really looks like.

We'll do two assignments together to look at:

1. How changing ISO alone affects the exposure triangle.
2. What noise looks like at different ISO settings.

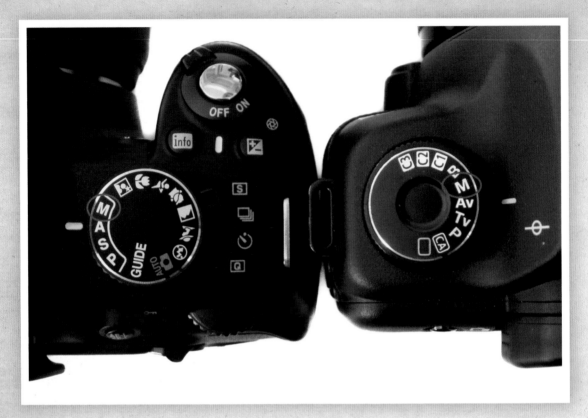

FIGURE 2-4 Manual mode.

Assignment 2-1: How ISO Affects Exposure

Get your camera and set it to manual mode (see Figure 2-4). You will be making all the exposure decisions for this assignment, so be patient and take your time. You might not understand all the elements we are working with yet, and that's alright. Our goal in this assignment is to learn how ISO affects exposure.

Choose any subject you want; it doesn't really matter, but perhaps something stationary that won't mind being photographed again and again. I'm using a vintage camera for this exercise.

Follow these steps:

1. Inside a room lit with daylight, set your ISO to 400, your shutter speed to 1/60, and your aperture to f/4. Figure 2-5 shows where to find those settings on your display. See Figure 2-7 to view my first image.

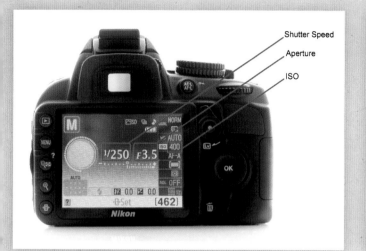 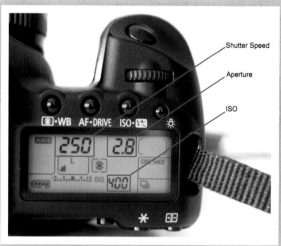

FIGURE 2-5 In manual mode, choose your ISO, shutter speed, and aperture.

2. Make a picture of your subject and look at your camera's LCD display. Notice how light or dark your image is. Your exposure is probably not going to be perfect, but that's alright—we're interested in the effect ISO has on our exposure for this exercise.

FIGURE 2-6 Review your images on the LCD display; note the ISO setting of 400.

3. Change the ISO setting to 800 and make another picture. Review the image, noting that this image is brighter than the first image you made. See Figure 2-8.

4. Change the ISO setting to 200 and make a picture. Depending on your light levels, you may notice a *clu...click* as your shutter speed slows down. As you review the image, notice that it's darker than the first two photographs you made. See Figure 2-9.

Simply changing the ISO one stop up or down, while leaving aperture and shutter speed the same, caused our images to become lighter or darker than the first frame we took.

FIGURE 2-7 Here is my first image made at the following settings: aperture f/4, shutter speed 1/60, ISO 400.

FIGURE 2-8 My second image, made at ISO 800, is much brighter than the first.

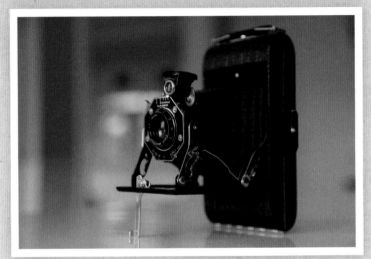

FIGURE 2-9 My third image, made at ISO 200, is darker than my first and second images.

Assignment 2-2: Noise at Different ISO Settings

For this assignment, and only this assignment, choose P (program) mode. In P mode the camera makes the aperture and shutter speed decisions for you, but you can override them. More importantly, though, you choose the ISO and the camera makes the other two exposure decisions based on your selection. Because we are interested in seeing what noise looks like at different ISOs, we are going to rely on the camera to choose aperture and shutter speed.

For this assignment, you will need a stationary subject. Again, it doesn't matter what subject you choose. I'm using the same vintage camera from our first assignment.

Follow these steps:

1. Set your camera to P mode.
2. Select ISO 100 and make an image.
3. Select ISO 400 and make an image.
4. Select ISO 800 and make an image.
5. Select ISO 1600 and make an image.
6. Select ISO 3200 and make an image.
7. Select ISO 6400 (if available) and make an image.

Let's compare my images side by side (Figure 2-10 on the following pages). As you can see, image 2-10a, made at ISO 100, has very little noise whereas image 2-10b, made at ISO 6400, has much more noise, especially in the black areas of the image. Don't worry if you have a hard time seeing the differences in noise. My camera handles noise very well and, as noise levels are often a matter of taste and tolerance, some will see little noise while others will find the noise unacceptable. Your camera may not handle noise as well and the differences may be more obvious.

With modern digital cameras noise is not as obvious as it once was and, for many people, capturing the moment is more important than some noise in the resulting images. In fact, the differences in noise may not be very evident to you—the amount of noise you are willing to accommodate in your images is a matter of personal taste and doing this exercise will let you see how your camera handles noise and how much you, personally, are willing to put up with.

FIGURE 2-10a ISO 100.

ISO really is the least sexy of the three exposure elements. It's straightforward—
a higher ISO number means more light and a lower ISO number means less light.
Other than noise, ISO doesn't really affect the "look" of an image the way motion
blur (shutter speed) or depth of field (aperture) does. When you change the ISO,
you are simply allowing more or less light to hit the sensor. ❖

FIGURE 2-10b ISO 6400.

Chapter 3
APERTURE AND DEPTH OF FIELD

Along with the other two points on the exposure triangle—shutter speed and ISO—aperture is a way of managing the amount of light coming into your camera. Aperture is how much light hits your sensor (or film) via the opening in your lens.

If we look at the exposure triangle again (see Figure 3-1), we see that aperture also affects depth of field (DOF). Depth of field refers to how in or out of focus the foreground and background are in your image.

As you change your aperture to let in more or less light, you are also changing the depth of field. Be sure to keep that in mind when you are choosing your aperture because aperture impacts more than just your exposure. In other words, just like changing shutter speed affects motion blur and changing ISO affects noise, changing aperture also affects how your image looks via depth of field.

As we move through this chapter, we will tackle what aperture really means, how it is expressed, and how it affects your exposure. After that, we'll explore the way aperture affects your depth of field.

FIGURE 3-1 In the exposure triangle, aperture controls depth of field.

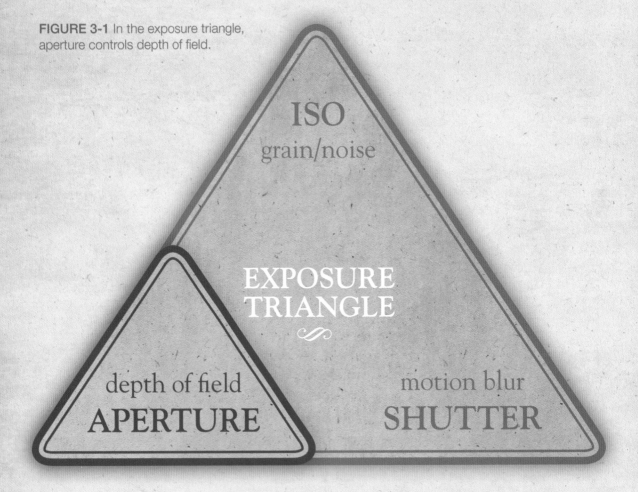

ISO
grain/noise

EXPOSURE
TRIANGLE

depth of field
APERTURE

motion blur
SHUTTER

WHAT APERTURE OR F/STOP MEANS

The terms *aperture* and *f/stop* are interchangeable. The aperture of a lens is essentially the opening in the lens and how big or small that opening is. With a bigger opening, more light reaches the sensor, and with a smaller opening, less light reaches it.

As we saw in Chapters 1 and 2 on shutter speed and ISO, we know that if our image is too bright we want to let in less light and if it's too dark we want to let in more light. With aperture, we let in more light with a smaller aperture number (like f/2.8) and let in less light with a bigger aperture number (like f/8). In Figure 3-2 (seen on next page) you can see a significant difference in exposures between the image made at f/2.8 (Figure 3-2a) and the one made at f/8 (Figure 3-2b).

UNDERSTANDING APERTURE

Aperture is a concept that stumps a lot of people because it's counterintuitive. You might think that a larger number equals more light, but it's the complete opposite. Don't worry if you are struggling with this concept—over time you will get it. Lots of people find the concept of aperture confusing and want to know why it is the way it is. Simply put, aperture is a fraction even though it isn't expressed as such. That means the bigger the bottom number (2.8, 4, 5.6, 11, etc.) the smaller the opening and the less light is coming through the opening.

Just remember that small number = more light; big number = less light.

In other words, small stops are expressed as larger f numbers and larger stops are expressed as smaller f numbers. If you can remember that with aperture everything is opposite, you'll be fine.

Revisiting Stops and F/stops

We learned about stops and f/stops in the "Quick Start Guide" earlier in the book, but let's refresh our memories.

An f/stop is simply the expression of the f/number: a ratio of the focal length of the lens to the diameter of the lens. In other words, it's a math equation of focal length over lens opening.

F/4, for example, means the lens opening is four times greater than the diameter of the lens. The "f" in f/stop simply means "focal," which makes sense given aperture is the ratio of focal length to lens opening.

FIGURE 3-2a

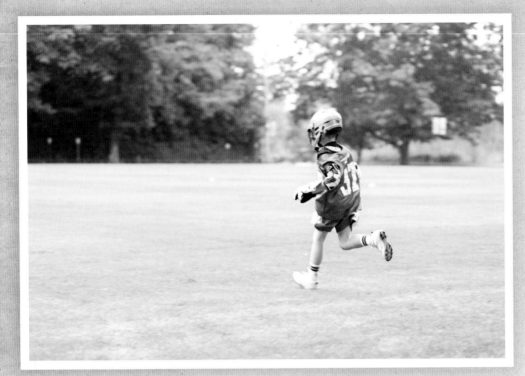

FIGURE 3-2b

These images were made using the same ISO (400) and shutter speed (1/200) settings, but with different aperture settings. Figure 3-2a was shot at f/2.8 and Figure 3-2b was shot at f/8.

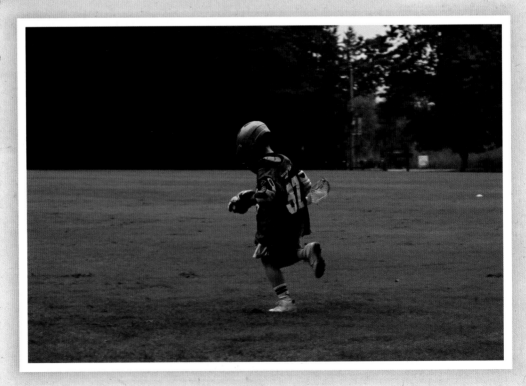

When you buy a lens, it has an aperture value attached to it. This value, shown as the f/value, is the widest the opening of the lens can get (maximum aperture of a lens) and, therefore, this affects the depth of field as well (more on that to come).

Take a look at your lenses. Can you see an f/number like in Figure 3-3? The lens in figure 3-3 is a Canon 24-105 f/4 lens. There is only one f/value (circled in red), which means we can use that lens at f/4 no matter what the zoom (or focal length) is.

FIGURE 3-3 The maximum aperture, circled in red, of a lens is f/4—shown here as 1:4.

FIGURE 3-4 Some lenses have variable aperture values (circled in red) related to different focal lengths of the lens. In this case the variable aperture is f/3.5 to f/5.6.

Have you ever had this happen: You put your camera in manual mode and you make an image where everything looks great in terms of exposure. You then decide to zoom in for a closer shot and the image is dark or muddy looking. You didn't change anything on your camera so it doesn't make sense to have one well-exposed image and then one dark image, does it?

F/stops and Aperture

Like shutter speed and ISO, we can talk about moving up or down a stop with aperture too. Remember, a stop doubles or halves the amount of light entering the camera.

Full stops (or true apertures) are:

1, 1.4, 2, 2.8, 4, 5.6, 8, 11, 16, and 22.

There are apertures above 22, but many cameras stop at f/22.

Take the time to play with the different f/stops on your camera. Your maximum aperture is determined by the lens you are using, while your minimum aperture will most likely be f/22. As you change aperture on your camera you will see half or third stops. When using a lens with a maximum aperture of f/4 you will see likely see the following f/stop options:

4, 4.5, 5, 5.6, 6.3, 7.1. 8. 9, 10, 11, and so on.

Just as with ISO, these third stops give you more flexibility when making images by offering a smaller increase or decrease in light than a full stop would offer.

Unlike shutter speed and ISO, the numbers for third stops don't appear to be truly double or half each other. That's because the formula for calculating f/stops is a bit more complicated than it is for shutter and ISO.

This happens when you use a lens with an aperture number that looks more like the lens in Figure 3-4.

The lens in Figure 3-4 came with the Nikon D3100 in a kit. Most kit lenses have two numbers like those circled in red, and odds are your lens has two values. This Nikon 18-55mm f/3.5-5.6 lens has more than one aperture value (shown as 1:3.5-5.6). This is a variable aperture lens, meaning the maximum aperture changes depending on the focal length (zoom) of the lens.

Let's simplify this a little bit. Going back to our example, you changed the focal length by zooming in for a close-up, and because you have a variable aperture lens, the aperture changed from f/3.5 to f/5.6, letting in less light and causing your image to be underexposed.

When the lens in Figure 3-4 is at its widest, the maximum aperture is f/3.5, which is larger than when the lens is at its longest. In other words, when your lens is at the widest zoom, you have a wider aperture than when your lens is at its longest zoom. If you leave your ISO and shutter speed settings alone, you will have a brighter image at the widest zoom and a darker image at the longest zoom—more light is coming in via the lens opening at f/3.5 than at f/5.6.

This concept can be a bit confusing at first, so let's look at it another way. Lenses with one aperture value listed (like 1:4 in Figure 3-3) can be set at f/4 no matter what the focal length. Whether the focal length is 24mm or 105mm the widest opening of the lens is always f/4. Zooming in or out won't affect the exposure.

With the lens in Figure 3-4, the maximum aperture (widest lens opening) will change depending on the focal length. The first number, f/3.5, refers to the maximum aperture at 18mm while the second number, f/5.6, refers to the maximum aperture at 55mm (the longest zoom). This is something to keep in mind moving forward when selecting the aperture for your image.

If you know you want a wide aperture and shallow depth of field, set your aperture at f/3.5 (the maximum). However, when you zoom to a different focal length there will be an aperture change. Because the aperture is smaller, there is less light coming into the camera and you will need to change your shutter speed or ISO to compensate for that. With these lenses, zooming in or out of the scene (changing the focal length) does affect exposure.

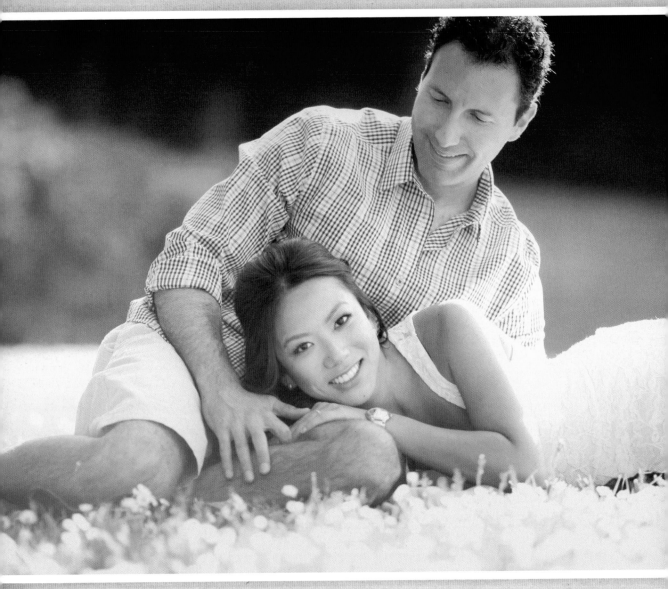

FIGURE 3-5a At f/2 we have a shallow depth of field.

DEPTH OF FIELD AND APERTURE

We touched on depth of field (DOF) earlier in this chapter, mentioning that DOF is how much, or how little, of your foreground and background are in focus. A shallow depth of field means there is less in focus, and an extended depth of field means there is more in focus.

FIGURE 3-5b At f/8 we have a deeper depth of field.

There are a lot of factors, such as focal length and image size, that combine with aperture to determine the depth of field, but let's talk about how aperture impacts depth of field directly.

In Figure 3-5 there are two images. One was made at f/2 and the other was made at f/8. Take a look at the image made at f/2 (Figure 3-5a). Notice how the couple is in focus while everything in front of and behind them is blurry. Now look at the image made at f/8 (Figure 3-5b) and note how much more of the image is in focus. In Figure 3-5b, everything is in focus equally except, perhaps, the mountains in the background and the horizon line.

When we find ourselves in low-light situations and try to allow as much light as possible to enter our camera, it is very tempting to use the maximum aperture. Obviously, doing that results in a shallower depth of field. This is a pleasing effect and one that helps ensure your subject stands out in the image, but might not always be the best choice for the image

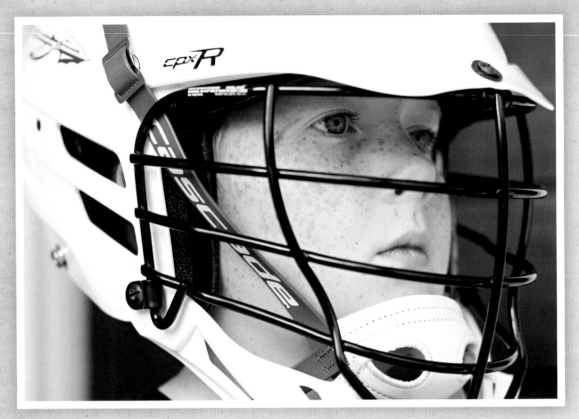

FIGURE 3-6a

FIGURE 3-6c

Working with a shallower DOF means you need to be more deliberate and careful about where you focus.

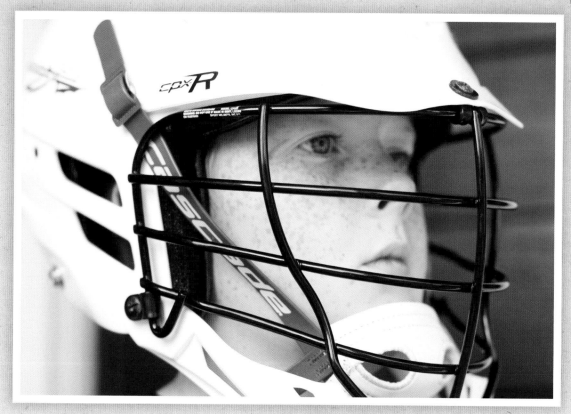

FIGURE 3-6b

you want to make. If you prefer a more extended DOF in a low-light setting, you need to decrease your shutter speed or increase your ISO to allow for a brighter exposure.

One thing to be aware of, however, is the challenges that come alongside a shallow depth of field. In particular, focus can be a little tricky. When you make an image at f/8, there is more in focus in front of and behind your subject. Therefore, if you focus on the general face area, for example, your image will be sharp. However, at f/2.8, you have a much smaller area that is in focus, so focusing on what you want to be sharpest is very important.

As you can see in Figure 3-6a, the focus is clearly on the boy's eye. However, in the image in Figure 3-6b, you can see how the focus slipped and his eye is no longer sharp. In Figure 3-6c, we see the close-up of how the focus slipped from the eye to the helmet.

As you decrease your aperture (increase the f/number) you have greater latitude with your focus. If you miss the exact point you want to be in focus, the smaller apertures are more forgiving.

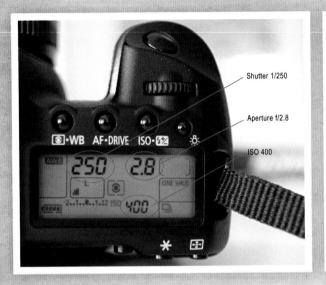

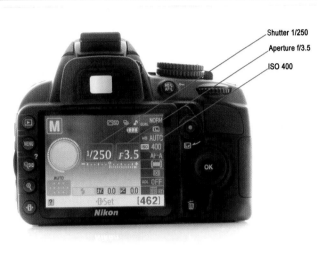

FIGURE 3-7a

FIGURE 3-7b

You can view your exposure settings either on the top (a) or back (b) display of your camera.

WHERE TO FIND THE CONTROL

When you look at the top of your camera, the display shows several values. In Figure 3-7a you can see where the shutter speed, aperture, and ISO are indicated on a camera. You might have a camera without that top display area, in which case you'll find those settings on your LCD display like in Figure 3-7b.

APERTURE AND LIGHT

Before making an image, evaluating the light levels around you is key. Assessing the light helps you choose your shutter speed, ISO, and aperture settings. But when setting up your camera for the shot it's not only the light levels you want to contemplate—you must also consider the DOF you are looking for.

How wide you can go with your aperture depends on the lens you are using. Lenses that have maximum apertures of f/2.8 or f/1.2 are referred to as "fast glass" because the aperture opens up so far. Lenses that offer a constant aperture of f/2.8 or higher are quite expensive and something to invest in at a later date. For now, let's work with the lenses you have already. Shooting as these wide apertures is also called shooting "wide open."

Basically, shooting wide open means you have the shallowest depth of field and most light coming in, at the same time. Remember, though, when you shoot wide open and let in lots of light via your lens, you want to keep an eye on your shutter speed and ISO. If your shutter speed is too slow, you will get way too much light and your image will be too bright (we had examples of this in Chapter 1).

Equivalent Exposure

In Chapter 2 we learned how to perfectly expose an image in bright sun every single time with the Sunny 16 rule. But, that requires an aperture of f/16, which means our foreground, background, and subject are all in focus. If we want a shallower depth of field to really isolate our subject, we need to choose a larger aperture.

We know, though, that to achieve perfect exposure, ISO, aperture, and shutter speed must stay in balance. At f/16, ISO and shutter speed are the same value no matter what, but what happens at f/4?

This is where equivalent exposures come into play—when we change one value, like aperture, there are corresponding changes in ISO and shutter speed to create the same exposure. When you choose a shallower depth of field with f/4, you are letting in more light. In order to have the same exposure we do with Sunny 16, we need to let in less light either via ISO, shutter speed, or both.

Here is an example of equivalent exposures that result from changing aperture and shutter speed, while leaving ISO constant:

f/1.4 at 1/1000	f/5.6 at 1/60
f/2 at 1/500	f/8 at 1/30
f/2.8 at 1/250	f/11 at 1/15
f/4 at 1/125	

Let's look at this another way. Say you are at Sunny 16 with your ISO and shutter speed at 200 and you change your aperture to 4. Here are the equivalent exposures to f/4, with a constant ISO of 200:

f/16 at 1/200	f/8 at 1/50
f/11 at 1/100	f/4 at 1/25

YOUR TURN

Let's work together to see how changing your aperture affects both exposure and depth of field. Make sure you have your camera and let's do three exercises to check out the following:

1. How changing the aperture effects exposure
2. Minimum and maximum aperture on your lens
3. How aperture affects depth of field

Assignment 3-1: How Aperture Affects Exposure

For this exercise, set your camera on manual mode. You'll be making all the exposure decisions for this assignment, so take your time. We want to see how changing the aperture setting affects exposure.

Choose any subject available to you, ensuring there is distance between your subject and the background. If you are inside, set your subject in the middle of the room, for example. If your subject is very close to the background, aperture differences won't be as evident.

Follow these steps:

1. Set your camera on manual mode.
2. Set your ISO (make it 400 if you are inside a day-lit room and 100 if you are outside on a bright day) and your shutter speed (1/60 if you are inside and 1/250 if you are outside). These setting will not change.
3. Set your aperture to f/8 and make a picture of your subject. It doesn't matter how bright or dark your image is, but make note of how it looks on your LCD display.
4. Change your aperture to f/4 and make another picture. You are now letting in more light by choose a larger aperture. As you review your image, it will be brighter than the first photograph.
5. Change your aperture to f/11 and make another picture. As you review this image, notice that it is significantly darker than the other images you made. This is because you are using a much smaller aperture and so there is less light available via your lens opening.

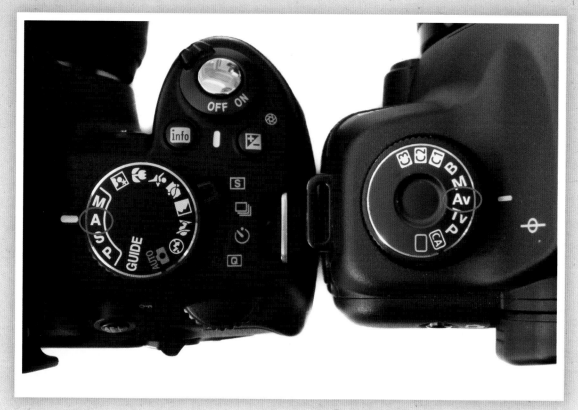

FIGURE 3-8 Aperture priority mode is indicated by AV or A.

Assignment 3-2: Finding Minimum and Maximum Aperture

Each lens has a different aperture range, which impacts how large an aperture you can choose. Choose the lens you use most often and let's work with the subject you used in Assignment 3-1 again.

In this exercise we are using AV/A mode, so choose your ISO and aperture. Your camera will choose the corresponding shutter speed.

Follow these steps:

1. Set your camera on AV/A mode (see Figure 3-8).

2. Choose your ISO. I've used ISO 400 because I am inside a day-lit room.

3. If you are using a zoom lens, ensure you have it set to the widest zoom and choose your maximum aperture. You will know you have the maximum selected when the aperture selection will not move to a smaller f/number. Make an image. (See mine in Figure 3-9.)

FIGURE 3-9 Made at ISO 400, shutter speed 1/15, and aperture f/4.

FIGURE 3-10 Made at ISO 400, shutter speed 2s, and aperture f/22.

4. Zoom out to the longest zoom and set your maximum aperture again. Notice if the f/number changed or not. Make another image if the f/number changed.

5. Choose the minimum aperture —you will know you are at the minimum when the f/number won't get any bigger. For most of us, the minimum aperture is f/22, but it might be different for you.

 Make an image and listen to the sound of your shutter speed. (See my image in Figure 3-10.) Because you are letting in much less light via your lens opening and you have not increased your ISO, the shutter speed will be extremely slow to compensate for the aperture change and you might find your image is blurry as a result.

6. As you review your images on the LCD, make note of your shutter speed and how it changed from Step 3 and 4 to Step 5.

When making Figures 3-9 and 3-10, I used a tripod because with my camera set at f/22 I knew my shutter speed would be too slow for me to hold my camera. If you don't have a tripod (or someplace else to set your camera), increase your ISO to 1600 or 3200 and try this exercise again.

Assignment 3-3: How Aperture Affects Depth of Field

We are going to use AV/A mode again. Choose ISO 1600 or 3200 for this assignment, as your aperture is going to change considerably and I don't want you to have to think about changing ISO as well. In this exercise, we are going to choose a variety of apertures and compare how those choices affect our depth of field. The camera will select the appropriate shutter speed for us.

Once again, there needs to be depth between your subject and the background. Keep your lens at the same focal length (don't zoom in or out) as we make this series of images together.

Follow these steps:

1. Set your camera on AV/A mode.
2. Select f/4 and make an image (Figure 3-11a).
3. Select f/5.6 and make an image.
4. Select f/8 and make an image.
5. Select f/11 and make an image.
6. Select f/16 and make an image.
7. Select f/22 and make an image. (Figure 3-11b).

Let's review the images together. In the images in Figures 3-11a and 3-11b (on the following pages), you can see how changing the aperture also affects the amount of the foreground and background that are in focus. There is significantly more out of focus in Figure 3-11a than in Figure 3-11b. Notice how the reflection on the surface becomes more obvious as the aperture decreases and the depth of field becomes much deeper.

Aperture can be challenging to understand at first, but it's simpler than it appears. The wider the aperture, the more light available and the shallower the depth of field. The narrower the aperture, the less light available and the deeper the depth of field.

That part is easy and makes sense. It is how aperture is numbered that causes the most confusion, with the smallest numbers like f/2.8 referring to the largest apertures. If you can remember *small number = large opening*, and *large number = small opening*, you will find it easier to make exposure and DOF decisions moving forward. ❖

FIGURE 3-11a

Changing aperture affects the depth of field in an image.

FIGURE 3-11b

Chapter 4
METERING + LIGHT

There is light everywhere. And it's light that allows us to make images with our cameras. But what we see with our eyes and what our camera sees are often different—at least in terms of detail, nuance, and more.

Learning how your camera "sees" or measures light, and ultimately about metering, is important as we move beyond auto mode. It's also somewhat complicated, occasionally overwhelming, and often frustrating.

Understanding what your camera sees and how it makes decisions regarding exposure goes hand in hand with understanding how to get the right exposure through aperture, shutter speed, and ISO settings. Take your time—there is a lot of information in this chapter. Know that you don't have to digest this all at once, but can come back to it again when you are ready.

HOW YOUR CAMERA "SEES" LIGHT

Look around you. You can see areas of light and areas of shadow. You can see dark things next to bright things. Your eyes change focus, quickly, between light and dark, allowing you to see objects in both types of light. But that is not how your camera "sees" things.

We call this dynamic range: the ratio between the lightest and darkest areas, and how much of those can be discerned. Put another way, it's the amount of detail your camera can record between the lightest area (highlights) and the darkest area (shadows).

Your eyes have a much greater dynamic range than your camera does, which can be frustrating when what you see in front of you is not what the camera records. Learning how your camera interprets light is key to knowing how to expose a scene. In a situation with bright light and dark shadow, the camera sees the totality of the scene, rather than two distinct areas of light and dark. Your camera seeks to average out the light in the frame when exposing an image rather than recording the distinctly different areas of light. Once the bright and dark areas exceed what your camera can see, they become white and black.

Do you ever make a picture and afterward check your LCD to see what looks like blinking lights on certain areas of the image? Your camera should come with something called "highlight control" or "highlight enable," which is what allows you to see those blinking lights. If you don't already have this feature turned on, do it now (you might have to check your camera manual for how to do this). Once you have highlight control enabled, that blinking shows you the areas that are overexposed, or blown. Those very bright areas have exceeded the dynamic range of your camera and are, instead, recorded as pure white.

Having these blinking lights enabled does not fix the exposure for you, but it does let you know when you have overexposed your image to the point where there is a loss of information. This gives you the opportunity to change one of your settings to let in less light and retain detail in those very bright areas. Some photographers choose to blow the highlights for artistic reasons (as we'll see later in this chapter), but they do so intentionally and expose accordingly.

FIGURE 4-1 Here is an image made in portrait mode with the subject in front of a large bank of windows. The baby's skin tones are muddy as the camera tries to balance the light. The settings were ISO 400, aperture f/2.2, and shutter speed 1/400.

Let's try an experiment together. Grab a subject (person or object) and put it in a place with a bright background behind it. This will work best if it's a sunny day, but you can also achieve this effect by placing your subject in front of a bright window. If you are outside, place your subject in the shade under an overhang with her/its back to the bright background. Put your camera in portrait mode, making sure your flash is turned off.

Does your image look like mine in Figure 4-1? In this example the baby, being held his place by his mother, is in front of a window, but is still well lit from the lights in the room. The camera wants to balance the light in the scene and it results in a muddy (underexposed) subject.

Figure 4-1 is just one example of how you see differently than your camera. When you placed your subject in the shade, the subject did not look dark, did it? You could also see detail in the background, right? Your camera measured the total amount of light in the scene and made its exposure decisions based on that, which led to an underexposed, muddy looking, image. Basically, your camera tried to even out all the light when choosing exposure, and that doesn't work in backlit settings like this one.

FIGURE 4-2 We changed from portrait mode to manual mode. Using ISO 800, aperture f/2.2, and shutter speed 1/250, the subject is now well exposed.

FIGURE 4-3a

FIGURE 4-3b

The exposure bar lets you know if you are over or underexposing your image. In 4-3a the exposure is even or neutral and in 4-3b it is one stop overexposed.

Let's try it again. To compensate for a backlit situation, you want to let more light into your camera (overexpose the image). This might result in the background losing some highlight detail, but you will have a well-exposed subject like that in Figure 4-2.

Look at the exposure settings in Figures 4-1 and 4-2. ISO increased by one stop, aperture stayed constant, and shutter speed decreased by two-thirds of a stop. The resulting gain was one-third of a stop more light. There are many situations such as this one where overexposing by one-third of a stop is enough to ensure that your image is exposed the way you want it to be.

If your camera thinks you are letting too much light into the scene it will show you that on the exposure bar (Figure 4-3). The exposure bar shows underexposure to the left of center and overexposure to the right of center. In some cameras, the exposure bar is reversed, with underexposure to the right of center and overexposure to the left of center. Check your camera to determine the +/- orientation of your exposure bar.

Knowing your camera will always try to even out the light in a scene enables you to make decisions about how much or little light to let into your camera and how to work around your camera's limitations.

GETTING THE RIGHT AMOUNT OF LIGHT INTO YOUR CAMERA

Your camera has an internal light meter that reads the light and then uses that reading to determine exposure value and settings. It tells you when you have your exposure right—for the way your camera "sees" light.

Let's go back to the exposure triangle and add one more piece of information. (See Figure 4-4.)

It doesn't matter what mode you are using—automatic, semi-auto, or manual—the exposure bar will indicate where, on the scale, your exposure is. Your camera likes it to be in the middle—to your camera, that is the proper exposure.

Your camera is right. When the line is in the middle of the exposure bar, that is the right exposure. That said, just because it is the correct exposure triangle doesn't mean it's the correct exposure for the image you want to make.

EXPOSURE TRIANGLE

FIGURE 4-4 When you have the correct settings for the exposure triangle, the exposure bar looks like this one, with the indicator in the middle.

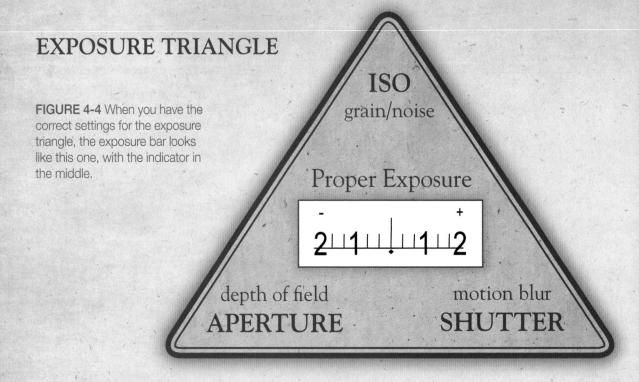

You are probably relying on your camera's meter to help you make exposure decisions and that is totally fine. We'll get into more detail on how that works in the next section. Before that, though, we should repeat one very important thing:

> **If your images are too dark you need to let in more light,**
> **and if your images are too bright you need to let in less light.**

It sounds simple right? That's because it is. Remembering that one simple rule will help you work through times when your images don't look the way your eyes think they should, but the exposure bar says things are just right.

Ultimately, you have to decide what kind of exposure you are looking for. For example, Figure 4-5 shows an image of a girl against a window. All the highlight detail behind her is gone (it's just white), but her face is well exposed. To some people, this is too overexposed, for others, it's just right.

Figure 4-6, on the other hand, is a much darker image, and some people might think it's underexposed. It comes down to taste and what the maker of each image intended, which is something you have to decide for yourself as you move forward with photography.

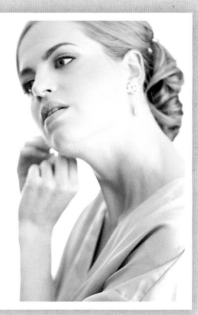

FIGURE 4-5 How you handle highlights is a matter of taste. To some viewers this image is too bright while others will like the way the subject is isolated against the clean, white background.

FIGURE 4-6 To some, this image is underexposed while others will appreciate the play of light and shadow and the well-exposed subject.

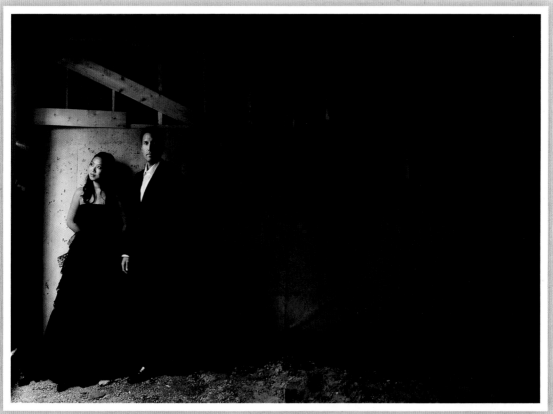

METERING MODES
AND HOW THEY WORK

Ideally, when you are making a picture you want to expose for your subject. That means you want to make exposure decisions based on what will make your subject look the best. If your subject is a person, you will use her face as a basis for your exposure. If your subject is an entire landscape scene, you will expose differently, choosing to focus on one feature while balancing the exposure for the entire frame. Your camera doesn't know what's important to you in an image, though, and therefore won't always expose for what you want.

The different metering modes in your camera let your camera know what you want to expose for—what is important to you in an image. The metering mode you choose tells your camera how you want it to determine exposure.

There are three main metering modes. They might have slightly different names, depending on the camera system you are using, but what they do is the same. Depending on your camera model, you will find this information on the top or back LCD display.

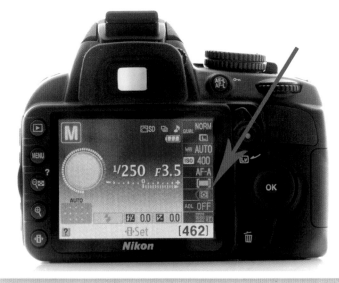

FIGURE 4-7 The metering mode as indicated on the top and back display of a camera.

The three metering modes are:

1. **Evaluative/Matrix metering:** In this mode, the camera is using a number of metering points to evaluate all the light in the scene. The camera then takes all that information and averages it to choose what it thinks is the best exposure. Basically, all the light that is in the scene is evaluated, and then balanced out by the camera—it's "auto" for metering, as the camera makes all the metering decisions for you. (See Figure 4-8a.)

2. **Center-weighted metering:** This mode assumes the subject of the photo will be placed in the middle of the frame. It still uses information from other areas of the frame to choose exposure, but the bulk of the information is taken from the center focal point. This can be useful in a tricky lighting situation to ensure your subject is well exposed. (See Figure 4-8b.)

3. **Spot metering:** Your camera uses a very small area (spot) of the scene to meter from. That spot is determined by you—simply focus on what you want to use to measure your exposure (like a face, for example) and the camera will read from that spot. This is most useful in situations where the scene around your subject is significantly brighter or darker. (See Figure 4-8c.)

FIGURE 4-8a FIGURE 4-8b FIGURE 4-8c

The camera uses a large number of points in evaluative metering (a), points in and around the center focus point for center-weighted metering (b), and a very small area for spot metering (c).

DECIDING WHAT MODE TO USE

As you are learning about exposure and light while working to get beyond auto mode, choosing the right metering mode can help ensure you are also choosing the right exposure. At this point in your journey, evaluative/matrix or center-weighted metering are your best choices.

FIGURE 4-9 With even light, evaluative/matrix metering works well.

In a situation where your light is fairly even across the frame, evaluative/matrix metering works well. Whether you use your center focus point or another focus point won't matter—the camera will give more weight to the auto-focus point and the zones surrounding that point when making exposure decisions.

If you choose to try center-weighted metering, you must either keep your subject in the center of the frame, or do something called focus-recompose. When you focus-recompose, press the shutter button down halfway while using the center focus for your subject. Once your focus is locked (you will probably hear a beep), keep the shutter button depressed halfway and move your subject within the frame, and then press the shutter button the rest of the way to take the picture.

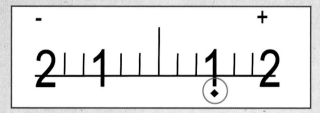 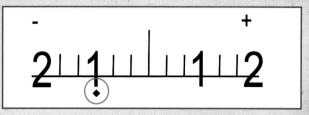

FIGURE 4-10a FIGURE 4-10b

The exposure bar indicates whether your image is overexposed (a) or underexposed (b), based on what the camera thinks the correct exposure is.

EXPOSURE COMPENSATION

When you are in manual mode, you choose your ISO, aperture, and shutter speed settings on your own. The exposure bar we saw in Figure 4-3 lets you know what the camera thinks about your exposure.

If you overexpose your image, the exposure bar will look like Figure 4-10a with the marks to the right on a Canon (and to the left on some Nikons). As you can see in Figure 4-10b, underexposing an image sends the mark to the left on Canon (and to the right on some Nikons). In the exposure bar in these examples, there are third stops indicated, so we say we are over/under by a third, two-thirds, etc.

We have discussed "stops" several time already. A stop is basically doubling, or halving, the amount of light coming into your camera. If your exposure bar is one stop over (Figure 4-10a), that means you are using double the amount of light your camera thinks it needs for a correct exposure. If your exposure bar is one stop under (Figure 4-10b), there is half the light the camera thinks it needs.

In manual mode, you over/underexpose when you change your shutter speed, aperture, or ISO. In a semi-auto mode like aperture or shutter speed priority, you over/underexpose by using the exposure compensation wheel or dial (see Figure 4-11).

In essence, exposure compensation overrides the setting determined by your camera in semi-auto modes, and allows you to choose the correct exposure for the kind of image you want to make without changing aperture or shutter speed directly. For example, if you are in AV/A mode (see Chapter 7) you have set your aperture and ISO and your camera has chosen the "correct" shutter speed for you. As you use exposure compensation, the camera will change the shutter

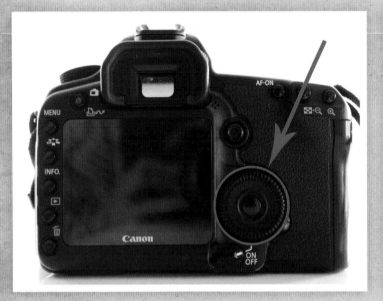

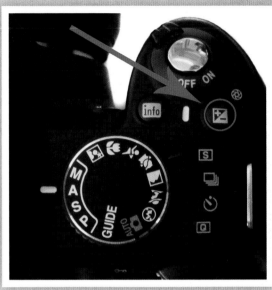

FIGURE 4-11a FIGURE 4-11b

Use the dial on your camera (a) or the +/- button (b) to let in more or less light while in semi-auto modes.

speed to reflect the changes you have made. If you overexpose, the camera will choose a slower shutter speed, and if you underexpose, the camera will choose a faster shutter speed. You are, in effect, controlling shutter speed with exposure compensation in this semi-auto mode.

This sounds more complicated than it really is in real-world situations. Figures 4-12 and 4-13 give you an idea of how to use exposure compensation in AV/A mode. You will learn more about this in Chapter 7, but in AV we make our initial exposure decisions of aperture and ISO. Our camera is set to evaluative metering and we make our first image. While there are times our initial exposure decisions are correct, there are also times we need to adjust our exposure to make the image we want.

Figure 4-12 is my first frame, and I used this frame to fine-tune my settings. Reviewing the image on my LCD display, I realized it was a little dark and so I wanted to brighten the image. Using exposure compensation, I overexpose by two-thirds of a stop, slowing down the shutter speed to let in more light. The resulting image—Figure 4-13— is brighter and in keeping with the image I wanted to make.

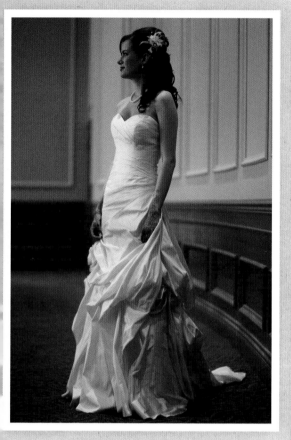

FIGURE 4-12 My first try was a little dark.

FIGURE 4-13 I got the brighter shot I wanted by using exposure compensation in AV mode to overexpose my image.

Exposure compensation simply means we are over or underexposing our image based on the internal camera meter. In semi-auto modes we use the exposure compensation button or dial to change exposure settings. We also use exposure compensation to let in more or less light in manual mode, but we do it by changing aperture, shutter speed, or ISO.

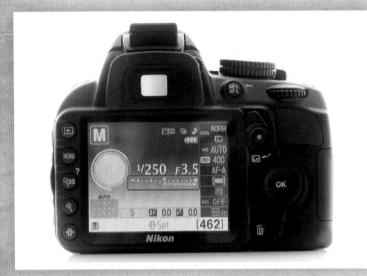

FIGURE 4-14a

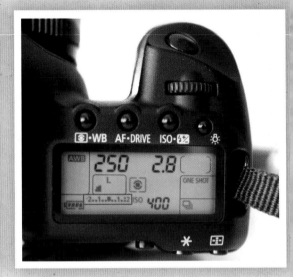

FIGURE 4-14b

Take a look at your camera and find the exposure bar (see Figures 4-14a and 4-14b). When your camera thinks you have the right exposure triangle, the mark is in the middle. Let's assume, though, that you took a picture at that exposure and it was too dark. Now you have to let in more light.

Whether you change aperture, shutter speed, or ISO depends a lot on what you are photographing. If, for example, your subject is a moving child, you won't want to slow down the shutter speed to let in more light as that might lead to motion blur. Rather, you will want to try increasing your lens opening by moving your aperture to a smaller number (larger f/stop). If you are already at your maximum aperture and can't let in any more light that way, increase your ISO.

On the other hand, if you are photographing a still subject and the background is bit messy, changing your shutter speed to let in more light might be the right choice. In this scenario, we want a shallow depth of field to blur out that distracting background. Remember, the smaller aperture numbers (more light) mean less of the foreground and background are in focus. In a scene like Figure 4-15, slowing your shutter speed down to let in more light is the better option to try first. If your shutter speed ends up too slow, then look at increasing your ISO.

You will notice aperture and shutter speed were our first choices when making exposure changes. Generally speaking, to compensate for the camera's exposure, change aperture or shutter speed first, and ISO last. ❖

FIGURE 4-15 When using a wide aperture for a shallow depth of field, decrease the shutter speed or increase ISO to let in more light.

Chapter 5
USING LIGHT

Light ... I've used that word over and over again. I've discussed how important light is, talked about how your camera sees light, and more. What I have not yet done is talk about what light looks like, where to find it, and how to use it.

Light is one of the most important concepts to grasp as a photographer. We often find ourselves challenged by less than ideal lighting conditions, especially when photographing sporting events or while being the official family photographer. It's easy to make images in safe, even lighting—and there is nothing wrong with that! In fact, using safe light while you experiment with the exposure triangle will make it easier for you to master both. More often than not, though, you'll be working with light that requires you to think about your exposure decisions.

There are entire books already written on light and lighting. For the purposes of this section, we are focusing on natural or available light—the kind of light that surrounds us, without flash or other supplemental lighting.

As we move through different lighting examples, it will be helpful for you to have someone as a subject to work with. However, you can also use your hand to see the way light affects a subject. You might feel a little silly doing this, but it is a quick and easy way to see light. In fact, we do it (ok, I do it) all the time in professional shooting situations where the environment, and light, is unfamiliar to me. Your hand is covered in lines and that makes it a great gauge for knowing if the light is flattering or not. As we move through the examples listed in this chapter, your hand will help you see how light affect the subjects you photograph.

LIGHT AND WHITE BALANCE

We can't talk about light and how to use it without also mentioning white balance. Different light sources have different color temperatures, or color casts, associated with them.

Our eyes take in the varying color casts of light and make them appear white. Your camera, however, is not always able to do this and occasionally your images will have a strange color cast. A tungsten light source, for example, has an orange (warm) cast and a fluorescent light source has a blue (cool) cast.

In the simplest terms, your camera interprets the light source and corresponding color cast and adjusts the white balance accordingly. Called auto white balance, or AWB, this setting is how your camera determines what it thinks the best white balance is for each situation.

FIGURE 5-1 With auto white balance (AWB), your camera adjusts for the light in the scene to make white objects appear white.

FIGURE 5-2

View your white balance setting on the top or back display; change
your white balance via the buttons indicated in each image.

White Balance Preset Icon	When to Choose This Setting
AWB Auto	**AUTO:** The camera chooses the white balance setting for you.
☀ Tungsten	**TUNGSTEN:** Use indoors under incandescent lighting.
☀ Fluorescent	**FLUORESCENT:** Use indoors under fluorescent lighting.
☀ Daylight	**SUNNY** or **DAYLIGHT:** Use in bright, sunny settings.
⌂ Shade	**SHADE:** Use in open shade where you notice a blue cast on your images.
☁ Cloudy	**CLOUDY:** Use in overcast settings.
⚡ Flash	**FLASH:** For use with the camera flash.

Often AWB works fine, but there are times when you will need to change the white balance to one that better reflects the lighting conditions.

There are several different presets that come with most cameras. The table on the previous page shows some of the different presets you might find in your white balance menu.

SUNLIGHT

The biggest, brightest, and most natural source of light is the sun. Sunlight offers all sorts of opportunities, such as using backlight, harsh direct light, or soft diffuse light.

We can't control the sun as a light source, and often are forced to work within the confines of what the sun is doing at any given time of day. This means we are often working with light we would not have chosen. For example, let's say you are with your kids in the park in late afternoon. The sun is low in the sky and strikes your daughter's face beautifully, but everything around her falls into shadow. How do you expose for that situation? As we move through this chapter, we'll share the exposure settings we've used in each setting, and as you work with different light, use those as your starting points.

FIGURE 5-3 Part of what makes images interesting is the creative use of light and shadow.

You will encounter all sorts of lighting conditions, using each to make interesting photos. Here are some of the most common:

Soft Frontal Light

Perhaps the easiest light to work with, soft frontal (or diffuse) light is also the most flattering light to work with when photographing people. This kind of light is even, and we don't have to worry as much about over- or underexposing our subject.

You will find this light everywhere. It's indirect, so there is no harsh sun pointing directly at or behind your subject. If you place your subject facing a window, for example, you will see his or her face bathed in soft light that minimizes imperfections.

If you're using your hand, simply stand with your back to the window and hold your hand out in

FIGURE 5-4 With soft, frontal light, our subject is evenly lit across the entire frame. This image was made at ISO 400, aperture f/2.8, shutter speed 1/160.

front with your palm facing you. Hold your hand slightly to the side so your head and body don't block the light on your hand. Obviously your hand has wrinkles, and when it is facing soft light you'll notice the wrinkles are minimized.

We'll use that window as an example as we move through the discussions about different kinds of light you'll encounter, turning your subject so you can see the effects of light on his or her face.

The great thing about using soft frontal light is that it enables you to turn almost any environment into an impromptu photo studio. While windows provide a great source of light, open doorways work well also. In Figure 5-5, I used the light spilling into the room via a doorway and a bank of windows to create a portrait of this couple in their home.

FIGURE 5-5 The diffuse light creates an even exposure across all elements in this frame. Camera settings: ISO 800, aperture f/2, shutter speed 1/1000.

You won't always have windows or a doorway to work with, but don't worry. Soft frontal light can be found in outdoor settings as well. Often areas of open shade have lovely soft frontal light (see Figure 5-6). Learn more about how to find great open shade locations in the "Shade" section later in the chapter.

Calling this type of light "soft" is a little deceiving, though. The light is soft in that it is uniform and easy to work with, but the images made with this light don't have to appear soft. In Figure 5-7, for example, we used diffuse window light to create a dramatic portrait.

FIGURE 5-6 Soft frontal light can be found outdoors as well as indoors. Camera settings: ISO 400, aperture f/2, shutter speed 1/1250.

FIGURE 5-7 Soft frontal light can be used to make dramatic images. ISO 400, aperture f/1.84 shutter speed 1/400.

The subject was placed close to the window with her face angled toward the light. As you can see, she is well lit but the background is black. This is the result of something called "light falloff"— there is significantly less light in the background than what is lighting our subject.

Take a look at your own windows or doorways. Note how the light comes in through the opening but illuminates only a certain area before the level of light falls off. Using your hand, compare the light level at the window (or doorway) to the light level several feet away. You should see a difference. There will be less light on your hand further away from the source, making your hand appear darker.

Because we placed the subject as close to the light source (the window) as possible, it emphasized the light falloff. If we had placed her further from the window, the difference in light level between her and the background would not have been as extreme.

Let's try this. Choose an open doorway to use as a light source. Ensure there are no lights (such as table lamps or light from other rooms) turned on in your background and spilling into the area. Place your subject in the doorway. Make your exposure decisions based on your subject's face—not too bright and not too dark. When you make the image, notice the light around your subject. The area closest to her will be bright while the background will be significantly darker.

Backlight

In a backlit setting, the light is coming from directly behind your subject and into the camera lens. This can often cause a silhouette and can create several problems when trying to get the correct exposure.

FIGURE 5-8 In this backlit photo, the subject has her back to the light and the light "wraps" around her creating a soft, hazy look. Camera settings: ISO 100, aperture f/1.8, shutter speed 1/500.

Remember the camera considers all the light in the scene and tries to balance it, so your backlit subject will be underexposed if you allow the camera to do the thinking for you. Using the exposure bar as your guide, you will want to overexpose your image by a couple of stops depending on the scene. This is something you are going to have to experiment with. In some scenes you can overexpose by one stop, other scenes might require two stops or more. Be patient with yourself—you'll get there. Remember you can use third stop increments as well, so if you overexpose by one stop and it's not enough, try two stops and if it's too much, you might need to be overexposed by one and one-third stop.

In the same window you used for soft frontal light, turn your subject around so her back is to the light and your camera lens is pointing right at the window. If you are using your hand to check light, stand with your body toward the light, palm facing towards you (the back of your hand is towards the light). You likely have a hard time seeing your hand clearly—the palm is dark and the background is very bright in comparison.

Set up an exposure that your camera thinks is correct. (The exposure bar is at even). Try taking a picture—your subject will be underexposed, looking muddy and dark.

Now try changing your aperture or shutter speed to let in a full stop of light. Remember that you have options when letting in one full stop of light—you can open the aperture to a smaller f/number, decrease your shutter speed, or increase your ISO.

Assuming you are already at the maximum aperture value of your lens, and you can't slow your shutter down any more without risking a blurry image, try increasing your ISO. What happened? The image became brighter as you added more light, right?

In a backlit situation, it might be tempting to rely on our semi-auto modes to help us out. You can do that, but with most cameras, you can only over or underexpose your frame by two stops, and you might need to overexpose more than that to get the perfect exposure. In other words, you can use a semi-auto mode to help gauge exposure if you want to, but if you need to overexpose your image by more than two stops you can't do that in a semi-auto mode—you must switch to manual mode.

When shooting with backlight, you have two options for making a well-exposed image. You can blow the highlights and keep the skin tones intact, or you can make a silhouette where the background is still bright and your subject is very dark (like a shadow). The tradeoff for exposing for the face is the loss of detail in the background.

Look back at Figure 5-8—the grass in the middle and foreground of the frame has detail, but the sky has lost all detail. The highlights in the sky are blown and are recording as white, but the subject is well exposed. Remember the flashing lights we talked about in Chapter 4—the lights in this image were flashing in the sky and across her right shoulder, but her face did not have any flashing lights on it. That is one way to know your subject is well exposed while the background is blown.

When making a silhouette like Figure 5-9, we are emphasizing the light and dark areas in our frame. Place your subject in front of something very bright. In our example we used the sun, but this also works with a bright window. Rather than exposing for our subject, we expose for the brightest part of the image, which makes our subject dark.

If you need help choosing an exposure for a silhouette, switch to aperture priority mode (AV/A), choose your ISO and aperture, and then focus on the brightest part of the scene and make a picture. Check your shutter speed and make note of it. Now switch to

FIGURE 5-9 A backlit setting provides a great opportunity to make a silhouette, which is another way to tell an interesting story with your images. Camera settings: ISO 1600, aperture f/1.8, shutter speed 1/1000.

FIGURE 5-10 Silhouettes can also be made during the brightest times of the day. Camera settings: ISO 100, aperture f/8, shutter speed 1/1250.

manual mode and choose the same ISO, aperture, and shutter speed you had in AV/A mode. Focus on your subject this time and make a picture. You will be close to the right exposure for this kind of image, but may find you want to make your subject even darker—underexpose until you have the look you want.

You can use AV/A mode to help find exposure in other settings as well. Following the same steps, choose your aperture and ISO, allowing the camera to choose the shutter speed. Make note of the shutter speed and then switch to manual mode. Choose your original aperture and ISO, and the camera's suggested shutter speed. As you transition from automatic to manual modes, using semi-auto mode is a great way to get a little extra help with your exposure decisions.

Whether you like the way blown highlights or a silhouette looks depends on your personal preferences and what your subject really is. If you want to have the background fully in focus and your subject well exposed, it might be best to move to a more even lighting situation, rather than one with extreme backlight.

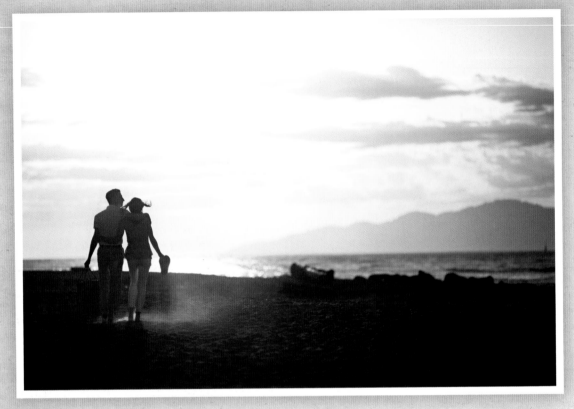

FIGURE 5-11 With a backlit setting we can make images that fall somewhere between a blown out, hazy background and a silhouette. Camera settings: ISO 160, aperture f/2, shutter speed 1/6400.

Working with light that seems challenging at first can lead to great images, though. One of a photographer's favorite times of the day is often as the sun is starting to set. We have all sorts of lighting options—from soft frontal light, to backlight, flare, and sidelight (which we'll cover later in the chapter). We can choose to blow the background, make a silhouette, or create something in the middle of those options. In Figure 5-11, I used backlight to make a great storytelling image.

In Figure 5-11, an "almost silhouette" was created, which is not an official photography term but does describe this image well. The late day sun is highlighting the sand at the subjects' feet, and we maintain more detail in the background than we would have if exposing for the subject. Rather than exposing for our subject or exposing for the brightest area, we settled in the middle, creating balance between the blown highlights in the sky and the potential for a silhouette.

Sidelight

While frontal light and backlight can result in balanced scenes, sidelight can be a little harder to work with. As the name suggests, sidelight is where the light is coming in from one side of the scene (to the right or left of your camera position) and creates an unequal or unbalanced lighting scenario. Typically, one side of the subject's face is brightly lit, while the other side is relatively dark.

In Figure 5-12 the light is coming from the left side of the frame, which is why that side of our bride's face has more light on it than the other side.

At the same window you used to experiment with soft frontal light and backlight, let's look for sidelight. It's easy to find. Simply move your subject so her face is perpendicular to the window, just like the subject in Figure 5-12. You will see right away that the side of the face closest to the window is bathed in diffuse light. The other side is darker. Finding the right exposure in this lighting can be tricky.

FIGURE 5-12 When your subjects are side lit, there are bright and very dark areas on their faces. This light is also referred to as split lighting. Camera settings: ISO 500, aperture f/2.8, shutter speed 1/320.

You don't want to overexpose to the point that the lit side of the face is blown out, but you don't want to underexpose to the point there is no detail at all in the shadowed side of the face.

When we experimented with backlight earlier, we exposed for the subject's face, causing the background to blow out and lose detail (refer back to Figure 5-8). In a side lit situation, you want to find a balanced exposure so that you don't blow out your subject's face. Start with the same exposure settings you used for your soft frontal light image. Make the image. How does it look? Is the bright side of the face well exposed, and can you still see detail in the shadow side? Or, do you need to make an exposure change to let in more or less light?

FIGURE 5-13 Mixing soft frontal light and sidelight in this image creates beautiful and interesting light across both faces. Camera settings: ISO 2500, aperture f/4, shutter speed 1/30.

FIGURE 5-14 Sidelight can be used to make compelling and interesting portraits. Camera settings: ISO 200, aperture f/1.8, shutter speed 1/5000.

Each side lit scenario is different, based in a large part on how dark the shadow side of the face is. While finding the perfect exposure might take some trial and error, sidelight can be used to make compelling and interesting images.

Don't be afraid to use different kinds of light in the same image. When you have more than one person in a scene, as in Figure 5-13, you can use the light differently for each subject. In front of your window, imagine you have two people facing you, perpendicular to the window. Keep the subject closest to the window as is, but have your other subject turn her face toward the light until her face is evenly lit. The light source is the same, but how it is used is different.

Side or split light can make a man's face, in particular, look fantastic. Be careful with women, though, as split light can emphasize skin imperfections such as blemishes or wrinkles, and when we photograph women we want to minimize those things.

Direct Sun

Soft frontal light, backlight, and sidelight are all diffuse sources of light. Direct sun, on the other hand, is not diffused in any way. Sunlight shining directly on your subject can be harsh. It can lead to squinting, and can be overwhelming or too bright for your camera. Yet, it is also quite powerful and interesting at the same time.

If you are reading this on a sunny day, you're in luck. Go outside and hold your hand out in front of you and see just how bright the sun is. Look around the entire scene, though, and notice that your hand is not significantly brighter or darker than everything around it.

FIGURE 5-15 Direct sun allows us to expose for our subjects while keeping detail in the background. Camera settings: ISO 100, aperture f/2.8, shutter speed 1/1250.

The advantage to working with direct sun is that it is even light—there are unlikely to be areas of bright light and dark shadow (other than the shadow cast by your subject).

As you can see in Figure 5-15, when working with direct sun we don't have to sacrifice detail in the background to expose for our subject. Rather, we are able to keep the detail, and in Figure 5-15 you can see how blue the sky was that day. Interestingly, this is the exact same location used in Figure 5-8. Rather than working with backlight, we simply turned our subjects to face the sun instead. That's something to think about when you are making images—simply walking around your subject often gives you different types of light to work with.

With this kind of light, watch your backgrounds closely for distracting elements. It can be challenging to have a wide aperture (small f/number) and a shallow depth of field (background and foreground blurry) while using a fast enough shutter speed to control the amount of light coming into the camera using direct sun. This means we might not be able to blur out distracting background elements with a shallow depth of field.

Let's try this. On a sunny day, take your subject out into the sun and position him (or it) so that he is facing directly into the sun. Your back will be to the sun in this setting. Set your ISO to 100, your aperture to the maximum aperture value (f/2.8, for example), and your shutter speed to 1/500. What happened? Is your image too bright or too dark? Those settings were the starting point for Figure 5-15.

The image was too bright initially. Because we have a base to work from, we can brighten the image by letting in more light, or darken the image by letting in less light. If you need more light, decrease your shutter speed, and if you need less light, increase your shutter speed. In Figure 5-15, we had to let in less light and did that by adjusting our shutter speed from 1/500 to 1/1250. Figure 5-15 is the result.

As you work with subjects in direct sun, be cautious of where you have them look as there is potential for squinting eyes and dark shadows if the face is angled incorrectly. While this might be a relatively easy lighting situation for you to work with, the image can be ruined if your subject's eyes are closed or his brow is furrowed. Instead, try having him look off to the side, or try the one-two-three game. With one-two-three, have your subject close his eyes and keep them closed while you get the correct exposure. When you are ready, let your subject know you are going to count to three and he should open his eyes when you get to three. Get ready to make the image—there is a split second where your subject will open his eyes without squinting at you.

Shade

On a bright day, it can be tempting to place our subjects in a shady area. The light is typically diffuse, soft, and even, and our subjects will not squint the way they do in direct sun. Exposure is relatively easy as well.

There are a few things to consider when working in a shady area, though. First, what is your background? On a bright sunny day, the only shade might be adjacent to a very bright background. This will have the same effect as backlight in that exposing your subject well can result in blowing out that background.

Second, look for open shade. We saw an example of open shade in Figure 5-6. This is the area where light and shade meet to create a space that is evenly lit. Place your subjects in the open shade, facing the light. Overhangs on buildings, alleyways, and porches often offer great opportunities for this. In Figure 5-6, the couple was in a field shadowed by large trees.

The final thing to be aware of is that shade can often cause a blue color cast on your images. This would be a time to change your white balance to shady, which will warm up the image and get rid of that blue cast.

In Figure 5-16 the subject is in the shade, but notice the light on her hair and around her shoulders and arms. This is called "rim light" and it happens when there is a light source behind the subject, creating almost a ribbon of light that highlights the edges of the subject. As with Figure 5-13, this is another example of using two kinds of light to make an image. Rather than lighting two subjects differently, though, Figure 5-16 mixes backlight with open shade.

FIGURE 5-16 Open shade and backlight combine to create rim light. Camera settings: ISO 100, aperture f/2.8, shutter speed 1/200.

FIGURE 5-17 Camera settings: ISO 400, aperture f/11, shutter speed 1/100.

Flare

Flare is one of my favorite ways to use light. Often a combination of backlight and direct light, flare occurs when the light hits the front element of your lens and causes reflections in your images (see Figures 5-17 and 5-18). Using a zoom lens is often the better choice in this situation, as there are more surfaces for the light to bounce off.

How the reflection looks can be different, but the effect of flare is the same: it decreases the contrast in an image and often causes a hazy effect. As you see in Figures 5-17 and 5-18, there is flare in both images, but it doesn't look exactly the same each time. Notice Figure 5-17 was made at f/11 rather than f/4 like Figure 5-18. Using a smaller aperture (larger f/number) creates more dramatic and obvious flare. Done correctly, flare can be spectacular.

FIGURE 5-18 Camera settings: ISO 500, aperture f/4, shutter speed 1/320.

Timing is important when creating an image with flare. It is all but impossible to create flare at high noon on a sunny day—the angle of the sun simply won't allow for it. Earlier or later in the day, when the sun is lower in the sky, is the perfect time to try for flare.

Place your subject between your camera and the sun. Generally speaking, you must underexpose your image when working with flare. You also need to work with a smaller aperture (larger aperture number) as well, like in figure 5-17.

ROOM LIGHT

While it's great to work with sunlight, we often find ourselves forced to work indoors with room light. Say, for example, you are at a friend's birthday party or an anniversary dinner that is happening at night. The only light available to you is the light in the room you're in.

When working with room light, there is typically a mix of light sources from tungsten to candlelight, and occasionally some daylight as well. Each light source has a different temperature, or color cast, associated with it and your camera has a variety of white balance settings to compensate for that. (Refer back to the white balance chart at the beginning of the chapter.) Balancing competing color casts can be a challenge.

Figure 5-19 shows a scene with two light sources. The fire in the background is obviously one source and the other is a tungsten spotlight illuminating the foreground.

Firelight is a warm light source, slightly orange in color. Tungsten light is a slightly cooler light source than firelight, but it still has a warm cast to it. In Figure 5-19 the camera was set to AWB, which works to balance the light in any scene. In this particular image it worked, balancing the two light sources and temperatures because they are similar.

As you work indoors, you may find your images sometimes take on very different color casts than what you see with your eye (this happens outdoors as well). In many

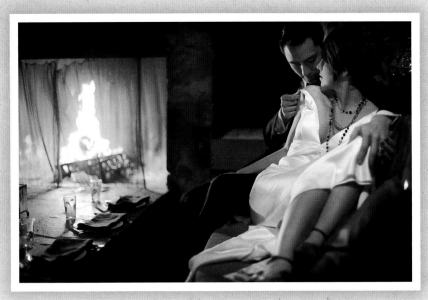

FIGURE 5-19 When you make images indoors, you might find yourself working with more than one light source like in this image. Camera settings: ISO 1600, aperture f/1.2, shutter speed 1/50.

situations using AWB is fine, but there are times when your camera is fooled by the light and the white balance shifts accordingly. This is something to keep a close eye on.

Let's assume you are inside, working with AWB, and your image looks blue. You notice the light is mostly fluorescent, which causes a cool, almost blue, color cast. Now would be the time to change your white balance settings. Choose the fluorescent setting and see what happens. There should be a change in the color cast of your image. When you find yourself seeing an odd color cast, remember it can likely be fixed by choosing a different while balance preset.

EXPOSURE SETTINGS IN ROOM LIGHT

Obviously, the level of light in each room is different. A room filled with daylight requires different exposure settings than a room with no daylight at all. This is where ISO becomes particularly important.

In Chapter 2 we learned that in a dimly lit room we typically want our ISO to be at least 800. We know that higher ISO settings result in more noise in our images, but the newer cameras have vastly improved our ability to use higher ISO settings without significant noise. If ISO 800 is not enough, try ISO 1600 or 3200.

Once you set your ISO, choose your aperture and shutter speed. In a dim room, you want to let in as much light as possible, so you might shoot wide open, with the maximum aperture your lens will allow. That leaves shutter speed. Ensure your shutter speed is fast enough that you don't hear the *clu...click* of a slow shutter, and that you are not choosing a shutter speed significantly lower than the focal length of your lens (refer back to Chapter 1 to brush up on this concept).

You might have to adjust your ISO again in order to get the correct exposure for your scene. While noise is something to be aware of, you also have to consider what is more important to you in these settings—making images of wonderful moments, or minimizing the noise. For most people, it's probably safe to say they would rather have a little noise in their images than miss that moment.

While photography is technical in execution, it's often emotional in scope. Capturing a child blowing out her birthday candles or your parents celebrating their 50 year anniversary is far more important, in my opinion, than a little bit of extraneous noise in the image. But it is the opportunity to capture those moments that makes mastering exposure and getting beyond auto mode so important—you don't want to miss the moment because your camera made the wrong decisions for you. ❖

SEMI-AUTO AND MANUAL MODES

However it is you wish to document your life, whatever the types of images you want to make, having a solid understanding of the exposure elements will make your images that much better. Photography is complicated, yet it is also simple: Make the correct exposure decisions for the image you want to make.

In this section we delve into two of the semi-auto modes—aperture priority and shutter priority—as well as manual mode, discussing how they work, when to use them, and how to ultimately take full control.

Sometimes referred to as "creative" modes, the semi-auto modes on your camera offer you shared control of your settings. You set one or two corners of the exposure triangle and your camera sets the third. Using semi-auto modes in your journey to get beyond auto mode is a way to gain a greater understanding of how one piece of the exposure triangle affects the others.

I often alternate between the semi-auto AV setting on my camera and manual mode as a professional photographer. A lot of professionals do—especially wedding and portrait photographers, who often work in changing light conditions. Although professionals do, on occasion, choose to use the semi-auto modes, they are also proficient in manual mode.

As we move into manual mode, you will discover it is not just understanding exposure elements that will make your photographs better, it is also being able to use those elements and manipulate them independently of each other that will make you a better image maker.

In auto and semi-auto modes you give up some measure of control, often compromising the image you want to make to be certain you catch the moment at hand. That is commendable, to be sure, but it is also unnecessary. As you gain a better grasp of exposure and become more adept at changing your settings on the fly, you will not have to compromise the moment for control again.

For many, being able to make great images in manual mode is what defines them as photographers. I would argue this instead: Once you understand how to make exposure decisions in manual mode, you are better equipped to make an informed decision about what mode best suits you. What mode you use is ultimately up to you; using the different modes effectively is much easier when you are armed with the knowledge of how the parts of the exposure equation work together.

Chapter 6
CHOOSING A CAMERA MODE

Modern cameras come with a variety of modes designed to make it easier for new users to make images. These automatic settings are exactly what I want you to move away from while transitioning through semi-auto to manual mode. One of the advantages of a DSLR is the control we have over exposure decisions—that control is what makes us better photographers.

Before leaving automatic behind, though, we'll discuss what the most common automatic modes are designed to do for you. Offering specific exposure settings based on the mode you choose, you can reflect on what auto modes offer while making your own decisions in semi-auto and manual modes.

With most cameras, there are three modes available to you:
* automatic
* semi-automatic
* manual

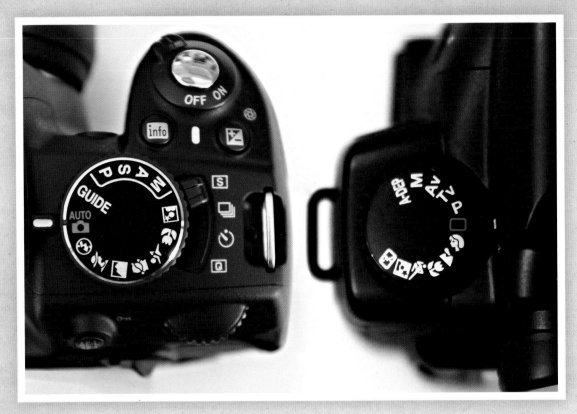

FIGURE 6-1 Automatic modes are indicated with pictures, while semi-auto and manual modes are indicated by letters.

Let's look at Figure 6-1. You see two camera dials with a variety of images and letters. Camera modes are grouped together on the dial based on the level of control they offer. Most of the automatic modes are indicated by pictures. For example, the person's head indicates portrait mode and the flower indicates macro mode (close up). The green "auto" or box image is just plain automatic—no specific situation is required or considered.

The semi-auto, or "creative," modes are indicated with letters like A, S, and P (or AV, TV, and P), while manual is indicated with an "M."

Not all DSLRs come with specific automatic modes represented by pictures, but they do all have at least one automatic mode as indicated by the green box, or "auto," in addition to semi-auto and manual modes.

Now that you know where to find these modes on your camera, let's talk about what they do.

AUTOMATIC MODES

The basic difference between automatic and manual modes is who/what is doing the thinking for each image being made. When using automatic modes, you trust the camera to make all exposure decisions for you. You are merely a button pusher at this point. You cannot override the camera's exposure decisions in any way.

When you first purchased your DSLR, you likely chose one of these modes initially. Automatic modes can do a good job, assuming the conditions are ideal, but they are limited in many ways. The camera has no way to know what you want to make an image of or why you want to make it. It cannot know if the background is messy or your subject is moving. In automatic modes your camera makes decisions for you that you should be making for yourself.

Your camera might have more modes than what we discuss, but some of the common auto modes are:

Auto: This is a general setting. In this mode the camera chooses all the settings, from exposure, to white balance, to flash (if you have a pop-up flash). The camera makes a best guess based on the information it is given, but does not account for the kind of image you want to make. This mode makes your camera a point and shoot.

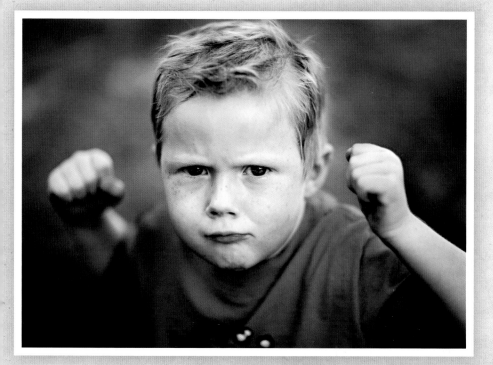

FIGURE 6-2 Portraits are typically made with a shallow depth of field.

FIGURE 6-3 For landscapes, a narrow aperture is typically chosen for the deeper depth of field.

 Portrait: In portrait mode the camera still chooses all the settings for you, but the camera adjusts the aperture to blur out elements in the foreground and background with a shallow depth of field. On some cameras you can adjust the ISO and turn off the flash as well, although the pop-up flash might fire automatically in this mode.

 Landscape: In landscape mode your camera tries to get as much in focus as possible with a deeper, or extended, depth of field. The aperture is set to the narrowest opening, causing the foreground, subject, and background to all be in focus. This mode is best for scenic views where all the detail in the image is important. The pop-up flash likely will not fire, unless it is a fairly dark scene.

 Close Up (Macro): This mode is for getting really close to your subject. The flash is minimized to avoid making your subject overly bright. There are limitations, however, based on lens choice. Each lens has a distance at which it can focus, and using macro mode won't enable you to get any closer to your subject and still have it in focus.

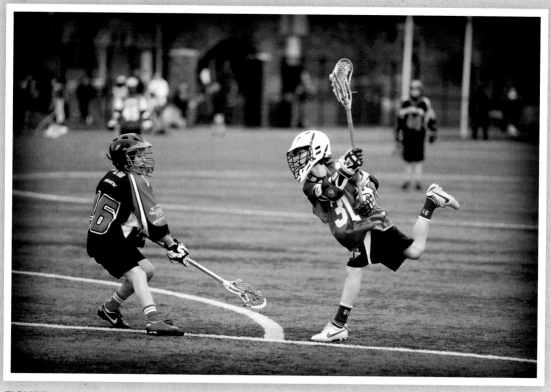

FIGURE 6-4 When photographing sporting events, or any other moving subject, choose a fast shutter speed to avoid motion blur.

Sport: Sport mode is designed to capture moving subjects. The camera chooses a higher shutter speed to freeze the motion and avoid motion blur. Best used outdoors, or in a bright setting, sport mode is limited based on the amount of light in a scene. In darker settings (like in an ice arena) the shutter might not be fast enough to avoid motion blur.

※ The APERTURE is the size of the lens opening, which allows light to reach the sensor. Aperture also controls depth of field (how much or little of the background and foreground are in focus).

※ The SHUTTER SPEED controls how long the shutter is open, allowing light to reach the sensor. Shutter speed also controls motion blur.

※ The ISO is the sensitivity of the digital sensor (also known as film speed) and also controls the level of noise, or grain, in an image.

It can be tempting to use one of these automatic modes for the specific scenario you are working with. After all, when you first bought your camera and you wanted to photograph a sports game, sports mode made it relatively easy for you. Now that you understand the exposure triangle and the three elements involved in choosing exposure, however, it's time to take your camera off automatic and put it into a semi-auto or manual mode.

CREATIVE OR SEMI-AUTO MODES

In each semi-auto mode, except P, you choose one part of the exposure equation (like aperture or shutter speed) plus ISO, and the camera makes the corresponding aperture or shutter speed choice for you. The camera uses its internal light meter to make the third exposure decision, which may not always be the proper exposure for the image you actually want to make.

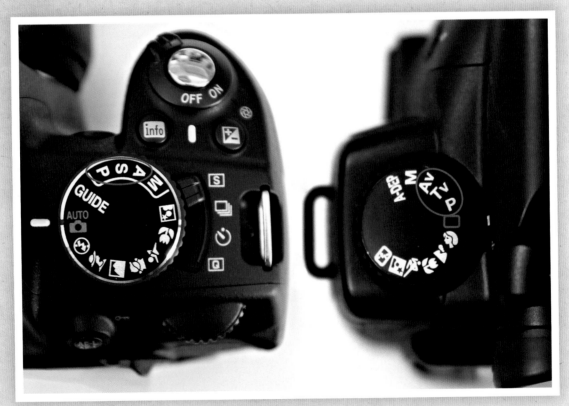

FIGURE 6-5 The semi-auto modes on a Nikon camera (left) and Canon camera (right).

As you will see as we move into Chapters 7 and 8, you can override the camera's input via exposure compensation, but the reason these are considered semi-auto modes is that you are allowing the camera to assist in making the exposure decisions.

Program mode: In program mode (P), the camera chooses aperture and shutter speed based on the scene (lighting conditions). It chooses ISO if you have auto-ISO enabled; otherwise, you are able to make that choice. This is much like auto mode, in that the camera makes the initial exposure decisions for you. Where P differs from auto mode is that you are able to override the aperture and shutter decisions made by the camera.

FIGURE 6-6 If you prefer a shallower depth of field, aperture priority is the better choice.

As you transition from automatic to manual mode, P is an interim step that can help you understand how your camera interprets light and exposure. Because our ultimate goal is for you to understand exposure and exposure elements, and move beyond auto mode, I encourage you to ignore P mode and use aperture or shutter priority mode instead. P is simply too close to automatic and enables you to rely on the camera for exposure decisions, rather than relying on your understanding of the exposure triangle.

Aperture priority: In aperture priority mode (AV or A), you choose the aperture and ISO, and the camera chooses the corresponding shutter speed. You can override the shutter speed by adjusting the exposure compensation values. Often this mode is chosen to control the depth of field in an image, as AV/A ensures the aperture is constant across all exposures. This mode is also useful when making images with a constant aperture, but rapidly changing light. In Chapter 3, we learned more detail about aperture and depth of field. Chapter 7 discusses this mode in more detail.

Shutter priority: In shutter priority (S) or time value (TV) mode, you choose the shutter speed and ISO, and the camera chooses the corresponding aperture. As with A/AV mode you can make adjustments via exposure compensation, overriding the camera's aperture selection and changing the exposure triangle. S mode works well when a faster shutter speed is required in order to capture a moving subject and avoid motion blur. Chapter 8 focuses on this mode in detail.

FIGURE 6-7 If you prefer a constant shutter speed and are not as worried about your depth of field, shutter priority might work best for you.

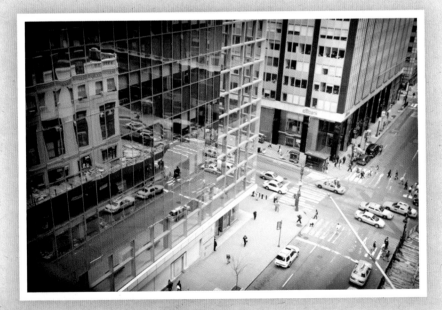

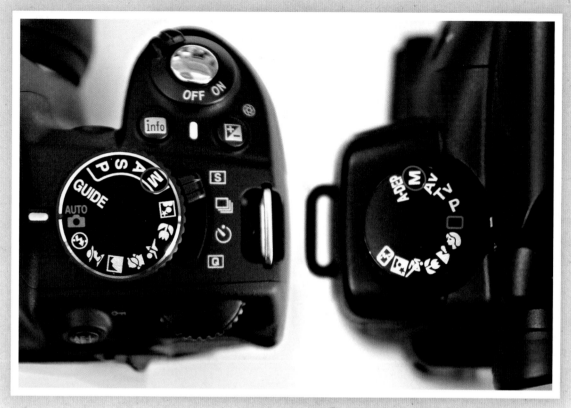

FIGURE 6-8 Manual mode is indicated on the dial with an "M."

MANUAL MODE

In manual mode (M) you make all the decisions about your exposure: ISO, shutter speed, and aperture.

When you make your exposure decisions in manual mode, your camera lets you know if it thinks you are over or underexposed (if your image is too light or too dark) via the exposure meter (Figure 6-9). If the indicator is to the right, or plus, side of the center line, the camera thinks too much light is coming in and your image will be too bright, or overexposed. If the indicator is to the left, or minus, side of the center line, the camera thinks there is not enough light and your image will be dark, or underexposed.

FIGURE 6-9 The exposure bar indicates what the camera thinks of your exposure: the right is overexposed, the left is underexposed, and the middle is what you camera considers the correct exposure.

FIGURE 6-10 In a backlit setting, with evaluative metering we overexpose to create the correct exposure for the image we want to make.

As we move thorough Part 2, we will build on the concepts you learned in Part 1—particularly the exposure triangle. One thing you will discover, if you have not already, is that what your camera considers the correct exposure is often different from the exposure that you actually need for the photograph you want. The camera has a preset formula for determining exposure calculations and that formula does not always provide the best set of calculations for the image you want to make. Part of moving beyond auto mode is knowing when to override what the camera considers "correct" and choosing settings that you know will produce the images you want. ❖

FIGURE 6-11 When shooting in aperture priority mode the camera chooses shutter speed for you, but this often works well in even lighting conditions like this.

FIGURE 6-12
In manual mode you control the entire exposure triangle, creating images you want without relying on the camera to do it for you.

Chapter 7
APERTURE PRIORITY

Aperture priority, denoted as "AV" (aperture value) or "A" on your dial, enables you to control the amount of light coming in through your lens (aperture), while the camera chooses the shutter speed based on its internal formula for correct exposure and the built-in light meter reading.

Put another way, you choose your ISO and your aperture while the camera chooses the shutter speed. Remember, though, your camera wants you to have a balanced exposure—and you may not end up with the exposure you intended.

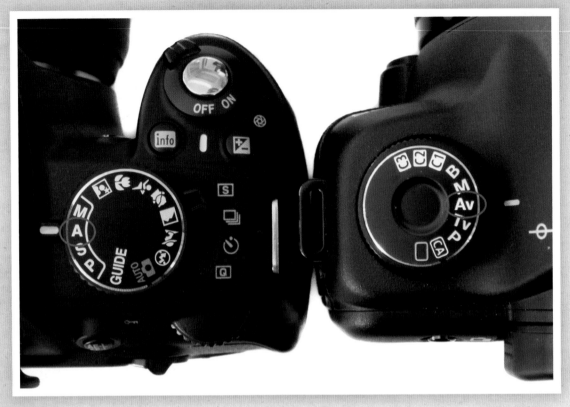

FIGURE 7-1 Aperture priority is indicated as *A* or *AV* on your camera dial.

In Chapter 3 we learned that aperture controls two things:

1. The amount of light coming in our lens (via the size of the lens opening)

2. The depth of field

A larger aperture (like f/2.8) lets in more light and gives us a shallower depth of field. A smaller aperture (like f/16) lets in less light and has an extended or deeper depth of field.

With that in mind, you might choose AV/A mode when you want to ensure a specific and consistent depth of field in your images. If you know you want to create a certain look via depth of field and you know what ISO you should use, but you are uncertain what the shutter speed should be, using AV is a quick way to determine the correct exposure without the trial and error that might come with manual mode.

WHEN AND WHERE TO USE APERTURE PRIORITY

There are times when using AV is easier or more convenient than using manual mode. Three main situations involve:

※ Changing light conditions

※ Controlling depth of field (DOF)

※ Using variable aperture zoom lenses

Changing Light Conditions

There are times you might find yourself in a situation with changing light conditions. In this environment, AV enables you to make images with the same depth of field and ISO while the camera changes the shutter speed for you.

EXPOSURE TRIANGLE

FIGURE 7-2 In aperture priority mode, you choose two of three exposure elements (ISO and aperture) and the camera chooses the third (shutter speed), working to create the correct exposure triangle.

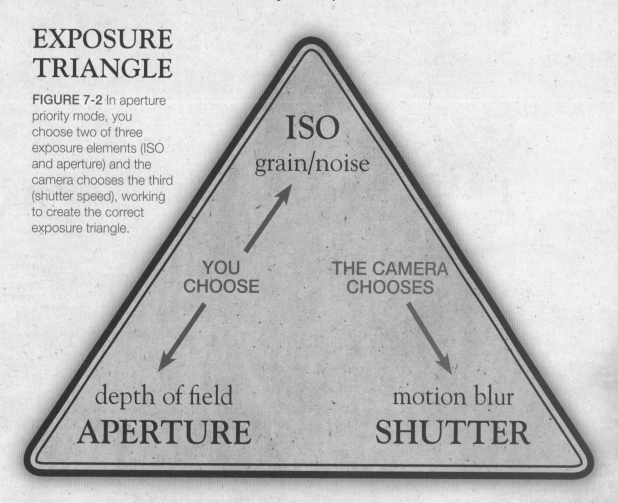

ISO
grain/noise

YOU CHOOSE

THE CAMERA CHOOSES

depth of field
APERTURE

motion blur
SHUTTER

Consider a kid's outdoor soccer or lacrosse game. These events are
played on open fields and there are times when parts of those fields
are in shade. We know that making a photo in the shade requires
different exposure settings than an image made in full sun. We also
know that a shallower depth of field will isolate the player while
blurring the background. Let's say you want your aperture set at f/4 for
all the images you make—what do you need to do with your shutter
speed in the areas of light and dark?

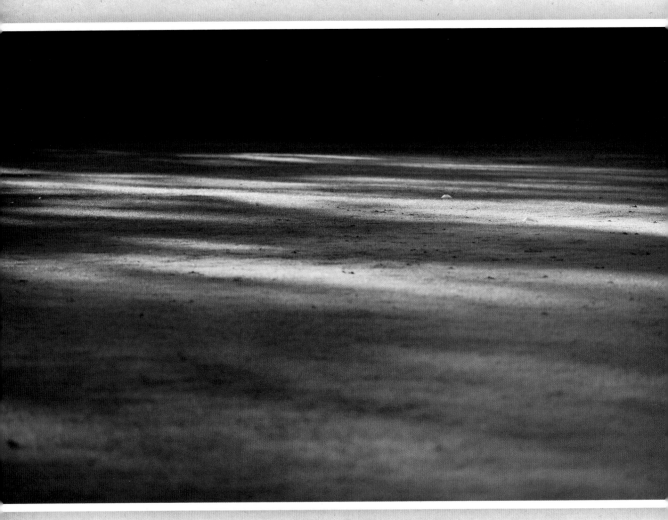

FIGURE 7-3 With the areas of light and dark on this lacrosse field,
using AV ensures the camera will choose the correct shutter speed.

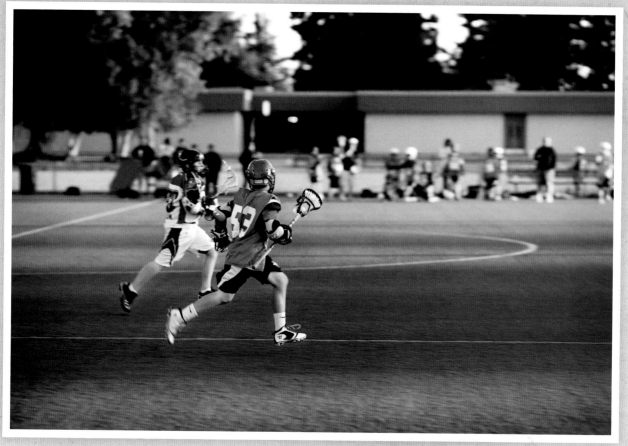

FIGURE 7-4 By using AV, we keep our aperture and ISO consistent, allowing the camera to select the shutter speed in the areas of light and dark.

You know you need more light (a slower shutter speed) in the shade, and less light (a faster shutter speed) in the sun. The question, then, is: Are you fast enough to make those changes while your child is taking the ball down the field, moving in and out of sunny areas as he goes? In this scenario, it is probably more important to ensure you catch the action in a well-exposed image than to ensure you do it via manual settings.

Because you set your aperture and ISO, and allow the camera to choose the shutter speed, tracking a moving subject through light and dark areas is easier to do. Instead of worrying about changing your shutter speed, you are thinking about catching the moment.

Controlling Depth of Field (DOF)

When you make portraits, you often want a shallow depth of field to really showcase your subject and blur out any distractions in the foreground or background. Alternatively, some people really like the look of a deeper, more extended depth of field and choose to make images that reflect that preference. With landscapes, for example, we typically want to show more of the foreground and background to convey the overall scene and work with apertures of f/8 through f/22.

Depth of field is a matter of personal taste, and using AV is one way to ensure it is consistent across all your images.

Using Variable Aperture Zoom Lenses

One of the advantages of using AV mode is evident when you are using a lens with different maximum aperture values. Take a look at your zoom lens—it should say something like 1:4 or maybe something like 1:3.5-5.6 (see Figure 7-7). The first designation means your lens has the same maximum aperture at all focal lengths, the second means the maximum aperture changes depending on the focal length.

Many of us are working with a variable aperture lens, which means we cannot simply set our aperture in AV and know it will be constant at all focal lengths (zooms). Let's go back to that same soccer or lacrosse game. Your maximum aperture varies from f/3.5 to f/5.6, but you can only use

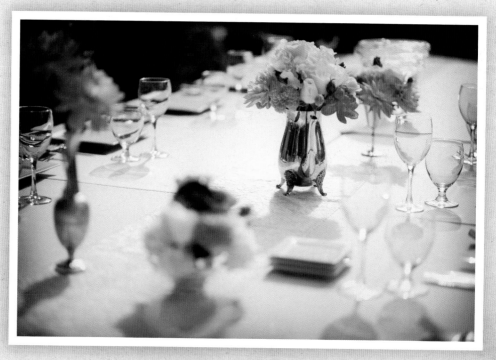

FIGURE 7-6 A shallow depth of field means much of the foreground and background are blurred.

FIGURE 7-5 An extended depth of field means more of the foreground and background are in focus.

f/3.5 when you are using the widest zoom. If you want to zoom in on your child when she has the ball, your aperture will now be f/5.6.

There is a way to work around this. When you choose your settings via AV mode, ensure you are at the widest zoom when selecting your aperture. This will allow you to pick f/3.5. The camera will change the aperture (keeping the lens as wide open as possible) automatically as you zoom in and out of the scene, assuming you want the shallowest depth of field possible, because you set your aperture while at the widest zoom. This is one less thing you have to think about when you're trying to get that perfect shot.

This can be confusing, so let's look at it another way. Imagine you are using the lens in Figure 7-7 in AV. If you are zoomed out all the way (at your longest zoom), the widest aperture you can choose is f/5.6. Because f/5.6 is available at all focal lengths, the camera will not choose a wider aperture as your focal length changes. However, if you select your aperture while at your widest zoom and you select f/3.5, the camera will always use the maximum aperture possible, given the zoom. So, for example, if you are using a zoom somewhere between 18 and 55mm, the maximum aperture might be f/4—the camera automatically changes that setting, and the corresponding shutter speed, for you.

In manual mode, the same aperture changes happen, assuming you have chosen the maximum aperture while at your widest zoom. However, because the aperture is changing automatically as focal length changes, you will need to be aware of corresponding changes in exposure (like shutter speed). Because the camera changes the aperture automatically, it can result in your image being over or underexposed by a full stop between your widest and tightest zooms if you aren't paying attention.

FIGURE 7-7 The 1:3.5-5.6 indicates the maximum aperture of your lens. The two numbers indicate this 18-55mm lens has a variable aperture from f/3.5 at the widest zoom (and f/5.6 at the tightest zoom).

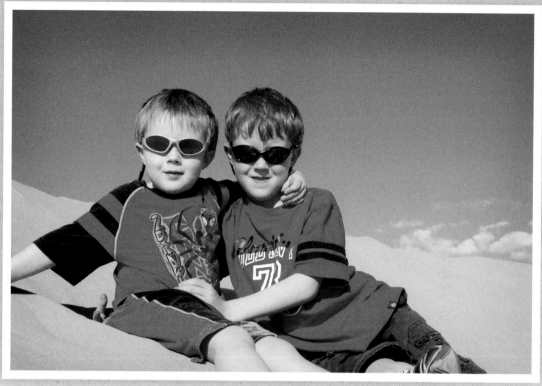

FIGURE 7-8a Use a longer focal length (tighter zoom) to get closer to your subjects.

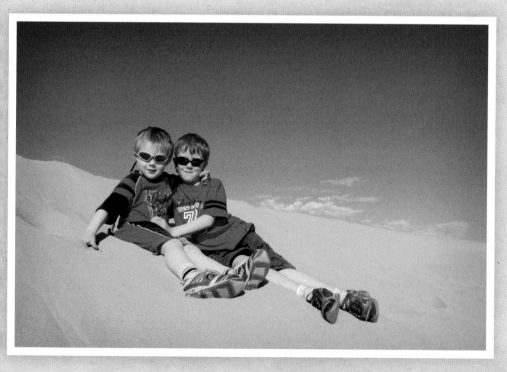

FIGURE 7-8b
Use a wider zoom
to show more of the
entire scene.

MAXIMIZING CONTROL

As we learned in Chapter 4, your camera seeks to create the correct exposure triangle every time. But sometimes, the "correct" exposure triangle is not the right exposure for your scene. In a backlit situation, for example, your camera wants to balance all the light in the scene, resulting in an underexposed subject.

It's up to you to override the shutter speed set by your camera, letting in more or less light to make the photo you want.

This is where the exposure compensation feature of your camera becomes so important. Remember the exposure compensation bar from Chapter 4 (see Figure 7-9)? This is displayed on the top or back of your camera, and you can also see it when looking through the viewfinder.

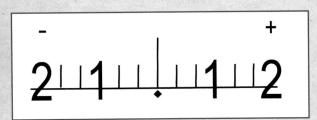

FIGURE 7-9 The exposure compensation bar.

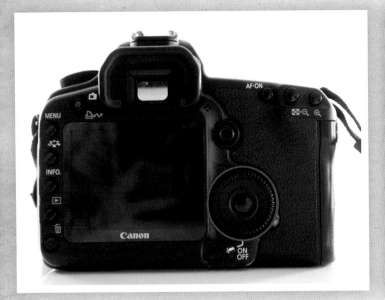

FIGURE 7-10a

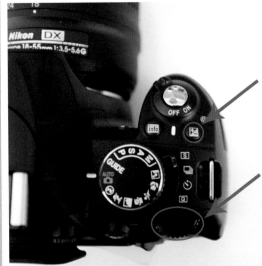

FIGURE 7-10b

To override the shutter selected by the camera, use the exposure compensation dial (a) or button and dial (b).

In semi-auto modes such as AV, you can change your exposure (shutter speed) by using this feature. On a Canon 5D MkII you use the wheel at the back to change exposure (Figure 7-10a), and on a Nikon 3100 you use the EV button plus dial (Figure 7-10b).

If your image is too dark, you want to let in more light (overexpose the image). When you do this, the indicator on the exposure bar moves to the right, or plus, side. Turn the back dial to the right on the Canon or hold the +/- button and turn the dial to the right on the Nikon. That allows more light into your camera by slowing down the shutter speed. If your image is too bright, simply do the opposite. Remember, some cameras have the plus and minus sides reversed, so double-check your exposure compensation bar to know which direction your dial turns—if your +/- is reversed, you move the dial left to overexpose and right to underexpose.

It is tempting to rely on the camera to make the shutter speed choice for us, but that really is no better than using your camera in a fully automatic mode. In AV mode, the camera gives us a starting point for our shutter, but the final exposure decision is completely up to us.

APERTURE PRIORITY AND MOTION BLUR

Let's go back to the soccer/lacrosse field example. If there are no shadows—not a cloud in the sky—and it's very bright, choose ISO 100 and set your aperture. Focus (push your shutter button down halfway) on a player and make note of what your shutter speed is. Now take that picture and check your LCD display.

Without seeing the image you made, I would guess it's either a little dark or a little too bright and you have flashing lights letting you know your highlights are blown. Your camera wants to even out all the light in the scene and makes the shutter determination with that in mind, taking into account your ISO and aperture.

If your image is too dark, what can you do about that? Try adding more light via the exposure compensation feature. Maybe one- or two-thirds of a stop (the first or second bar on the plus side). The scene got brighter because your shutter speed slowed down to let in more light.

If your image is too bright, try letting in less light by underexposing your image one- to two-thirds of a stop (the first or and second bar on the minus side). Your image is now darker because you increased the shutter speed to let in less light.

Imagine you now have the exposure you want, the game has begun, and you take a picture of your child with the ball. You check the image and notice your child is blurry. What happened? (See Figure 7-11.)

Everything moving in Figure 7-11 is blurry to some degree (we've circled the most obviously blurred players) because my shutter speed was too slow. When you were adjusting your exposure compensation, you ended up with a shutter speed slow enough to also allow motion blur. Assuming you want to keep your aperture the same and you need to increase your shutter speed, you will now want to increase your ISO, letting in more light without changing the aperture/shutter points of the triangle.

When you increase your ISO, leaving your aperture the same and the image overexposed by one- or two-thirds, the camera recalculates the shutter speed based on those settings. Your shutter speed will increase to compensate for the change in ISO, but your image will still be overexposed by whatever your exposure compensation settings indicate.

As we move into Part 3 you'll find out how to troubleshoot these situations in more detail. ❖

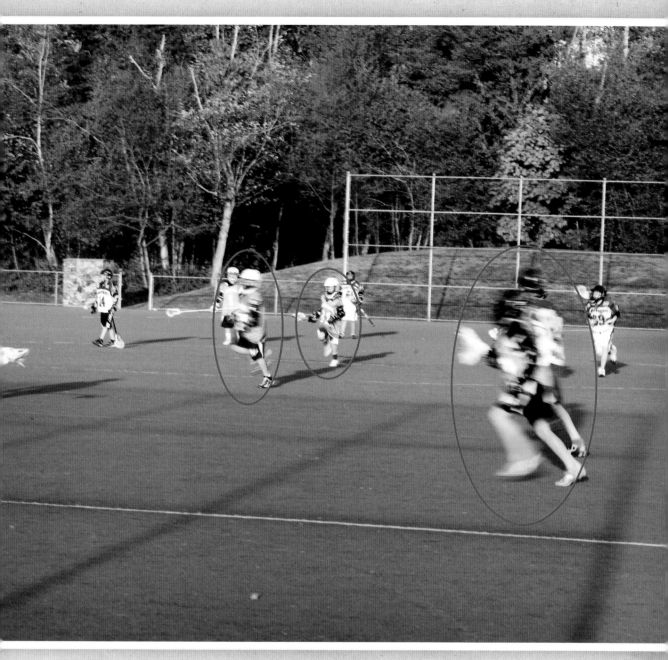

FIGURE 7-11 A "correct" exposure can result in motion blur if the shutter speed is too slow. Note how the circled players are blurred, while other elements of the image are not.

Chapter 8
SHUTTER PRIORITY

The shutter priority mode (S), also referred to as time value (TV), allows you to control exposure by setting the shutter speed and ISO while allowing the camera to select the aperture.

Remember from Chapter 1 that shutter speed controls two things:

❋ The length of time light hits the sensor or film when the shutter is open after you press the shutter button

❋ Whether or not there is motion blur in your image

A lower number like 1/250 is a faster shutter speed and, therefore, lets in less light than a higher number like 1/30. This is because in the first example the shutter opens and closes in 1/250 of a second, which is a much shorter amount of time than 1/30 of a second. *Less time=less light.*

Knowing this, and knowing you also want to keep your shutter speed equal to or faster than the focal length of your lens, you will use TV or S mode when you want to avoid motion blur, create motion blur, or simply work with a specific shutter speed throughout a series of images. When using TV/S mode, depth of field, which is controlled by aperture, is not the first concern.

EXPOSURE TRIANGLE

FIGURE 8-1 When using the shutter priority setting, you choose the shutter speed and ISO, and the camera chooses the aperture.

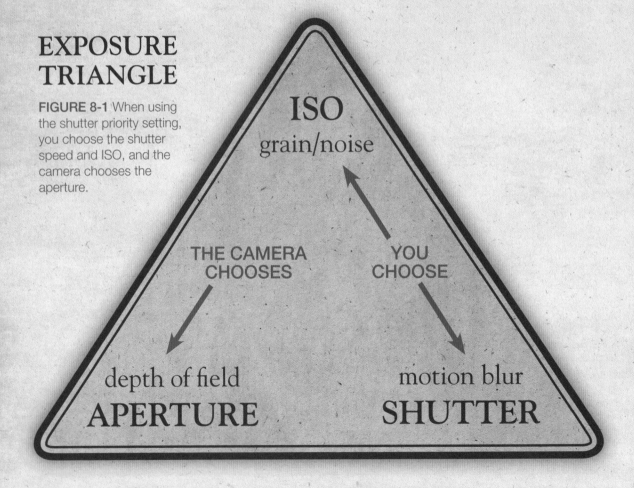

ISO
grain/noise

THE CAMERA CHOOSES

YOU CHOOSE

depth of field
APERTURE

motion blur
SHUTTER

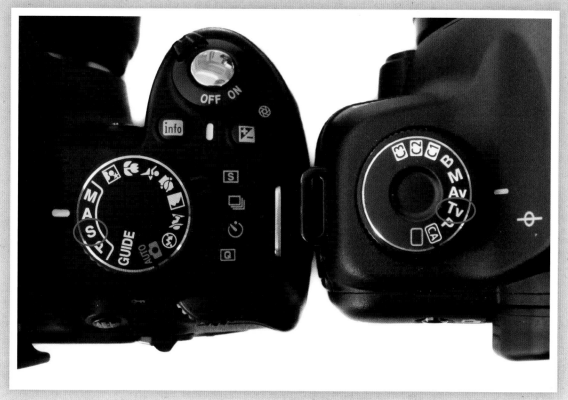

FIGURE 8-2 The shutter priority/time value setting on the dial is denoted as *S* or *TV*.

Rather than trying to sort out all three points of the exposure triangle, when using TV mode you know you want your shutter to be at a certain place and trust the camera to select the best aperture for that (based on your ISO selection as the third exposure variable).

WHEN AND WHERE TO USE SHUTTER PRIORITY

Just as with AV mode, there are times you might find TV/S mode more convenient than manual mode. In particular, photographing a moving subject is a time TV might be an easier choice.

Let's go back to the soccer/lacrosse example we used in Chapter 7. We are outside on an open field. It can be day or night in this example, with the sun or the field lights illuminating your scene.

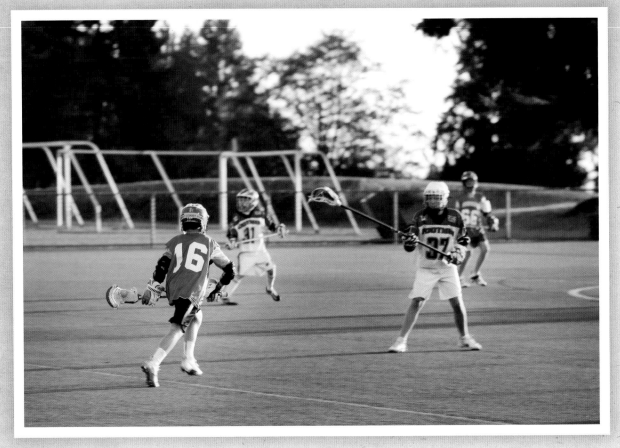

FIGURE 8-3 When working with a moving subject, TV mode allows you to capture the moment without worrying about motion blur.

What is your goal in making these images? You want to preserve the memory of that first goal, of the championship game, or even the first time playing the game. In capturing those moments, you want to ensure that your images are crisp and clear, not blurry.

In other words, you want to make sure your soccer/lacrosse player is sharp and in focus.

We need to choose a shutter speed that works for this setting at a lacrosse field—let's say 1/500 or 1/1000. This is definitely fast enough to ensure we freeze motion. Now choose your ISO (100 on a bright sunny day, 800 or 1600 at night, under lights). You know your shutter speed is fast enough to freeze motion and you are now free to make images across the entire playing field, without worrying about that third setting.

When the player moves into areas with shadow (less light) your camera will increase

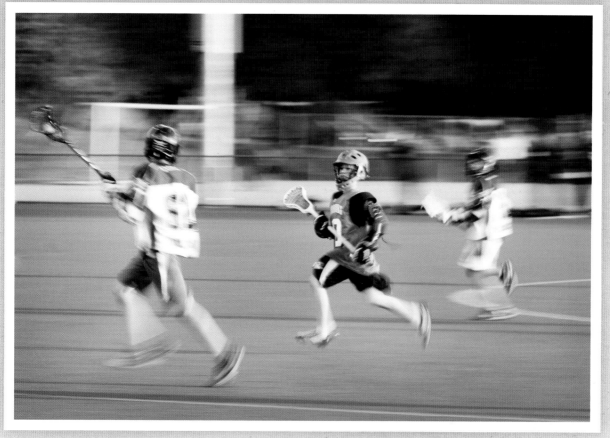

FIGURE 8-4 In this image, we panned with the player in blue, creating the impression of movement.

the opening in your lens to let in more light. Conversely, in brighter areas, the aperture will decrease that opening to let in less light. This results in varying depths of field across your images if there are changing light levels, but ensures there is no motion blur.

Although we might use TV/S to avoid motion blur, we can also use it to facilitate motion blur. Motion blur can be used to make compelling and dynamic images that tell a different story than the crisp, sharp images we talked about previously.

At that soccer/lacrosse game, let's try panning with a player. Panning means you follow the movement of your subject (the running player) while pushing the shutter button. To create the illusion of movement, your goal is to blur the background, so you need to use a relatively slow shutter speed. Try setting your shutter speed between 1/40 and 1/125 and see how that looks. You might have to try this a few times to achieve the effect you want (the amount of blur in the background). (See Figure 8-4.)

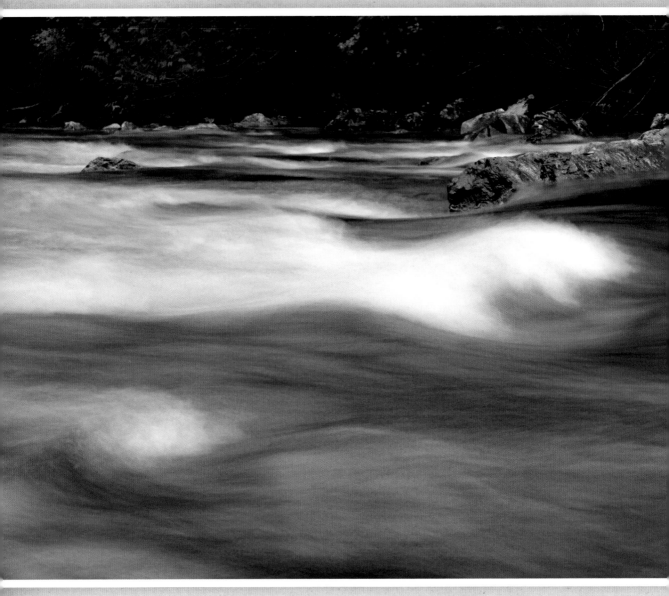

FIGURE 8-5 By using a very slow shutter speed, the water in this image appears to be moving.

Another time you might choose TV/S mode is for images where the water seems to be moving, and everything around it is crisp and in focus (see Figure 8-5). A longer exposure (shorter shutter speed) gives the impression of movement—in this case, the water appears to be moving. We talk more about how to make images like Figure 8-5 in Chapter 12. This might also be a good time to go back to Chapter 1 and retry the assignments at the end of the chapter.

MAXIMIZING CONTROL

As with aperture priority (AV) mode, when using TV/S mode you can override the third exposure setting your camera makes and, therefore, over or underexpose the image as necessary. We know the camera seeks to balance exposure and will make an aperture selection for the "correct" exposure triangle, based on the shutter speed and ISO settings you have chosen.

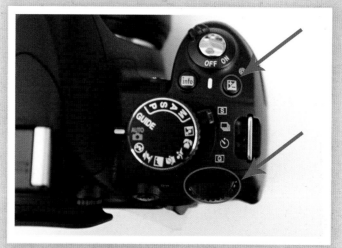

There will be times the camera doesn't quite get it right—at least not right for the kind of image you want to make. When this happens, you can change the exposure by letting in more or less light. Do this by using the same exposure compensation dial or button/dial combination you used in AV mode (see Figure 8-6), only this time it is the opening of the lens, or aperture, you are changing.

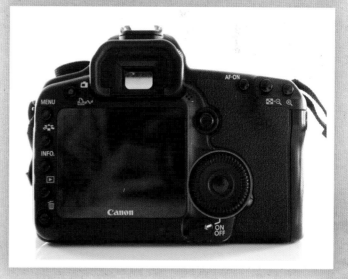

FIGURE 8-6
Adjust exposure compensation via the button and dial (top) or the dial (bottom).

If your image is too dark, you need to overexpose your image—the indicator on the exposure bar will move to the right (see Figure 8-7), and if you underexpose the image, the indicator will move to the

FIGURE 8-7 When an image is overexposed in TV/S mode the aperture has increased, letting in more light and resulting in a shallower depth of field. The exposure indicator moves to the right, or plus, side of the exposure bar.

left. Please revisit Chapter 7 for a thorough explanation of how to use the exposure compensation bar.

There will be times you work with a very slow shutter speed. Making images of a cityscape at night, or cars moving down a roadway while the head and tail lights snake like ribbons, for example, require a shutter speed of at least 10 seconds. Remember from Chapter 1 that the ideal shutter speed is no shorter than the focal length of your lens, and an extremely slow shutter speed like 10 seconds will result in camera shake (where your hands cause movement/blur in the frame). Making images with very slow shutter speeds requires an investment in a tripod.

SHUTTER PRIORITY AND DEPTH OF FIELD

If we go back to that soccer/lacrosse game example, let's see how aperture affects the final image. Set your ISO and shutter speed and focus on a player, making note of the aperture. Now make the picture.

Aperture controls the amount of light coming in through the opening in your lens, but it also controls depth of field. In this example, let's assume your aperture was f/16. Your subject, plus everything in front of and behind your subject, is in focus. There is nothing wrong with that, however, there is no clear indication of who your subject is in the image. The viewer might think you were focusing on the player with the ball, but maybe your focus was on your own child who was doing something away from the ball. How would the viewer know that?

We use depth of field to showcase who and what our subject is, by isolating him against the foreground and background. That same example, made at f/4, would more clearly show what your intended subject is (see Figure 8-8).

In TV/S mode, we can lose the effect offered by a specific depth of field. Knowing this, and knowing we want to control our shutter speed first and have a relatively shallow depth of field second, we need to consider the ISO setting we are using. If there is too much light for a larger aperture, decrease the ISO. Alternatively, of course, you could

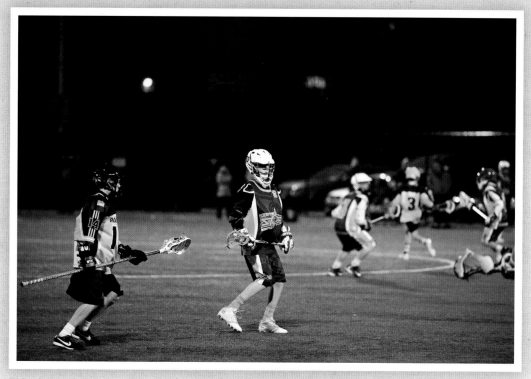

FIGURE 8-8 Avoid motion blur with a fast shutter speed and choose a depth of field that is shallow enough to isolate your subject in the action.

increase the shutter speed, which would result in a larger aperture and shallower depth of field.

Assuming you are at an even exposure (neither over nor underexposed) but you want a shallower depth of field—you know this requires a larger aperture (more light), and to get that you need to make the lens opening larger by overexposing your image by at least one stop. Because there is now more light as a result of this change, your image will be too bright.

You need to compensate for this change by letting in at least one stop less light, but you don't want to decrease the aperture and go back to the extended depth of field again. That leaves ISO. Decrease your ISO by at least one stop to let in less light and you will see the exposure indicator settles back in the middle of the exposure bar.

When you find yourself in situations where you really need control of both shutter speed and aperture to create the images you want, you are ready to move into manual mode and gain full control of these settings. ❖

Chapter 9
MANUAL MODE BASICS

As the name suggests, manual mode gives you full control over all elements in the exposure triangle. You choose ISO, aperture, and shutter speed based on the scene you are trying to capture, which also affects noise, depth of field, and motion blur. The camera will then let you know, via the exposure bar, what it thinks of your decisions.

Interestingly, unless you have a fully manual camera, our modern cameras still control several elements of an image even when you are in manual mode. You do set the three exposure controls, but the camera still controls white balance and the way exposure is evaluated or metered. In fact, you can give up control of your ISO in some cameras by setting it to auto-ISO, even in manual mode.

For our purposes, we're going to suggest the following: leave the camera in auto white balance (AWB) and set the metering mode to evaluative. Odds are your camera is already at these settings, but double check to be sure (Figure 9-2). There will be times when the color cast is off and will need to be corrected by a different white balance preset. You can deal with that when the situation warrants, but as you are learning to expose correctly, white balance is not your first concern.

The same holds true with the different metering modes we discussed in Chapter 4. Experiment with those once you feel comfortable with your exposure settings in general. When you are in manual mode, the

EXPOSURE
TRIANGLE

FIGURE 9-1 When using the manual setting, you choose the shutter speed, ISO, and aperture.

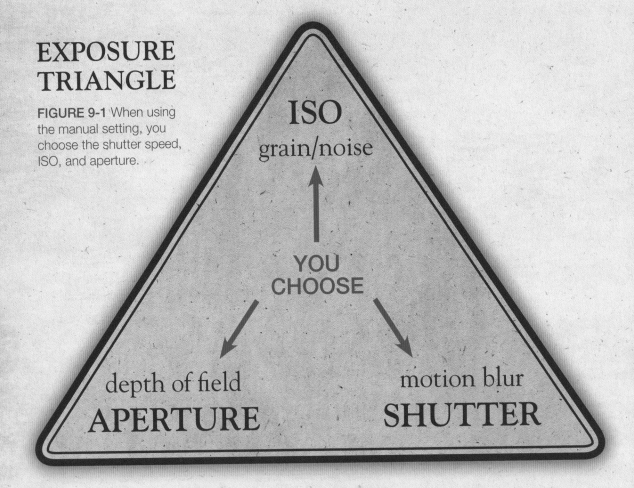

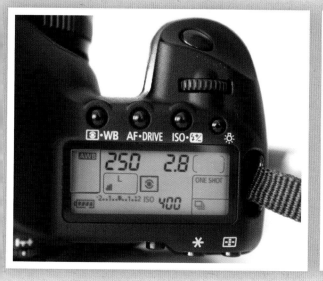
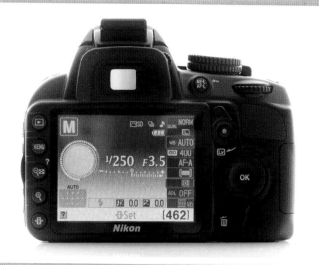

FIGURE 9-2

Ensure that your camera is set to AWB and evaluative metering.

camera meter serves only as a guideline for what the camera thinks the correct exposure is—you are making the decisions. More often than not you will be slightly over or underexposing what the camera wants you to do.

As we talked about aperture in Chapter 3, we learned where to find our aperture, shutter speed, and ISO settings indicated on the camera. In Figure 9-3, we've also noted where the exposure bar is.

As you can see, different cameras offer different information detail. The Canon 5D MkII in Figure 9-3a indicates ISO as 400, shutter speed as 250, and aperture as 2.8, whereas the Nikon D3100 in Figure 9-3b shows the ISO as 400, shutter speed as 1/250, and aperture as f/3.5. If you have a camera that displays settings the way the Canon does, you'll have to remember that a shutter indicated at 250 is really 1/250 and aperture indicated as 2.8 is really f/2.8.

The top and back displays are not the only place to find this information. As you look through your viewfinder, you see information across the bottom of the screen. It looks something like Figure 9-4.

Having the exposure information available via the viewfinder is extremely helpful when making an image. Looking at figure 9-4, for example, you see that your camera

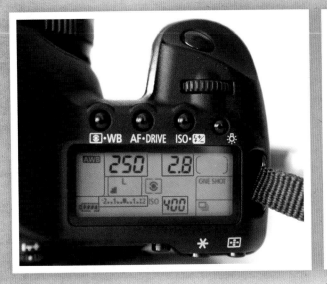

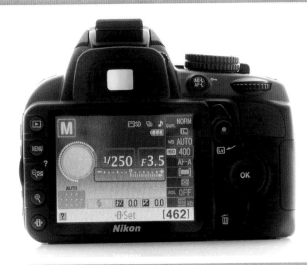

FIGURE 9-3a

FIGURE 9-3b

The ISO, aperture, shutter speed, and exposure bar on the top (a) and back (b) displays of a camera.

250 2.8 2|||1|||||1||2 **400 99**
SHUTTER APERTURE EXPOSURE COMPENSATION ISO MAX BURST

FIGURE 9-4 Exposure information is available via the viewfinder.

thinks the exposure is over by one stop. This enables you to adjust one of your exposure settings to compensate for that, or leave your exposure as is. As you adjust your settings, the information you see via the viewfinder also changes.

The more you use your camera, the more familiar with it you become. Changing the different settings becomes second nature over time and before you know it, you won't have to take the camera away from your eye to adjust the various exposure elements. This is when the information available via your viewfinder becomes particularly helpful in determining your exposure settings.

CHOOSING MANUAL MODE

It would be easy to say your goal should be to use manual mode every time you pick up your camera. Many people do just that and it is a wonderful goal to work toward.

Perhaps a more reasonable goal, however, is to know how to use manual mode in every situation you photograph.

In real life, the mode you choose should depend, in part, on what you are trying to achieve with your images and how confident you are in your ability to use manual mode effectively. In Chapter 7, for example, we talked about a soccer/lacrosse game that had the subject of your images moving in and out of light and shady areas while advancing the ball. If you are using AV/A mode, the camera will adjust the shutter speed for you, ensuring you capture well-exposed images in both the light and dark areas. The question we posed to you was whether you could adjust your shutter speed quickly enough in manual mode to manage the changing light conditions.

We go back to what is more important to you in that moment. Personally, I can change my shutter speed quickly enough to manage the differences in exposure. That said, in a situation where it is my child carrying the ball, I want to be able to both enjoy the moment and capture it with my camera. I might choose AV/A in that situation.

This might sound contradictory to what you expected—after all, the title of this book is *Beyond Auto Mode*. And you're right, it is contradictory. But it's also practical. As someone who has an understanding of exposure, who understands her camera and how it works, and who can change exposure settings almost without thinking, there are times I choose not to use my manual settings.

The goal of moving you beyond auto mode is to get you to a place where you understand how the exposure elements work and how to control your camera. I would encourage you to work in manual mode as much as possible, but if you choose to use a semi-auto mode on occasion there is nothing wrong with that.

That being said, there are many times manual is the better choice. Imagine that same soccer/lacrosse field we mentioned in Chapters 7 and 8, but instead of areas of light and shadow, imagine the light is even across the entire field. Maybe it's an overcast day and a single exposure will work across the whole scene. This is a time to use your manual settings. You don't have to worry about rapidly changing your exposure; rather you can set your ISO, aperture, and shutter speed, feeling sure in the knowledge you won't have to change them on the fly.

HOW TO USE MANUAL MODE

Set your camera on manual mode (Figure 9-5) and take a look at what you want to photograph. You already know the three settings you need to choose: ISO, aperture, and shutter speed.

ISO is a great first choice. Consider how bright or dark your scene is. As we learned in Chapter 2, on a bright sunny day start with ISO 100, on an overcast day start with ISO 400, and in a dimly lit room start with ISO 800 or 1600.

Let's assume you are at the beach with your family and one of your children is playing in the sand. We choose ISO 100.

Now let's think about what we want from this image. Are you more interested in capturing the scenic view at the beach, with your child as one part of the image, or do you want to make a portrait of your child and you're not as concerned about the background? In this example, let's make an image that shows the child and the scenery.

Knowing that both the foreground and background are important to us, we know we want an extended depth of field. We learned in Chapter 3 that a higher number means a smaller lens opening, and a smaller lens opening means an extended depth of field. Let's choose f/8 for this example.

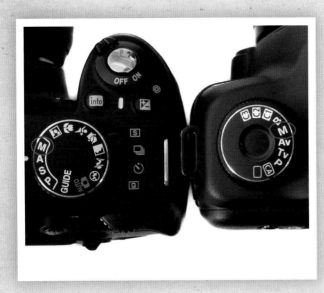

FIGURE 9-5 Choosing manual mode—look for the "M" on your dial.

Now that we have the ISO and aperture chosen, all we need is the shutter speed to balance our exposure triangle. Our subject isn't moving fast, and we are using a wide lens to capture the whole scene. Because it is a bright day, we know we need a relatively fast shutter speed so we don't let in too much light. Let's try a shutter speed of 1/500.

As you can see in Figure 9-6, we have a balanced exposure (nothing is too bright or too dark) and an extended depth of field, just like we planned.

FIGURE 9-6 The following exposure settings were used to make this image: ISO100, aperture f/8, shutter speed 1/500.

Making the right exposure decisions in Figure 9-6 was made a little easier by the fact that we had an even lighting scenario. The sun is over our subject's shoulders, casting a small shadow. Because his back is to the sun, we don't have to worry about him squinting, either.

USING MANUAL MODE IN REAL LIFE

As you gain confidence as a photographer and begin to use manual mode more often, it can help to have an action plan for each scenario you find yourself in. It is also easier to use manual mode when you know you have two of the three exposure settings just the way you want them so you only have to adjust that third point of the triangle.

While you can certainly make exposure decisions in whatever way you wish, the following steps are a great way to get started every time:

Step 1: ISO

You already know the basic rules for choosing your ISO: 100 on a bright sunny day; 400 on an overcast day or indoors during the day; and 800 to 1600 in a dimly lit room.

Evaluate the scene you will be working in. Use your hand to get a rough idea of where the light is coming from and how bright or dark the environment is. Choose the ISO you think is best.

Step 2: Aperture

The next thing to consider is what you are photographing and how you want your image to look. There are two considerations when choosing aperture: how much light is coming into the lens and how shallow, or extended, the depth of field is. A wide aperture like f/2.8 lets in more light and offers a shallower depth of field than a narrow aperture like f/11.

Some people really like the way a shallow depth of field looks, while others prefer and extended depth of field. What you prefer is up to you.

Ask yourself the following questions:

※ Am I photographing a person or a place?

※ Am I making a portrait?

※ Is my background distracting? If so, do I want to blur it out?

※ Is the scenery important to me?

If you are photographing a person in front of a distracting background, you will choose a wide aperture with a corresponding shallow depth of field. If, on the other hand, you are photographing a place and want to show the entire landscape, you will choose a smaller aperture for an extended depth of field.

Step 3: Shutter

Shutter is an easy variable to understand and control. A fast shutter means less light and a slow shutter means more light. Once you have chosen your ISO and aperture, select your shutter speed based on a few considerations.

Are you photographing a moving subject? If so, you will want to keep your shutter speed above 1/250 or even 1/500 to freeze that movement. What focal length is your lens? If you are using a 24mm-105mm, for example, and have it zoomed in as tight as possible (105mm), you will want a shutter of 1/125 or higher. Remember, also, that hand holding a shutter speed below 1/30 can be challenging, so unless you are on a tripod try to keep your shutter speed above 1/30.

Step 4: Troubleshooting

Let's say you've gone through steps 1 through 3 and something is not working. Let's work through some common problems and how to solve them. In Part 3, I share some situational examples, but there are some general problems to address here.

The image is blurry. If you find your images are blurry, it means your shutter speed is too slow. You need to choose a faster shutter speed. Because you are letting in less light via the shutter, you need to let in more light another way. You can choose a wider aperture or a higher ISO to compensate for the change in shutter speed.

The image is too bright. When your image is too bright, there is too much light coming into the camera. One way to control this is to increase your shutter speed to let in less light. If that doesn't work, try decreasing your ISO or choosing a smaller aperture (larger aperture number).

The image is too dark. This means you don't have enough light coming into your camera. Take a look at your shutter speed and see if you can slow it down a little bit. If not, try choosing a wider aperture or a larger ISO to let more light in that way. ❖

GOING BEYOND AUTO MODE IN THE REAL WORLD

To this point, we've talked a lot about the science of photography—the numbers, if you will. We needed to spend that time to really understand the technical side of photography in order to get to my favorite part of image making—the art.

For me, making photographs has always felt a little magical. It's about so much more than just exposure triangles and meter readings. What drew me to photography initially, and what keeps me interested 15 years later, is the opportunity to freeze a moment in time forever. Through those frozen moments, memories are recalled and stories are told. Whether viewing your parents' wedding photos, images of your children through the years, or the journalistic images that document our time, photography allows us to see what we may have forgotten and look into our families' histories.

By now you have a solid grasp on the science behind making images. Your exposures are getting better and you understand what is needed to improve them. As you spend more time making photographs, you will become even more proficient in your exposure choices, leaving time for the other elements of image making.

Working alongside the correct exposure of an image is the composition of the frame. Exposure affects how the image is recorded, while composition affects how it looks. Before moving into our real-world examples in Chapters 11 and 12, we spend some time exploring the "rules" of composition and how to create compelling images. Chapter 10 focuses on the ways to organize the elements within an image and how to take your photographs from good to great.

We end this part with Chapter 13, "Adding Flash and other Gear." This chapter answers the basic questions of how and when to use flash effectively before moving into other gear considerations.

You'll find little technical language in the next few chapters—merely a brief reiteration of what you have already learned. This part of the book is about making images that are important to you and your personal history. It's about common shooting situations and how to work in those, as well as troubleshooting some common problems.

Chapter 10
COMPOSING IMAGES

Exposure, and control of exposure, has been our focus to this point. But exposure is merely the technical aspect of making images. How aperture, shutter speed, and ISO work together, whether used for creative purpose or not, is essentially a math equation.

Composition is all about how the elements in your frame are organized. Everything that goes into your image is part of composition, which means your depth of field, motion blur, and noise decisions all affect composition. So while the exposure triangle is technical in nature, the items affected by the exposure triangle are artistic in nature.

Beyond the three elements affected by our triangle, there are lots of other elements that make up the composition of an image. What you include, or don't include, in the frame is a compositional decision. Things like the background and foreground, the kind of light, and other items impact the way the viewer feels when looking at the image. A compelling composition draws viewers in while a poor composition turns them away. Without great composition, it doesn't matter how well you have mastered the exposure triangle—your image simply won't be interesting to look at.

Think about images you find yourself drawn to over and over again. Some images, like those of loved ones, forge a connection based on the relationship of the viewer to the subject. If you see an image of your child, no matter what he or she is doing, you will feel connected to it. Images that are interesting to you, and are not filled with a moment you remember or a person you love, are interesting because of how they are composed.

Look around your home at the artwork on your walls and consider what you like about those pieces and what draws you to them. Maybe it's the way the artist used lights or lines or texture; maybe it's the color palette. Whatever the reasons, the pieces fit together in a way that is compelling to you, the viewer.

Composition is the photographer's way of interpreting the moment and telling the story he wants the viewer to see. There are many different "rules" of composition within photography, and we discuss the more common or popular ones in this chapter.

THE RULES

Like anything else in photography, there are rules for how images "should" look. Rather than strict rules like those surrounding exposure, though, consider the rules of composition more as guidelines to keep in mind when making an image. As you become aware of what compositional rules and elements interest you, you will find yourself naturally making images that reflect the compositions you like.

The Rule of Thirds

The rule of thirds divides the image frame into three equal parts—horizontally and vertically (Figure 10-1). When starting out as photographers, many people naturally place the subject (focal point) right in the middle of the frame, which

FIGURE 10-1 The rule of thirds divides your frame into three equal parts, horizontally and vertically.

is considered the least attractive or compelling place to put it. Because the default focus point of most cameras is the center point, and you can see the red/green box in your viewfinder, it makes that the default positioning for many people.

Rather than placing your subject squarely in the middle of the frame, the rule of thirds suggests the subject, or focal point, should be placed at one of the positions where the lines of the frames intersect. Those positions are marked with red lines in Figure 10-1. Simply shifting the subject from the center of the frame to one of those intersections causes the image to become more interesting.

Figure 10-2 is an example of the compositional differences between a subject placed in the center of the frame and a subject placed along one of the intersecting lines. According to the rule of thirds, the images on the right are more compelling.

FIGURE 10-2 The images on the left place our subject in the center of the frame, while the images on the right adhere to the rule of thirds.

FIGURE 10-3 The most interesting area in a landscape image gets two-thirds of the frame.

FIGURE 10-4

For landscapes, use the horizon line as a "one-third" line, placing it along the top or bottom third of your frame. In Figure 10-3, the horizon line is along the bottom one-third of the frame. I chose this composition because the sky, and the lines of clouds streaming through it, was interesting.

If I had found the water more compelling, as in Figure 10-4, I would have placed the horizon one-third from the top. As a general rule, with landscapes the most interesting area, or the area you want to showcase, gets two-thirds of the frame.

The rule of thirds works well with abstract images as well. The image in Figure 10-5 is a reflection in water. It's an image that is less literal or obvious than our other landscape examples, but still utilizes the rule of thirds in composition. Rather than the horizon line falling on the top or bottom third of the frame, the darker reflection of the trees is in the top one-third, leaving the texture of water on sand in the bottom two-thirds.

Notice, though, that the horizon line is not straight and bleeds into the rest of the frame. This is one way to use the rule of thirds as a guideline. A compositional element is still placed in the top one-third of the frame, but I was not strict about keeping the entire element constrained in that section of the frame.

FIGURE 10-5

There *are* times when a center composition is preferred and interesting to view, which is why the rule of thirds is a guideline more than a hard-and-fast rule. As you are learning about composition and how to best frame your subject for an interesting image, though, the rule of thirds is something you can rely on. When in doubt, place your subject along the more optimal lines.

When composing with the rule of thirds in mind, remember to try different ways of composing the same subject. Figure 10-6 shows three different ways to compose the same scene. In Figure 10-6a we see a vertical composition, whereas Figure 10-6b is a horizontal composition. Both use the right vertical line as the compositional guideline.

FIGURE 10-6 Choose several different compositions when making your image, remembering that the rule of thirds often results in more compelling images than those with the subject in the center of the frame.

FIGURE 10-6b

FIGURE 10-6a

FIGURE 10-6c

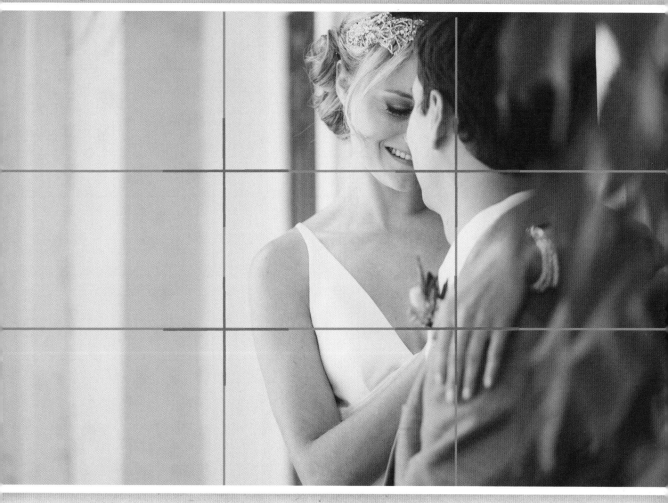

FIGURE 10-7 Use the rule of thirds as a general compositional guideline.

In Figure 10-6c we see what this frame would look like if our subject was placed directly in the center. It is not as compelling or interesting as the other two frames.

Bearing in mind that these "rules" are really guidelines, don't worry if your subject is not exactly on one of the third lines. Having your subject in the general area still facilitates the overall effect of this rule. In Figure 10-7, for example, our subject is not exactly on any of the third lines, but rather in the general area of the lines. This doesn't mean it's a poorly composed image—the subject is still within the overall area prescribed by the rule of thirds.

FIGURE10-8 Place interesting or important elements in your composition along and between these diagonal lines.

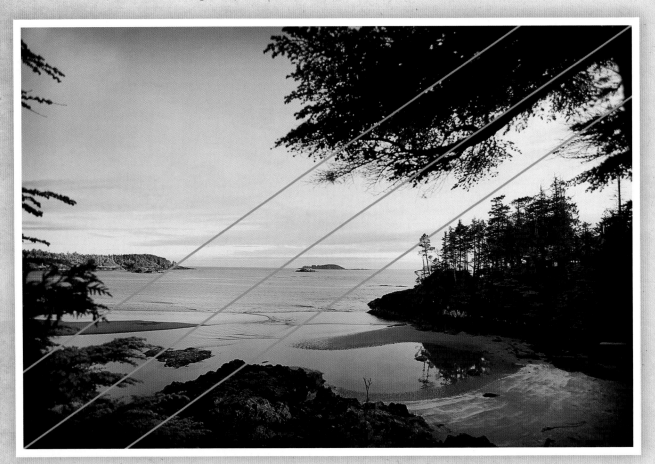

FIGURE 10-9 The most interesting parts of this composition fall along the diagonal guidelines.

Diagonal Lines

Another way to divide your frame is with diagonal lines (Figure 10-8). Like the rule of thirds, this is another way to generate an interesting composition. Basically, we want to place the important elements of our image between these lines.

Typically this is applied more to landscape photography than other forms of image making. That said, one of the best parts of photography is we are not stuck coloring within the lines, if you will. Taking a rule typically associated with one genre and using it in another is a wonderful way to experiment with image making. I would encourage you to discover what "rules" are most interesting to you and then use them in all types of photography, experimenting with what works for you and what does not.

Whether the diagonal goes from top right to bottom left (Figure 10-9), or top left to bottom right (Figure 10-10) is not important. The idea is to have a line that draws the viewer's eye into and through the frame. Sometimes you can apply this rule literally with elements like railing or lines; other times, it is more interpretive in nature.

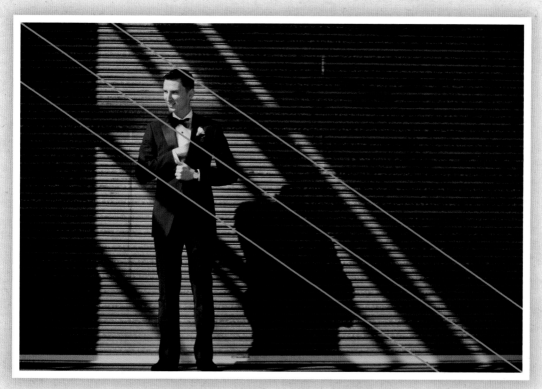

FIGURE 10-10 Using a "landscape rule" in portrait photography is a great way to experiment with different compositional rules.

Leading Lines

Just like it sounds, leading lines draw the viewer's eye into the image, toward the subject and beyond. You can use these lines almost like a road map to clearly define who, or what, the focal point is, or you can use them to create layers of depth in an image. Lines are everywhere in both natural and urban environments, and are a fantastic way to create a meaningful composition.

FIGURE 10-11 The railing leads the viewer to the subject of this image.

FIGURE 10-12 Lines draw the eye through the image to the different layers of visual information.

In Figure 10-11 the railing draws the viewer from the left side of the frame to the focal point of the image—the couple in the lower right of the frame. In Figure 10-12 the viewer's eye follows each line through the image: the railing, the cabanas, where the grass meets the sand, and where the sand meets the water, all of which provide different layers of depth to the image.

Fill the Frame

When the frame is filled with the subject of your image, all distracting or competing elements are removed. This works well when people and objects are your subjects, especially if the foreground and background are filled with items you don't want to include. Filling the frame ensures there is no question what your subject is in the image.

FIGURE 10-13 Filling the frame with your subject eliminates all distracting elements from your composition.

Neutral Backgrounds

Keeping your backgrounds simple, especially when making portraits, is a way to ensure your subject is the clear focus of the frame. That's not to say your background needs to be a single color or pattern. Instead, a neutral background is something that complements the overall structure and subject of your image.

As the photographer you often choose where to place your subject, thereby giving you the choice of backgrounds. There are times, however, when you are unable to move your subject and you need to make images with a less than ideal background. When you find yourself in that situation—and you will—use a wide aperture to give yourself a shallow depth of field. This will blur the background elements and cause them to be less distracting.

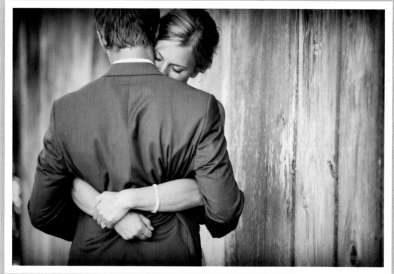

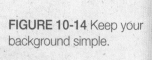

FIGURE 10-14 Keep your background simple.

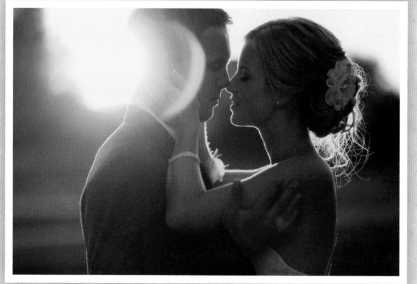

FIGURE 10-15 With a shallow depth of field, the background becomes secondary to your subject.

Negative Space

Completely opposite to the idea of filling the frame, negative space is evident in Figure 10-16. Our subject is placed along one side of the frame and the rest of the space is, essentially, empty of storytelling information. Negative space works well in conjunction with the rule of thirds as well as neutral background. Place your subject along one of the optimal lines and fill the rest of the space with a uniform background.

Using negative space effectively means working with a background that does not detract from your subject. Look for a clean, simple background when composing with negative space, otherwise the background could prove distracting from your main subject.

FIGURE 10-16 Combine the rule of thirds with negative space to create interesting portraits.

FIGURE 10-17 Pushing the boundaries of composition, this image is filled with negative space.

Sometimes, negative space can result in extreme compositions, such as Figure 10-17. This image takes the subjects outside the optimal area outlined in the rule of thirds and combines their placement with negative space to create a unique look. Understanding what makes a composition interesting and effective enables photographers to push boundaries, deliberately taking things to the extreme.

Balance and Symmetry

On occasion, using the rule of thirds may lead to an image with one interesting side of the frame where your subject is, and one less interesting side of the frame. Some people love that kind of negative space and others don't. One way to add interest to a frame is through the addition of another element to balance the frame, or symmetrical elements like reflections.

Let's revisit Figure 10-17. When working in this location, we varied our composition. Some frames, like 10-17, found our subject alone with a great deal of negative space. Other frames, however, had a complimentary element to balance the composition, like in Figure 10-18.

Figure 10-19 is an example of two different elements providing balance within a frame. In this image, the basketball net and the tree complement each other. Both elements are placed along opposite third lines vertically, while matching each other on the horizontal.

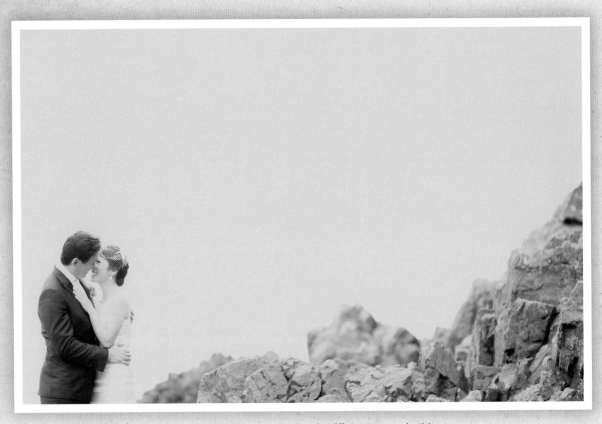

FIGURE 10-18 Try composing the same scene in different ways. In this example, we added a symmetrical element to balance the frame.

Without the basketball hoop, the image would still be interesting but it would lack the balance provided by the addition of that extra element.

In symmetrical compositions the same pattern is repeated across the background, or there are repeated elements on both sides of the frame. In Figure 10-20 there are both reflections and a staircase repeated on either side of the frame, as well as the line in the center of the image that leads you into the frame.

You can use all the compositional elements in this chapter in isolation or in combination with other rules. Most of the examples I've shared, for instance, comply with the rule of thirds in conjunction with another rule. Don't be afraid to use these different guidelines in a variety of combinations when making your own images.

FIGURE 10-19 Include elements to balance your composition.

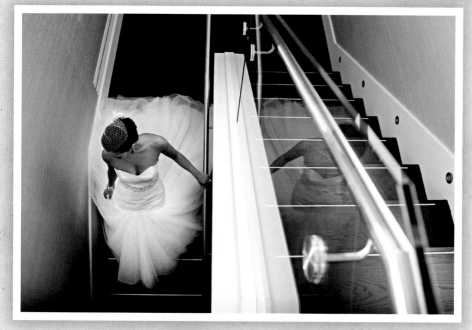

FIGURE 10-20 This image uses reflection and repeating elements to balance both sides of the frame.

FIGURE 10-21a

Cropping the subject's head can create a more intimate image, but is a matter of personal taste.

FIGURE 10-21b

Cutting Off Body Parts in Your Images

Generally speaking, it's not a good idea to cut off your subject's limbs in a photograph. A full-length portrait, for example, would not look as nice if you cut off your subject's toes. That said, if you are going to cut off parts of the body in an image, there are specific places it is acceptable to do so.

The general rule is to leave joints or bends intact. In the case of a three-quarter portrait, cut your subject off above the knees. With arms, above the elbow or wrist is appropriate. In a close up-portrait, the subject is typically cut off between the shoulders and the chest.

When it comes to the head, it comes down to personal taste. Using Figure 10-21a as an example of heads that are fully in the frame, we see the same image in Figure 10-21b with a different crop. In Figure 10-21b, the groom's head has been cropped slightly out of the frame, which brings us closer to the subject (the subject is larger in the frame).

BREAKING THE RULES

Once you are familiar with the rules of composition and start using them in your own images regularly, you can start breaking some of them. When you break rules with intent, the viewer understands that what you are doing is deliberate and appreciates it.

In Figure 10-22, for example, I used leading lines to draw the viewer to the subject, who is placed in the middle of the frame, breaking the rule of thirds. Although the rule of thirds tells us our subject should not be placed in the middle of the frame, the composition doesn't suffer for it. If we did not have the leading lines, though, or the interesting lighting, this image might not have been interesting to look at.

Don't be afraid to make several different compositions of the same subject and location, or of mixing and matching compositional rules. Go ahead and break the rules when you want. This is the art of photography and while the rules are in place to help you make pleasing images, it can be just as valuable to create images that turn those rules on their heads. If everyone followed the same rules all the time, images would look similar. But when rules are broken, and broken well, images are made that cause the viewer to stop and think.

Images like Figure 10-23 break more rules than they follow. Our subject is in the middle of the frame, we have competing background elements, and there is no symmetry. Despite this, the image works and is interesting to look at. Photography is a creative endeavor, and breaking the rules is one way to explore that creativity.

Earlier in this book we learned to control our camera settings and use light in creative and interesting ways to make images reflective of your vision. Composing your images is no different—it's about creating something that illustrates the story you want to tell. ❖

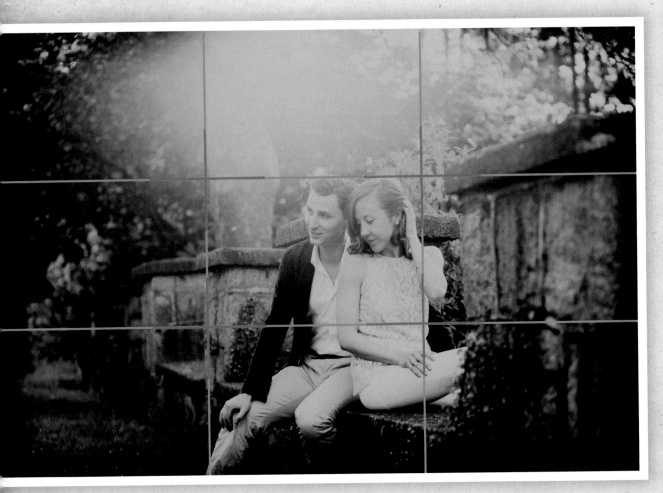

FIGURE 10-22 Breaking compositional rules intentionally can result in great imagery.

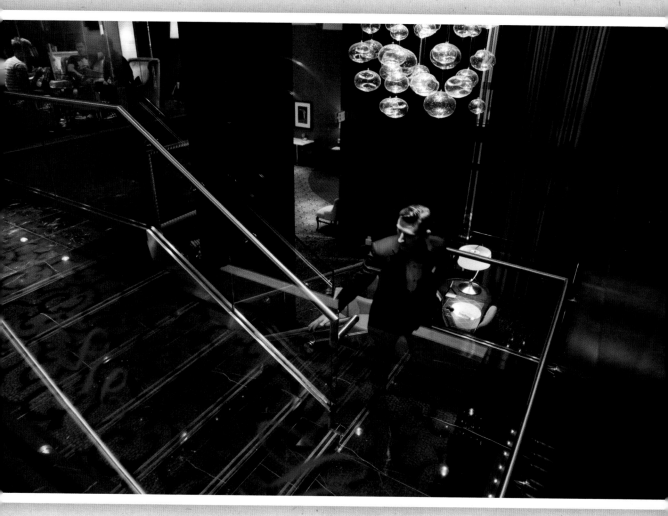

FIGURE 10-23 Break the rules to create something interesting.

PORTRAITS AND LIFE EVENTS

Whether you're a student, a parent, or anyone with a camera, odds are you often find yourself taking pictures of people. Pictures of people are, of course, portraits. Photographing people, however, is not limited to portraits. There are dozens of different occasions where we make pictures of people: weddings, birthdays, sporting events, anniversaries, school plays, and more. These are life events.

While portraits are about people, there are several different ways to approach making the images. In this chapter we cover how to make better portraits as well as how to photograph life events. After all, parents want to photograph their children at sports games, dance recitals, and school plays. As the photographer in your family, you will also find yourself documenting birthday or anniversary celebrations, along with other milestone events. At the end of this chapter, we'll troubleshoot some common problems that arise in different shooting scenarios.

PORTRAITS

A portrait is about the person, or people, in the photograph. As you can imagine, portraits are as varied as the people in them. From composition to light to camera settings, there are many ways to approach this kind of image.

The common thread connecting all portraits is the clear focus on who the subject is. In a busy street scene, for example, there may be several different people in the frame. In order to showcase our subject, we use a relatively shallow depth of field (large aperture) to have them stand out from both the background and the foreground. In other words, even in images where there is lots of visual information, we want to be clear about who our subject is.

Let's discuss four basic types of portraits:

※ *Single portrait*

※ *Group portrait*

※ *Environmental portrait*

※ *Lifestyle portrait*

As we move through these types of portraits, notice that the aperture and corresponding depth of field vary, depending on the purpose of our image. In a lifestyle portrait, for example, you use a more extended depth of field than a close-up. There is no hard-and-fast rule for what your aperture should ultimately be, however. Determining the story you want to tell in your image enables you to decide what aperture is best for the photograph.

The Single Portrait: Headshot to Full Length

For many of us, the only times we were photographed alone was for school or sports pictures, or to document a special event like prom. More often than not we were asked to smile for the camera and the experience was a little awkward. As such, it can be off-putting to know someone is making a portrait of you alone.

One of the challenges photographers face is keeping their subjects relaxed and looking natural in images. After all, the subject isn't interacting with anyone else in the frame, and is probably very aware of the camera.

Think about your favorite images of yourself or a loved one. Odds are those images reflect caught moments rather than posed ones. You love the way your children smile

or the way your parents look at each other, and those are tough expressions to capture when your subject knows you are watching him or her.

Try making images when your subject least expects it, catching him in a moment of candor. He might not be perfectly posed, or even perfectly composed, but those are the moments that matter most to you, and being able to catch them with a great exposure is one of our goals with getting beyond auto mode.

That being said, there are going to be times when you want your subject to be aware of the camera so you can make a headshot. Often referred to as a close-up shot, these images focus entirely on the face and expression of your subject (see Figure 11-1).

Being camera-aware doesn't have to mean static or boring, it simply means your subject is aware of, and interacting with, you as the photographer.

Because the headshot is all about the face, and expression, of your subject, you must be particularly aware of two things:

* *light*
* *background*

FIGURE 11-1 The headshot is all about your subject's face.

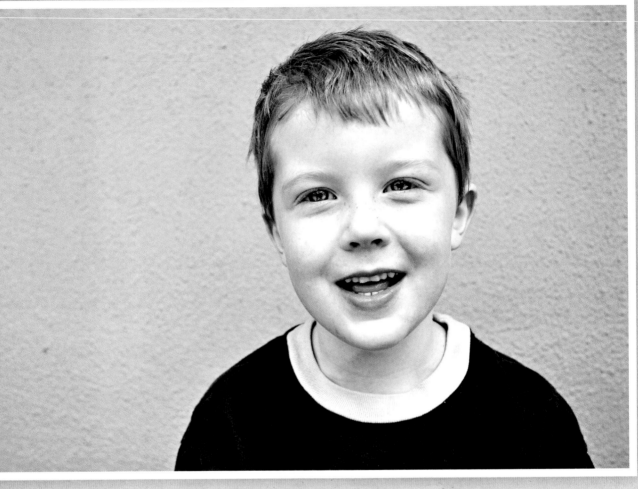

FIGURE 11-2 This headshot was made in soft frontal light at f/4 with a plain wall as a backdrop.

If you can control where your subject is situated, look for the kind of light you want. Start with soft frontal light if possible—it is both flattering and easy to work with.

Place your subject in the best light available, keeping an eye on what is in the background. You know your frame will be filled primarily with your subject's face, but parts of the background may still be visible, especially around the edges of your frame. Choose a large aperture (small f/ number) to help blur that background and make it appear neutral.

Select the largest aperture you can while keeping your subject in focus. Start with f/4 for a portrait. If you have a lens with a wider maximum aperture, such as f/2.8, you can

certainly use that, but bear in mind the challenges in maintaining an accurate focus at f/2.8. Once you have your aperture determined, choose your ISO and shutter speed.

Using a longer focal length is also flattering. That means being further away from your subject, but the longer focal length helps the background appear more blurry than if you use a wide-angle lens. (A smaller amount of the total scene is being captured and then compressed by your lens.)

You will find many occasions where you cannot control the light in your scene. That control is traded for the opportunity to catch your subject off guard and capture a genuine expression. Before making the image, make note of the way the light falls on both your subject and the scene. If the background is very bright in relation to your subject, you know you need to overexpose your image and in turn will lose some background detail.

Rather than rushing to make a photograph, stop for a moment to consider what the best composition is for the image you want to make. While it can be tempting to focus solely on the subject's face, there are other options. Perhaps a mid-length or a full-length portrait is more appropriate.

As you learn to see and use light in different ways, you will find light determining both the location and the type of composition you choose. In Figure 11-3, for example, the sun was low enough in the sky to offer this stunning hair light. The reason I placed her in this specific spot was to use that

FIGURE 11-3 This full-length portrait was made in backlight at aperture f/2.8.

light as an integral part of the image. As with a headshot, her facial expression matters, but we have included her entire body in the frame. Body language and background elements add interest to a single portrait. In this case the garden was a lovely backdrop, which appears blurry with an aperture of f/2.8.

Including other elements in the scene is a great way to create depth in a single portrait. A headshot has an obvious focus with no distracting, or complementary, elements. A mid-length or full-length portrait, on the other hand, offers an opportunity for the viewer to see more than simply the subject herself.

As you begin practicing making portraits, try various compositions. Maybe start with a full-length image and move to a close-up, or vice versa. Experimenting with different ways of framing your subject, in the same series of images, gives you variety in your work and the opportunity to discover the types of images you like to make.

The Group Shot

Photographing groups of people is another form of portraiture. You will make these images everywhere from family vacations to the team photo after a big win. Like the headshot, these images are more about the people in the photo than the background.

With the headshot, we wanted to keep our depth of field relatively shallow. The group shot, on the other hand, requires a more extended depth of field. As a general rule, you probably don't want to go much larger than f/4. In fact, f/5.6 is a great aperture to use for group shots.

In Chapter 3 we saw the image in Figure 11-4. As you look at this image, taken at f/2.8, notice how out of focus the eye is in the image on the right. If choosing a large aperture like f/2.8 can cause focus problems with a single subject, imagine using it while working with a large group of people. At f/2.8 it is much harder to keep each person in focus. At f/5.6, on the other hand, you are working with an extended depth of field, ensuring each person's face is in focus.

With large groups, more than a row deep, you will most likely want to use f/8 to maintain focus. Choosing a smaller aperture and shallower depth of field means some people in your group may be out of focus.

Figure 11-5 was made at a shallow depth of field and not all the boys are in focus. Figure 11-6, on the other hand, uses a more extended depth of field to ensure most of the group is in focus.

FIGURE 11-4 Working with a shallow depth of field can cause focus problems.

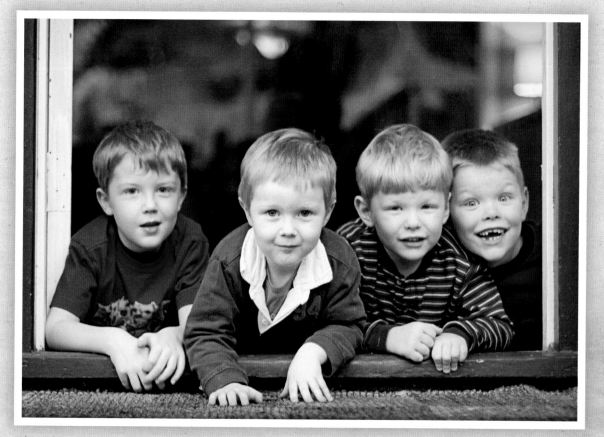

FIGURE 11-5 Made at f/1.4, not all the boys in this group are in focus.

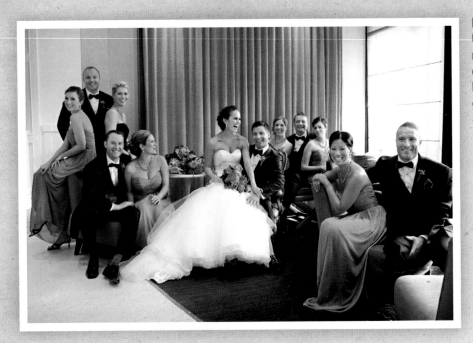

FIGURE 11-6
Using a deeper, or more extended, depth of field keeps more of the group in focus.

The Environmental and Lifestyle Shots

Unless you are photographing someone for a specific purpose, you will likely find yourself making environmental or lifestyle portraits most often. These images are as much about the environment and/or activity as they are about the subject.

Examples of environmental photography include images made in fields, on beaches, or in the mountains, and also include urban landscapes like portraits in front of landmark buildings. In other words, the environmental portrait focusses on the place.

Lifestyle portraiture is less about the surroundings and more about the activity the subject is engaged in. Some examples of lifestyle portraits include images of a child involved in her favorite activity, a family building sand castles at the beach, or a couple cooking together.

Made with similar settings and compositional decisions, it is easy to confuse these two types of portraits, and the terms "environmental portrait" and "lifestyle portrait" are often used interchangeably. Essentially, an environmental portrait is about the person and the place while a lifestyle portrait is about the person and the activity.

With these shots the portrait is still the most important part of the image, but the items included in the frame give context to the portrait. Figure 11-7 is an environmental portrait of a couple in a place they both love, while Figure 11-8 is a lifestyle portrait of a man photographing his girlfriend.

FIGURE 11-7 In an environmental portrait, the place is as important as the subject.

FIGURE 11-8 In a lifestyle portrait, what the subject is doing is an important element in the scene.

Depth of field is still an important consideration, but you might decide not to choose the maximum aperture available. Rather, consider the elements in the frame and what is important to telling the story. In a lifestyle image of a child playing with his favorite toy, you likely want that toy to be more in focus than out of focus. In an environmental portrait, you want to separate your subject from both the background and foreground, but you also want to ensure there is enough information in the scene to show where they are.

This is a great time for you to try different apertures to see what depth of field works for the image you want to make. Figure 11-7 was made at f/4, which was shallow enough

FIGURE 11-9 Playing peek-a-boo at the park through a hole in the play structure.

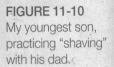

FIGURE 11-10
My youngest son,
practicing "shaving"
with his dad.

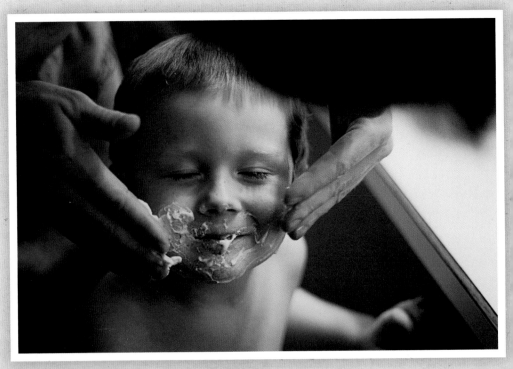

to isolate the couple in the frame, but extended enough for the viewer to see the bridge and shoreline in the background as well as the beach and water in the foreground. In Figure 11-8, the aperture was f/2, isolating the male in the image and placing the focus on what he is doing. The girl in the image is a secondary part of this story, and the other people on the beach, as well as the entire foreground and background, are distinctly out of focus.

As you experiment with different apertures in manual mode, you need to change the shutter speed each time you change the aperture. Choosing a smaller aperture, thereby letting in less light, means slowing down your shutter speed the corresponding amount to let in more light.

This is a great time to for you to revisit the "Equivalent Exposure" aside in Chapter 3 to review how different aperture/shutter speed combinations can give you the exact same exposure.

LIFE EVENTS

When you look back at images from your childhood, they are likely a combination of school portraits, family vacations, birthday parties, and Christmas mornings. Often faded with time, these images bring back memories of moments forgotten. My own visual history is filled with seemingly innocuous moments—not holidays or special events per se, but everyday images of my father playing with me outside or my mother and me making cookies. These are the moments that elicit the most emotion for me.

As photographers we are also our family's historians, making images of both the big and small moments in life. Too often our cameras are packed away until a championship game or a wedding happens. But it is the in-between moments of life that mean the most in that old shoebox (or hard drive) of images.

Obviously the biggest life events are important and you want to capture those with your camera, but a great time to test your skills in manual mode is during everyday moments in your life. In the next section we talk about different events and how to photograph them; but remember to use daily moments as a way hone your abilities. Figures 11-9 and 11-10 are examples of everyday life images. In both, the subject (my youngest son) is engaged in regular play activities. Having my camera with me at these times ensures my memory of day-to-day life with my family is intact. And, in truth, these types of images hold much more meaning to me than the ones made at the major life events. We'll chat more about everyday image making later in the chapter.

Sporting Events

Parents love to photograph their children's sporting events. From soccer to lacrosse to hockey or baseball, cameras are everywhere. This can be an incredibly frustrating experience for parents, though, as many rely on the "sports" or auto modes of their cameras.

In Chapter 6 we learned what the sports mode on your camera does. Basically, the camera chooses the fastest shutter speed possible to freeze the action. In Chapter 8 we learned that we can use shutter priority (TV/S) to set our shutter speeds fast enough to freeze motion as well.

Choosing the right shutter speed is important, especially because your subject is probably moving. With that said, remember that shutter speed is only one part of the equation. Choosing the right shutter speed does not necessarily mean you have the right exposure settings for the environment you are in.

FIGURE 11-11 Photographing kids' sports is both challenging and rewarding.

Let's address both inside and outside venues. Lots of children play ice hockey or other sports in an ice arena. Ice arenas are not camera-friendly venues. The lighting is often terrible, making the ice surface appear dirty, and the distance from where you are to what you are photographing is usually considerable.

Choose your shutter speed (1/250 at a minimum to freeze motion) and your ISO (at least 1600 in this type of setting). Now take a look at your lens and find the maximum aperture available. Most people purchase an entry level lens when they buy a camera. In fact, a lot of people purchase the lens and camera together. Invariably, that lens is a variable aperture lens like the one in Figure 11-12.

The lens in Figure 11-12 is the 18-55mm lens that came with a Nikon D3100. With a variable aperture of f/3.5 to f/5.6, this lens is not a great choice for shooting in an ice arena. Think about an ice arena and the logistics of making images there. You can make images from your seat in the stands or you can stand along the boards. In either location, you are going to need the maximum zoom (55mm) to get anywhere close to the action.

This is where most people run into trouble. With your shutter speed set at 1/250 and your ISO set at 1600, the maximum aperture you can use is f/5.6 when zoomed to 55mm. At f/5.6 you simply don't get enough light to properly expose your image. You will run into this same problem with a number of lenses, including those with more robust zooms like the Canon 70-300mm f/4–f/5.6. To get close to the action even 70mm is not enough and you will find yourself zooming to 300mm to focus on your child.

The biggest complaint I hear from parents trying to photograph in these settings is that their images are dark and/or the players are blurry.

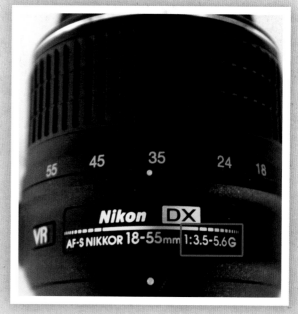

FIGURE 11-12 The maximum aperture of a lens.

FIGURE 11-13a

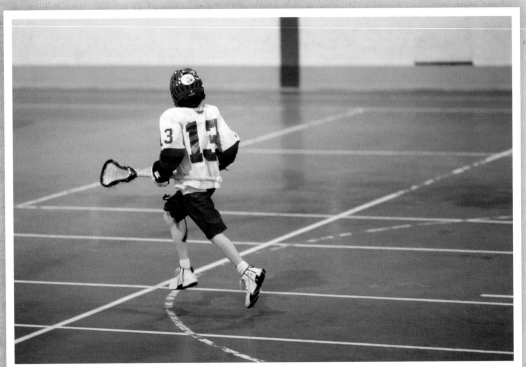

Motion blur is a frequent problem when photographing sporting events. In 11-12a the shutter speed was 1/250 and in 11-12b the shutter speed was 1/200.

FIGURE 11-13b

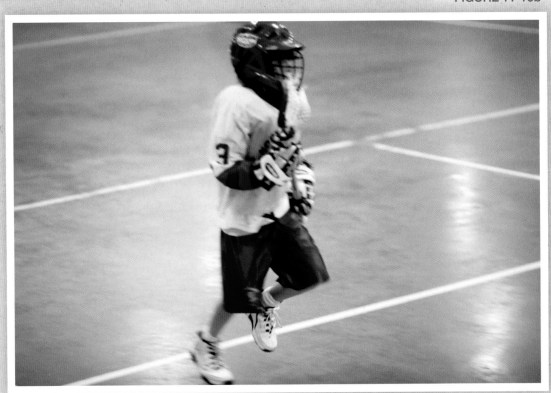

Up to now we have not talked about things like lens choice. As you have been learning to use your camera effectively and move beyond the auto modes, the maximum aperture of your lens has not been a huge concern. In the ice arena or other venue of this sort, however, the limitations of a variable aperture lens become obvious.

To effectively photograph your child in an ice arena you will have more success with a fixed aperture lens, preferably f/2.8. When photographing my children playing indoor lacrosse, I always set my ISO around 1600, if not 3200. My shutter is always over 1/250 and my aperture is rarely smaller than f/4. When my children were smaller and moved a lot slower, I was able to use a shutter speed of 1/200 or 1/250. As they got faster, my shutter speed also had to increase to avoid blur and now I find I need a shutter speed of at least 1/500.

Allowing your shutter to fall below 1/250 will likely result in motion blur. This depends, in part, on the sport and the speed of those playing it, so it's better to be ready for a fast-moving subject than to have to change your shutter speed continuously during the action. Set your shutter speed for action and you will have no problem when someone is standing still.

In Figure 11-13 are two images. In 11-13a the player is sharp, and in 11-13b the player is blurry. These images were both made with ISO 1600, aperture f/2, and a focal length of 135mm. The shutter speed for 11-13a was 1/250 and for 11-13b was 1/200. Even at 1/200, which is a fairly fast shutter speed, there is significant motion blur even though there isn't an obvious difference in the exposure itself (the image at 1/200 is not significantly brighter than the one at 1/250).

There is a trade-off when shooting at f/2, however, and that is the possibility that focus can slip, especially when you are trying to track a moving subject. In Figure 11-14, we have a great exposure and no motion blur at all. If you look closely, though, you can see that the focus has slipped from the player to the floor adjacent to the player, which makes the player look soft rather than sharp.

The same principles regarding motion blur hold true when photographing outdoor sports as well. Some challenges in shooting outdoors are different than those found shooting indoors, though. Rather than a constant inside light source, when outside we are often in variable lighting conditions. This holds true when the game is played in daylight and when the game is played under lights at night.

In Chapter 7 we talked about using AV/A mode when in rapidly changing light, and in Chapter 8 we talked about using TV/S mode to maintain shutter speed at a constant setting. When you arrive at the game, evaluate the lighting on the playing field to determine which mode you are going to use. If the light is even and the game is not being played late in the day as the sun drops, manual mode is a great choice.

As with the indoor setting, your shutter speed is your first concern. Choose a shutter speed of at least 1/250 or higher, and then choose either your aperture or ISO. If it is a bright, sunny day, set your ISO to 100 and leave your aperture as the final corner of the exposure triangle. You might have to try a few different settings to get the correct exposure. Start with f/4 and determine whether you need to let in more or less light.

If you find yourself with an ISO of 100, shutter speed at 1/250, and aperture at f/8, but instead want your aperture at f/4, increase your shutter speed by two stops to 1/1000. (Remember that a stop is a halving or doubling of the amount of light. Review Chapter 3 for a refresher.)

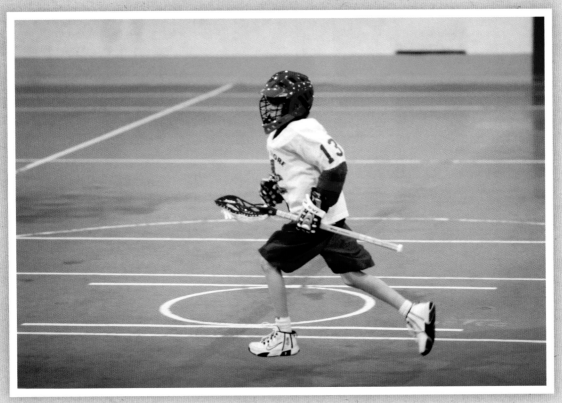

FIGURE 11-14 Using a large aperture can sometimes result in focus slipping from the subject.

FIGURE 11-15 With a longer zoom and a fast shutter speed,
you freeze the action and isolate the player in the frame.

In manual mode, you have ultimate control of both your shutter speed and depth of
field/aperture. Although you will start at 1/250 to gauge your exposure, you are not
stuck there. If having the aperture you want means setting a faster shutter speed, that is
not a problem at all. Try different settings as the players are warming up so you are ready
to go when the game begins.

We talk gear in Chapter 13, but once again, this is a time when having a longer focal
length comes in handy. Most people are interested in what a specific player is doing
(usually their own child) and want that player to be front and center in their frames.
Doing that with a wide-angle lens is difficult. If the focal length of a lens encompasses
the entire field, the individual players will be tiny. To be sure a specific player is
prominent in the frame, use a longer focal length.

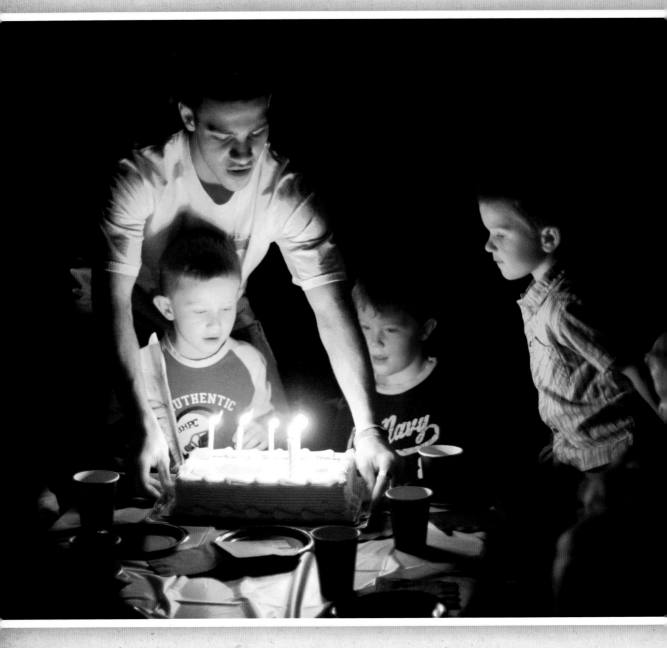

Plays, Recitals, and Parties

As frustrating as it is to photograph inside an ice arena, at least there is a fair bit of light to work with. At a school play, dance recital, or other event where lighting is often dim, if not totally dark, making great photographs can be daunting—but not impossible.

FIGURE 11-16 Life events don't always happen in the perfect light. Don't let that keep you from documenting the moment.

The challenge is two-fold: moving subjects and spotlights. In a dance recital in particular, having a shutter speed above 1/250 is extremely important. In a school play, a slower shutter speed is possible when the subject is stationary.

Coupled with the challenges of freezing motion are the spotlights used to light the performers on stage. Because the light is concentrated, and your camera meter wants to even out the light in the entire frame, the brightest areas will likely be overexposed if you rely on the camera to choose one part of the exposure triangle, like in TV/S mode.

The same challenges exist at birthday parties or anniversary parties, when the lights are turned down low to bring out the cake. Figure 11-16 shows a child's birthday party, where the only light available was that from the candles. This image was made with a 50mm lens, ISO 160, shutter speed 1/60, and aperture f/1.4 and is overexposed by nearly two stops.

In a dark theater, using manual mode, set your shutter speed, ISO (between 1600 and 3200), and aperture. Photograph a couple of frames and evaluate the scene via your LCD display. If the exposure bar indicator is in the middle, you will likely see the flashing lights that indicate an overexposed area in the brightest portions of the frame. Underexpose your image until the flashing lights in the spotlit area are gone. The spotlight will remain constant throughout; the only variable that will change is where the light is shining on the stage. Once you have that exposure locked, you should be ready to go.

You may find yourself trading off a fast shutter speed for a shallow depth of field, which can create challenges when trying to focus on your subject. This would be a great time to use a tripod if you have one (see Chapter 13 for more on gear). Remembering that we try to keep our shutter speed at least equal to, if not faster than, the focal length of our lens, the tripod allows you to use a slower shutter speed, especially if your subject is not moving. Because that slower shutter speed lets in more light, you can also choose a smaller aperture to gain a more extended depth of field.

Everyday Images

A great way to practice with your camera is to photograph everyday life. We saw examples of this earlier in the chapter as we began chatting about photographing life events. Whether you use those daily moments as a way to get beyond auto mode, or if you are already beyond auto and simply want to document your life, there are incredible, photo-worthy moments happening all the time. This is especially true if you are a parent. You likely find yourself immersed in moments you want to preserve.

Keeping your camera close and making images everyday will help you learn to see light and learn how your camera sees light. Not every image you make will be perfectly exposed or composed. But in the making of those images, you are learning to work with your camera quickly, and will soon find yourself making exposure decisions more easily. Every day you encounter different light and, therefore, different exposure decisions. The best way to get comfortable using your camera in manual mode is to keep it with you and use it frequently.

TROUBLESHOOTING

As you gain confidence beyond the auto modes and start to use your manual settings more often, you may find yourself getting frustrated when an image just isn't working the way you want it to. Know that even professional photographers find themselves challenged at times. Unfamiliar lighting, strange color casts, distortion in faces ... you can overcome all these issues with patience.

When you find yourself struggling with exposure, consider the following:

※ If your image is too dark or looks muddy, it is underexposed. Allow more light into the image by decreasing your shutter speed, choosing a larger aperture (smaller number), or increasing your ISO.

※ If your image is too bright and the lights in the display keep flashing, your image is overexposed. Let less light into the camera by increasing your shutter speed, choosing a smaller aperture (larger number), or decreasing your ISO.

Oftentimes, the solution is seemingly obvious. You may have, for example, moved outside into a bright, sunny setting, from a dim room with an ISO of 800. If you are in manual mode and have not changed any settings, your image will be far too

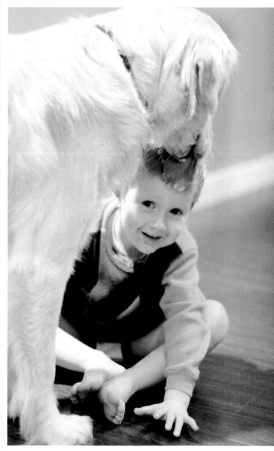

FIGURE 11-17

Each day offers opportunities to make pictures.

bright (overexposed). Simply changing your ISO from 800 to 100 may solve the problem.

There will also be times when you have tried everything you can think of and you are still not able to make the image you want. The following section offers some common problems people face when making portraits or photographing life events.

The subjects' faces look fat or distorted.

This effect happens when using a wide-angle lens, close up. Use a longer focal length and move further away from your subject.

The subject is dark but the background is bright.

You are working with a subject in a backlit scene. Take a look at the exposure bar on the camera—try overexposing by two-thirds to see what happens. Decrease your shutter speed until the indicator on the exposure bar moves two spaces to the plus side. Keep decreasing your shutter speed until your subject is well exposed. Be careful not to have your shutter speed go too low, though. If that happens, increase your ISO to let in more light.

I used a flash to light my subject and that made the background go black, even when there was light in the background.

This happens in auto modes—the camera is choosing to expose your subject (because that is what you focused

FIGURE 11-18 To preserve the ambient light in the background, turn off the camera flash and control the exposure yourself. This image was overexposed by two-thirds of a stop.

on) and has determined the scene is dark enough to warrant using flash. Because of this, your background is left underexposed (dark). The first thing to do is turn off auto mode and move to manual mode. Your scene is dark enough for your camera to think it needs to add light, so you should choose a fairly high ISO, like 1600. Set your aperture at the maximum you can and then choose your shutter speed. On your exposure bar, the camera will probably think you are overexposing the image.

In Figure 11-18 we see an example of a low-light setting where the ambient lights in the background provide context for the image. If we had used flash in this moment, the Christmas lights would not be as evident in the frame. Instead, we overexposed the image by two-thirds and used a large aperture to let in as much light as possible.

The subject's eyes are squinting.

The easiest way to avoid this is to ensure your subject is not looking toward the sun or any other bright light source. Have him look to the side, or turn him around so his back is to the sun. If you do have the subject turn completely, you will be working in a backlit situation, so be sure to overexpose to preserve the skin tones of your subject.

If you want to keep your subject facing the light, try the one-two-three game: have your subject close his eyes, and then open them when you count to three. Make the image as soon as he opens his eyes, before he starts squinting again.

I was photographing my family in front of a sunset and they are dark. When I turned my flash on, I couldn't see the sunset.

In Chapter 13 we talk more about when and how to use your flash, and photographing people with a sunset in the background is just such a time.

A sunset image is a backlit image, so balancing the correct exposure on your subjects' faces with the sunset can be challenging—you want to preserve the stunning color in the background, so you cannot simply overexpose the image. In fact, you need to underexpose the image to make the colors even richer. Also, switch from auto white balance (AWB) to shade to make the image warmer.

You will want to make this image with a little help from your flash, but you have another image or two you can make in this setting. Simply turn your subjects so they are facing the sun and you will see incredible, warm light on their faces. This is a great opportunity to make a headshot or to create an environmental portrait using the new backdrop.

I was photographing my daughter playing with her toys, but her hands and toys are blurry.

Check your shutter speed—odds are it's too slow. What you are seeing in that image is motion blur. Most likely your daughter was moving her hands, with the toys in them, and your shutter speed wasn't fast enough to freeze the motion. Motion blur can be an effective way to tell the story, and in this case you can see your daughter was involved in active play with her toys.

To avoid motion blur next time, increase your shutter speed to at least 1/250. You will have to make corresponding adjustments to your ISO and/or aperture to allow for more light, as increasing your shutter speed means less light is coming into the camera.

All the images from my son's hockey game are a different color.

In many ice arenas there are gas vapor lights, which pulse. You can't see that with your eye, but as you look through your images you see different color casts from frame to frame. Auto white balance (AWB) will not work in this setting. Take a look at the images you made and note what the color cast is. If you see orange tones, you need to cool down the image by choosing the tungsten setting; if you see blue tones, warm it up by choosing fluorescent white balance. You may have to experiment a little bit to find the white balance setting that works best in each rink.

Know also that all the white (ice) in the frame will fool your camera meter. Wanting to even out the exposure, the camera sees all that white and tries to darken the image by underexposing it. You need to overexpose (according to the exposure bar) the image as a result—try one-third to start. Keep a close eye on the flashing lights to ensure you haven't overexposed to the point you are losing highlight detail. ❖

Chapter 12
PLACES AND THINGS

There are stunning vistas and interesting objects at every turn. From sunsets to beaches to urban landscapes or farmers' fields, we can find incredible landscapes wherever we go. As we view landscapes with our eyes, we naturally focus on the elements we find captivating, all but ignoring the rest. Your camera, on the other hand, cannot do this. Rather, your camera treats the totality of the scene equally, unless you tell it otherwise.

Even though landscape images are typically photographed at an extended depth of field, the viewer needs something to draw her in. And you, the maker, need something to focus your image around. We can do this with our aperture choices.

The same holds true when photographing things like pets, food, statues, flowers, and more: The aperture we choose determines where our viewer looks and how the image is interpreted.

Beyond the exposure settings, compelling images of things rely on interesting compositions. (We learned about compositional rules [and how to break them] in Chapter 10.) Part of what makes one photograph stand out more than another is the way the photographer chose to organize the elements in the frame. When working with places and things, what you leave out of the frame is as important as what you include.

Photographing places and things is not that different from photographing people, and vice versa. With that said, when you are photographing places, you may want to add people into the scene—it's simply a matter of changing the focus of your image.

NATURE AND LANDSCAPES

Have you ever glanced out your window or pushed through the trees at the end of a walk and seen an incredible view? The entire scene before you is stunning to your eye and you want to make a picture that does it justice. More often than not, you take the picture and it's good, but it isn't exactly what your eye is seeing.

Just like working with people, working with nature and landscapes is all about light and composition. This can often be even more challenging than making a portrait since you cannot move the landscape into better light. Sometimes a large scene has very light and very dark areas, making it tough to find balance. Sometimes your image has all the elements that first caught your eye, but the image itself feels boring or flat.

Typically, the aperture setting for nature and landscape images ranges from f/8 to f/22. This is because an extended depth of field keeps more of the foreground and background in focus, thereby allowing the viewer to see what you, as the photographer, saw.

As we move through the various types of images in this chapter, I share the settings used in the sample images—you will find most of those are different than the "suggested" settings. Ultimately, you have control over the way your image looks and what depth of field or focal point you use. With every scene you photograph, try different settings to determine what works best for the image you want to make, worrying less about what you "should" do and more about the kind of feeling you want to invoke in your images.

When photographing nature and landscapes, consider what you find interesting about the scene. If you are in a forest, does a particular tree or series of trees catch your eye? In a beach setting, is it the waves, the boats on the horizon, or something else? What do you see on that long, lonely road? What about the sky or the sunset? When you can pinpoint what it is that draws you in to a scene, you will know how to focus and compose your image to reflect that.

Sunsets

Sunsets are made spectacular by the colors and the way those colors affect the clouds and the surrounding landscape. It is not only the colors and clouds that enrich an image, however. Sometimes, as in Figure 12-1, it is the way the light streams through the clouds that becomes our focal point. The overall image is pretty to look at, but it is the lines of light streaking through the frame that make this image appealing.

FIGURE 12-1 Having a specific focal point in your images enables the viewer to see what sparked you to make a specific image. ISO 160, shutter speed 1/8000, aperture f/2.8.

217

FIGURE 12-2

Here are two different ways of composing the same frame. Camera settings for both images: ISO 200, shutter speed 1/100, aperture f/4.

As the light drops lower in the sky, and the colors become more saturated, how you photograph the sunset will change. To ensure that the full effect of the sunset is seen in your image, underexpose your frame. In Figure 12-2 the images are underexposed by two-thirds of a stop. This is also a time to try taking your camera off auto white balance (AWB) and using the shade setting to warm the image even further.

One of the things that makes sunsets interesting is their relationship to the land around them. Whether the sun is setting over a mountain range, or a body of water like in Figure 12-2, the silhouette of the landscape contributes to the overall feel and interest of the image. It's up to you how to add that information into the frame: How much water or land do you want to show, and where do you want to place it in the image?

Landscapes and Interesting Places

Making images while on trips helps us recall the places we have been.

Images that showcase the totality of a scene are great for providing context, but it's often the more interestingly composed image of a place that draws viewers in. The great thing about photography is the opportunity it gives you to express your unique view of the world. In Chapter 10 we learned about compositional rules like those followed in Figure 12-3, where I used lines to showcase flags against the blue sky.

FIGURE 12-3

Choose interesting compositions for your vacation photos. This image was made with an aperture of f/20, which created the star shape of the sun. ISO 160, shutter speed 1/160, aperture f/20.

Obviously the flags in Figure 12-3 don't simply float against the sky without being attached to something. In Figures 12-4 and 12-5 you can see the flags in a larger contextual frame.

In Figure 12-4 (the overall scene) it is not clear what our focal point is and what attracted us to that scene specifically. Figure 12-5 gives the viewer a narrower perspective of the scene and what drew us to it, culminating with Figure 12-3, which isolates the flags against the sky.

When making images of places you visit or landscapes that appeal to you, remember that there are many different ways to compose your frame. Scene setters that give an overall view are a wonderful way to preface a visual story told with tighter framing in additional images. Looking at the flags in Figure 12-3 alone, there is no reference for what they are attached to or the place they can be found. Creating a series reminds us what the town square looked like as we approached it and what drew us into that location.

Landscapes are not limited to nature alone. Urban landscapes offer fertile opportunities for image making as well. Interesting buildings, busy streets, or urban landmarks are all places we can make compelling imagery.

The same principles for shooting in natural settings apply to urban landscapes: Find a focal point and choose what story you want to tell with your image via your exposure settings and composition. Ask yourself what draws you to this place or this moment. Sometimes it's simply the chance to photograph a landmark, but use that as an opportunity to experiment with different compositions and settings. Unlike a person, the landmark is stationary and won't mind if you photograph it over and over again.

In Figure 12-6, for example, is the iconic Sydney Opera House. As I approached, there were dozens of tourists making images, almost all from the same location and perspective. If you want to make that same image too, that's fine. After getting a "safe" shot, though, take the time to compose some different images. I was interested in showcasing some specific parts of the Opera House and the surrounding environment that resonated with me. Figure 12-6 sets the Opera House against the larger sky, providing an interesting contrast between something human built and something natural.

FIGURE 12-4 When photographing places, a wide shot gives context. This image was made with an aperture of f/2.8. ISO 160, shutter speed 1/3200, aperture f/2.8.

FIGURE 12-5
A tighter composition of the image in 12-4 highlights a specific detail from that larger context. ISO 160, shutter speed 1/2000, aperture f/4.

221

In Figure 12-7, I continued to explore the relationship between this human-made structure and the natural environment, but chose a much tighter composition contrasting the texture in the sky against the texture in the building itself. In doing this, the resulting images highlights something completely different than in Figure 12-6.

In every environment, whether rural or city, there are unexpected images waiting to be made. Look for buildings or storefronts that catch your eye, or simply look outside your hotel room—not across at the view, but down at the street. Identify compositions that provide context and really hone in on the story you want to tell. Look for different ways to frame and organize the elements in your images, creating something compelling for the viewer.

FIGURE 12-6
Made from the vantage point of a ferry in the Sydney harbor, this image contrasts the Opera House against the sky. ISO 100, shutter speed 1/2000, aperture f/2.8.

Nature Items

Water, flowers, animals, and other items found in nature offer opportunities for great photographs. Whether you are photographing a rushing river, a waterfall, or a rich tapestry of brightly colored flowers, your first concerns are (once again) exposure, composition, and purpose.

As with landscapes and other interesting places, determining what is most interesting about the scene will help you determine composition and focal point. Figure 12-8 offers

FIGURE 12-7 When photographing landmarks, try different compositions and perspectives. Aperture setting was f/2.8. ISO 100, shutter speed 1/8000, aperture f/2.8.

three images of the same tree, each with a different focal point and composition. Simply shifting what we focus on, and how we compose the frames, creates vastly different images of the same subject.

We mentioned earlier that composition is merely one piece of the image-making puzzle. With our aperture and, therefore, our depth of field, we dramatically change how the subject of an image is identified. When choosing your aperture, consider the distance of your subject to the background. If your subject is close to the background, a shallow depth of field won't be as evident as it is when your subject is further away from the background.

Consider Figure 12-9, for example. Notice how the background at the top of the frame is much more in focus than at the bottom of the frame. This is because the leaf is resting on the backdrop and because we are shooting down toward the leaf, with our

FIGURE 12-8

Changing how you frame a subject can create an interesting set of images.

FIGURE 12-9 Choosing a shallow depth of field, like f/2 in this case, will not blur the background when the subject and focal point are very close to it. ISO 400, shutter speed 1/400, aperture f/2.8.

focal point being at the top third of the frame. That said, because the background is interesting in texture, and because is not distracting from our subject, it complements the image.

In Figure 12-10, on the other hand, is an image made at the same aperture as Figure 12-9. In 12-10, our subject (the leaf) was in the foreground, away from the background of other branches, causing them to blur. This effect not only makes it clear what our subject is, but leaves enough information in the background for us to know what the background is. In nature images, having that information provides context for your subject matter.

FIGURE 12-10 Moving your subject away from the background and choosing a shallow depth of field (f/2) isolates the subject, while also providing a meaningful context for it. ISO 400, shutter speed 1/320, aperture f/2.8.

Water

On a calm day a lake or pond is likely still, while a river or waterfall is moving. The ocean can appear still, or you can watch the waves crash on the shore. Photographing still water is relatively easy—pick the correct exposure for the scene, choose your focal point and composition, and make the picture. With moving water, on the other hand, it can be challenging to capture that movement in your images.

To create the look of moving water you need motion blur. We discussed the relationship of shutter speed to motion blur in Chapter 1, learning that your camera requires a shutter speed of 1/250 or faster to freeze movement. With moving water you need to allow for motion blur, and capturing that requires a very slow shutter speed—much slower than what we need to capture motion blur with moving people or vehicles, for example.

After choosing your ISO, choose the shutter speed you think will capture motion best. Making images in which the water is blurred with great effect requires a tripod (see Chapter 13 for more on gear).

After you have selected your shutter speed, choose the aperture to finish the exposure triangle. One thing to note is your shutter speed will look different when you select it. To this point, our shutter speed has looked like 1/60 or 60 on our camera display, but with shutter speeds of more than 1 second, the display will look like 1.6 or 1"6. We discussed this during the assignment at the end of Chapter 1, when learning more about shutter speed.

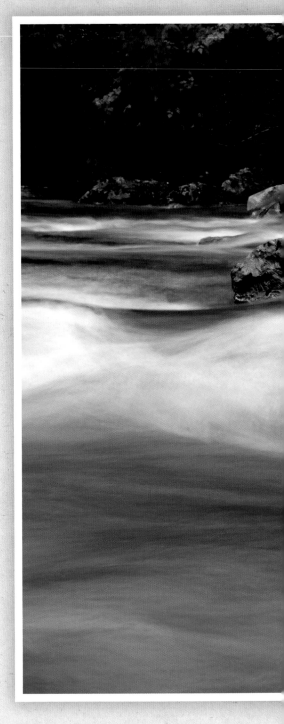

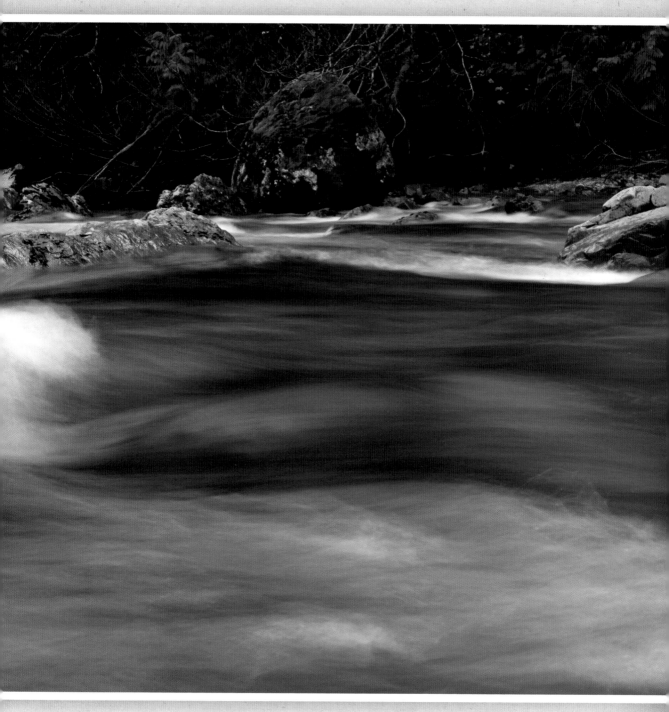

FIGURE 12-11 When photographing moving water, choose a slower shutter speed to blur the water and create the illusion of movement. ISO 160, shutter speed 1/160, aperture f/20.

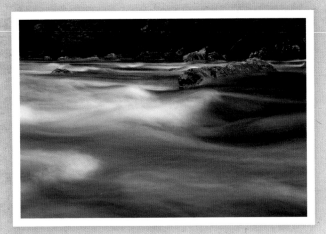

FIGURE 12-12a
ISO 100, shutter speed 3s, aperture f/22.

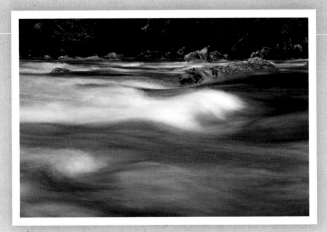

FIGURE 12-12b
ISO 100, shutter speed 1.6s, aperture f/16.

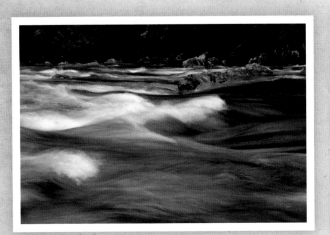

FIGURE 12-12d
ISO 100, shutter speed 1/2s, aperture f/10.

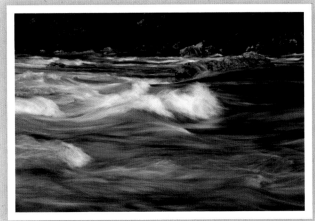

FIGURE 12-12e
ISO 100, shutter speed 1/4s, aperture f/7.1.

As you can see, the water in Figure 12-11 is blurred, which creates the illusion of movement, while the rock in the river is sharp. If you want the water to appear more blurred, choose a slower shutter speed and if you want it less blurred, choose a faster shutter speed.

Each image in Figure 12-12 was made with the same exposure triangle, but with varying shutter speeds and apertures. You can clearly see how shutter speed affects motion blur and how aperture decisions affect depth of field.

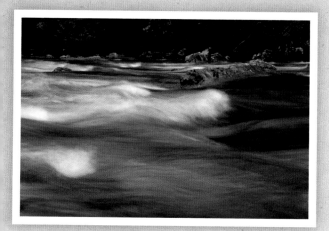

FIGURE 12-12c
ISO 100, shutter speed 1s, aperture f/14.

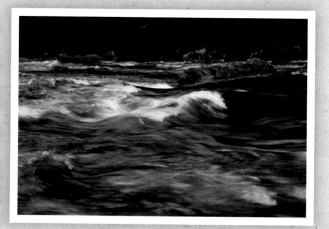

FIGURE 12-12f
ISO 100, shutter speed 1/13s, aperture f/4.

The original exposure in Figure 12-12a was ISO 100, shutter speed 3s, and aperture f/22. The ISO remained constant, and I increased shutter speed and aperture by one stop in each image (letting in the same amount of light each time), ending with ISO 100, shutter speed 1/13, and aperture f/4 in Figure 12-12f.

The technical information and settings aside, in this series of images, the water appears almost smooth and cloudlike in some images, and much crisper in other images. Not only that, the background and foreground are less in focus as the aperture moves from f/22 in Figure 12-12a to f/4 in Figure 12-12f. But what we are most interested in is the blur of the water, which really comes down to taste. Some will prefer the milky look of the water in figure 12-12a, while others will prefer the more realistic look of the water in 12-12f, or any of the images in between.

Personally, I'm drawn to the more ethereal and dreamy look of the water in 12-12a, but that's the best thing about photography—it's about personal expression as much as technical proficiency. As photographers we make images that suit our artistic temperaments, and everyone likes, and makes, different aesthetic looks.

I used a neutral density (ND) filter to make the images in Figures 12-11 and 12-12. In Chapter 13 I talk more about this, but basically an ND filter reduces the amount of light available to make an exposure, allowing us to choose much slower shutter speeds than we would typically be able to use.

OBJECTS

Not everyone is interested in photographing the same things. Some people love making the perfect landscape image, while others prefer photographing portraits, and still others enjoy photographing things like flowers, bugs, pets, or other objects.

When making images of objects or things, many of the same guidelines we've discussed apply. You must consider focal points, composition, and the elements that may appear in your frame. There is no hard-and-fast rule about which aperture to choose when making these images, rather you must determine how you want your image to look and choose accordingly.

As we chat about food, pets, and objects, I'll share different exposure settings and what considerations go into choosing them.

Food

Food photography is all about keeping it simple: simple backgrounds and compositions. Depth of field is one of your first decisions—how shallow or extended do you want your depth of field? Do you want everything in focus, or do you want a specific part of your subject in focus?

FIGURE 12-13b ISO 400, shutter speed 1/400, aperture f/1.6.

FIGURE 12-13a When photographing food, simple backgrounds and compositions work best. ISO 125, shutter speed 1/3200, aperture f/1.2.

Figure 12-13 shows two examples of food photography. The chocolate dessert image in Figure 12-13a was made at f/1.2, and the single wedding cake in Figure 12-13b was made at f/1.6. Both images are made with window light and both offer simple compositions.

The wide aperture used in 12-13a created a very shallow depth of field that worked well to isolate a single treat. While Figure 12-13b was also made with a wide aperture, using f/4 would also have achieved the same look. Because the cake in 12-13b is quite a distance from the backdrop, the depth of field didn't need to be as shallow.

Pets

Most people with pets think of them as part of their families. As such, approach photographing your pet the same way you photograph a portrait. Typically with portraits we look for a simple background, great light, and a relatively shallow depth of field. If your pet is still, you won't have to worry as much about your shutter speed, but if your pet is moving ensure that your shutter speed is 1/250 or faster.

FIGURE 12-14 Pet photography follows the same principles as portrait photography. Use a shallow depth of field to blur the background and isolate the subject in the frame. ISO 1600, shutter speed 1/100, f/1.4.

In Figure 12-14, our subject, Rocky, is side lit and standing on a dark floor. With a large aperture (f/1.4) the background blurs to almost black, isolating Rocky in the frame. I focused on his right eye as I called his name to capture his attention and then make the image. The shallow depth of field not only blurs the background, it also calls attention to his eye, leading the viewer into the frame. His nose and ear are blurred, as the result of our aperture setting of f/1.4. At f/2.8 or f/4, the background would still be blurry, but his nose and ear would be less blurred.

Just as with portraits, when photographing pets you should choose interesting compositions and framing. The rule of thirds and filling the frame are evident in the image of Rocky.

FIGURE 12-15 A complementary background adds interest to a frame and does not detract from your subject. ISO 250, shutter speed 1/30, aperture f/2.

Objects

Product photography is a great example of photographing objects. You have seen a lot of this type of imagery throughout this book, in fact. When working with an object, simple is best in terms of background. If you cannot find a simple background, working with a complementary backdrop is fine.

Let's take a closer look at complementary backgrounds. In Figure 12-15 notice the focus of the image is clearly the leaf, but the backdrop is neither simple nor blurred. This is an example of a complementary background: It adds visual interest to the frame but does not detract from the subject.

I want to walk you through a product shot, from start to finish, to show you how simple it can be. Using a favorite object, let's try this together. I chose a camera, but you can choose anything you have on hand like a candle holder, a kid's toy, a flower arrangement, or even a pair of shoes.

FIGURE 12-16 Choose an object for this assignment—I chose this camera. ISO 400, shutter speed 1/160, aperture f/2, exposure compensation +1.7.

The first step is to find the light you need to make your image. I'm going to use diffuse light for my image, coupled with backlight from my kitchen windows. My goal is to blow the background to the point of pure white. I should also note that the overhead lights in this area remain off as we make the image (see Figure 12-17).

Once we've determined the light source, we need to decide where to place our object. For this image, I want a simple background and surface. We are going to shoot into the bank of windows and, therefore, blow out our background. I have a glossy white table in

FIGURE 12-17 Using this bank of windows provides soft diffuse light and backlight for my subject.

my kitchen and I'm going to use that. Not only is it neutral, it will also provide an interesting reflection in my final image because it is a glossy surface. If I wanted a non-glossy surface, I would place my object on a piece of fabric or other material, like a placemat or pillow cover. When you compose your image, the edges of the surface will not be evident, so you don't need to choose a large piece of material.

With our light source and background in place, we are ready to make the image. For my image, I choose ISO 400 and aperture f/2 first. I know I want to blur out the background and light source, so I'm using a wide aperture for that shallow depth of field. When choosing my shutter speed I know I need to be at least one stop overexposed, possibly more. Use AV/A mode or manual, but if you choose AV/A mode remember that you can overexpose only two stops, and depending on how bright your setting is you might need to overexpose more than that.

I'll start in AV mode to get a meter reading from my camera. At ISO 400 and f/2 the camera chooses a shutter speed of 1/1600, but I know that will underexpose my image (because of the backlit setting). Knowing what my camera thinks the correct exposure is gives me a starting point when choosing my shutter speed. Now I switch to manual mode and ISO 400, aperture f/2, and shutter speed 1/800, which is one stop over what my camera thinks is correct.

As you are doing this with me, make your image and check your LCD screen. If the image is not bright enough, overexpose more than one stop—perhaps two stops. I am working with backlight and I want to blow the highlights in the background, but keep my object well exposed. You might nail the exposure in your next frame, or it might take a few tries to get it right. For my scene (Figure 12-18), the final exposure settings are ISO 400,

FIGURE 12-18 The final image of my object. By overexposing the image, the bank of windows and glossy surface created a seamless background to our image.

aperture f/2, and shutter speed 1/320, which is two and one-thirds of a stop over the initial setting the camera chose of 1/1600.

Your final image most likely will have different exposure settings than mine, which will depend on the light source you choose and the effect you want to achieve.

TROUBLESHOOTING COMMON PROBLEMS

As with portraits, sometimes you will struggle to photograph places and things the way you want to. You'll make many of these images outdoors where you cannot control the light. As such, there will be times an image won't work because there is too much or not enough light in the scene. You might need to come back to that setting at a different time of day to create what you are looking for.

Landscape photographers arrive on location hours before they plan to make an image, waiting patiently for sunrise (or sunset) to give them the areas of highlight and shadow they want to capture. If you are on vacation, however, that might not be realistic. Don't beat yourself up if the light is not perfect—do what you can with the time you have. If areas are blown out, underexpose your image and if areas are too dark, try overexposing. Experiment with different focal points and compositions to showcase the items that catch your eye.

Consider the purpose of your image: Why this place at this time? Why this tree/flower/animal? Do you want to use a shallow depth of field and isolate your subject in the frame, or do you want a more extended depth of field to showcase more of the environment in front of you?

Photographs bring us back to experiences and places we may otherwise have forgotten. Take your time and make great exposure and compositional decisions, always making the best image you can. Remember, though, if you are in a place where the light is out of your control and the image doesn't look exactly how you want, it's alright. Make the image anyway—perfect or not, you'll be happy to have it to look back at. Forgive your mistakes and know we all make them—even working professionals.

The following section addresses some common problems you may run into when photographing places and things.

My sunset images look washed out.

There are a few different things that can cause this to happen. First, there might still be a lot of daylight in your scene, like in the hour before sunset. Too much light in the scene can cause your image to look washed out.

The second reason this might happen is if you are allowing your camera to make exposure decisions for you. In trying to find the correct exposure triangle, the

camera wants to equalize the light in the scene. If you take control back and underexpose your image, you will have richer, more saturated colors in your sunset images. Finally, change your auto white balance (AWB) setting to shady, which will warm up your image even more.

I'm in a pretty place, but my pictures are boring.

There are a few factors that may be contributing to this. Look around the scene and make note of the light. Are there areas of brightness and shadow, or is everything lit the same way? Flat light (like on an overcast day) can make landscape images look flat and dull. You might need to come back when there is more contrast in your scene.

One reason your photo might be boring is because it lacks a focal point. Choose one element you want to highlight (an interesting tree or rock formation, for example) and frame everything else around it. You may want to choose a shallower depth of field (larger aperture) and assess how that impacts your image as well.

Try a different composition or perspective. If you are standing while making the image, try sitting for a different point of view. Perhaps you need to narrow the field of view from a vast, sweeping landscape to a narrower composition with one or two elements of note.

When I try to make images in a forest, they are really dark. My aperture is as wide as possible and I don't want to use a slower shutter speed. (I don't have a tripod.)

Leave your aperture and shutter speed where they are and try increasing your ISO. This will brighten your scene.

I can't make the water blur the way you did.

Check your shutter speed. To create the effect in Figures 12-11 and 12-12 you need an extremely slow shutter speed and a tripod. You might be able to rest your camera on a flat surface and make the image successfully, but ideally you need a tripod. Slow your shutter speed to at least one or two seconds long. Your ISO will likely be 100 and your aperture should be set so your exposure compensation bar is at a balanced exposure (not over or under). You will find your aperture is quite small (large number) to allow for the long shutter speed.

*I'm using a slow shutter speed to blur the water at the beach,
but my images are too bright.*

If you're at a beach and want to make the waves blur as they hit the sand or
rocks, you need a very slow shutter speed. Where you are likely running into
trouble is that you cannot choose a small enough aperture to balance the
exposure triangle because of the time of day, and therefore the amount of light
in the scene. Because you are letting in so much light via the shutter speed, you
need to let in as little light as possible via the ISO and aperture settings. Most
cameras, however, only go to f/22, and with a shutter speed of at least one second
that will result in overexposed image. This is the time an ND filter is necessary—
it cuts the amount of light available and allows you to use that really slow shutter
speed in bright conditions.

The ND filter will help, but it might not solve the problem. If you find your
images are still overexposed or you don't have an ND filter, you will have to
make this image very early or late in the day. Try this again just before sunset—
there is much less ambient light in the scene and, therefore, you are better able
to use the longer shutter speed with an exposure triangle that works.

When I photograph my vacation resort, my images are too bright.

Are you in a place like that in Figure 12-19? If so, it is very bright when you are
trying to make these images. There are lots of reflective surfaces, like pool water
or a concrete pathway, that can fool your camera meter. We know that overly
bright images are overexposed and, therefore, we need to let in less light. As
such, try decreasing your ISO and speeding up your shutter speed. If that doesn't
work, try also using a smaller aperture (bigger number) to let in less light.

Figure 12-19 was made just before noon at a resort in Los Cabos, Mexico. It was
extremely bright, and it would be easy to overexpose this image. In this setting,
keep your exposure bar at even or slightly underexposed to avoid blowing the
highlights or washing out the colors in the scene.

The colors in my pictures are dull or washed out.

Overexposing an image can result in dull or washed out colors. The sky, for
example, will capture as white when it is overexposed. Check your exposure bar
and ensure it is in the middle or slightly underexposed. This will result in more
saturated colors, especially with a blue sky. ❖

FIGURE 12-19 Made just before noon, the exposure settings for this image were ISO 80, shutter speed 1/1000, and aperture f/5.6.

Chapter 13
ADDING FLASH AND OTHER GEAR

You've probably noticed there is a lot of gear associated with photography. Whether it's the big-ticket items like lenses or the smaller accessories like camera straps, flash diffusers, or card wallets, there are many ways to spend your money.

The question, really, is what gear do you need to make the images you want?

In this chapter, we talk about different items available to you and when, or why, you might consider purchasing them. Before we get to that, though, let's talk about flash photography—how to use the flash on your camera and when to add a camera-mounted flash to your arsenal.

ADDING FLASH

Most consumer DSLRs come with a pop-up flash. In auto modes, when the camera determines there is not enough light typically the flash pops up automatically. In semi-auto and manual modes, however, you control when the flash is used.

There are times when there simply is not enough light available to make a well-exposed image. Sometimes there's not enough light in the entire scene, or sometimes there's not enough light on your subject. There is absolutely nothing wrong with using flash when required—the key is knowing when that is and how to use flash to your best advantage.

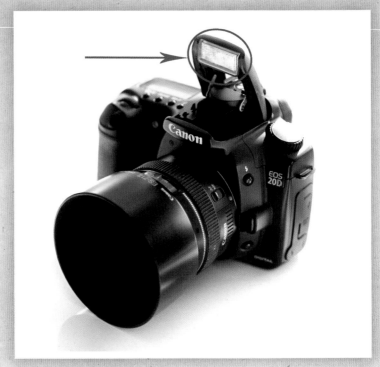

FIGURE 13-1 The pop-up flash on a DSLR.

Remember those sunset portraits we talked about in Chapter 11? We can run into two potential problems with sunset images: either our subjects' faces are dark while the sunset is well exposed (Figure 13-2), or our subjects are lit and the sunset all but disappears from the background (Figure 13-3). When we allow the camera to choose when and how to use flash, the latter example happens all too often.

Many, if not all, consumer level, interchangeable lens cameras come with a pop-up flash. If you upgrade your camera body to the prosumer or professional level, or already have a camera body at that level, you won't have a pop-up flash. That said, everything we chat about in this section applies to camera-mounted flashes as well.

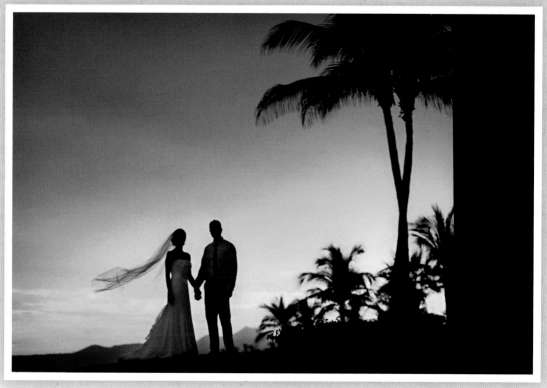

FIGURE 13-2 When exposing for the sunset, the people in the frame are too dark and underexposed.

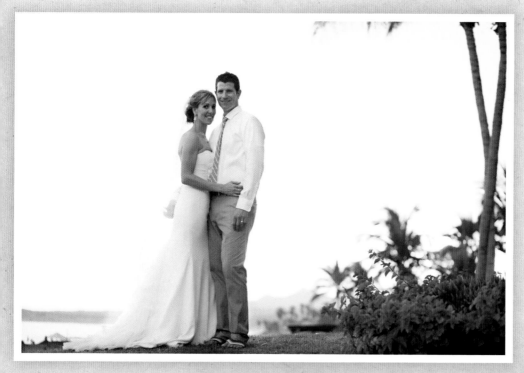

FIGURE 13-3
When exposing
for the people, the
sunset is washed out
and overexposed.

THE POP-UP FLASH AND HOW IT WORKS

In any mode where the camera is thinking for you, the flash could pop up when you least expect it. The camera thinks there is not enough light for the image you want to make and so adds flash to make the correct exposure.

The problem is, you don't always want, or need, flash. First things first: Turn off that auto mode and choose a semi-auto or manual mode. Next, disable the pop-up flash in your camera settings (you might need to check your camera manual for how to do this). Now you are back in control of the flash and can evaluate when, or if, you want to add it.

If you find you cannot disable the flash, double-check that you are no longer in one of the auto modes. Depending on the camera you are using, auto mode will not allow you to override the flash settings. Make it a habit to keep your camera in manual mode or one of the semi-auto modes all the time. That way you won't have to continually override things like the flash settings.

As we talk about your pop-up flash, I'm making the assumption that you have a relatively modern camera and your pop-up flash uses something called E-TTL (Evaluative Through The Lens) metering when determining the flash exposure. This means that the flash exposure is based on whatever you focus on. In other words, your flash exposure is based on your subject and how far your subject is from the camera.

The camera sends out a pre-flash to make this determination, which you see before you make the picture. As you press the shutter button, the pre-flash makes the flash exposure choice, and then the flash fires with that exposure decision. If you have ever had your picture taken and noticed what seemed to be two different flashes going off while the photo was being made, you saw the pre-flash and then the actual flash.

When flash is enabled, you are using two light sources—the flash and the ambient (available) light. Basically, it works like this: The shutter opens, the flash fires, and then the shutter closes. That means there are two exposures (the flash and the ambient) in one image.

The amount of ambient light is controlled by shutter speed. Changing your shutter speed will not affect your flash because your flash fires while your shutter is open. Your shutter speed affects how much, or how little, light from the total scene is available for

an exposure. A fast shutter speed lets in less ambient light and a slow shutter speed lets in more ambient light. We'll talk more about this as we get into real-world examples.

While shutter speed does not affect flash exposure, it does play a role in the ability of your flash to work. Most cameras have a shutter speed after which the flash is no longer effective. Known as the sync speed, if your shutter speed exceeds 1/200 or 1/250 in most cameras (check your manual to determine the sync speed of your camera) and you have the flash enabled, a black line or partial blackout will appear in your images. This is an almost universal limitation in all cameras: A flash will not work if your shutter speed exceeds the maximum. Many cameras have a high speed sync mode to address this, but you must manually set that option. If you find your images have that black line or partial blackout, check if high speed sync is available and, if so, turned on. You will have to check your camera manual to determine if you have this option and how to set it.

One final thing to keep in mind is the distance between your subject and your flash. Most pop-up flash units have an optimal distance of 3 to 12 feet from camera to subject. There is a concept called the "inverse square law," which explains this in detail, but essentially this means that the further the subject is from the flash, the less light is available. It's a sensible concept—obviously a light source can extend only so far before it no longer provides light. We talked about this in Chapter 5 with light fall off. Think of it like your car headlights. Everything close to the lights is bright and everything at a distance eventually fades to dark. The same holds true with your flash: The closer your subject is, the more light is available.

Your flash is simply another tool in your arsenal as a photographer. You may not use it all the time, preferring the look of natural light, or you may end up using it a lot—that is up to you as the photographer. Whatever your preference, knowing how and when to use it is important.

CONTROLLING THE POP-UP FLASH

Your pop-up flash does just what you would expect—it adds light to the scene. Where this can be advantageous is in dark rooms or backlit settings, but sometimes the flash overpowers all the ambient light and creates more problems than it solves. In the troubleshooting section of Chapter 11, one of the problems was that the flash lit the people in the foreground of the image, but everything else went black, including the lights in the background. That is just one example of what can happen when the flash is not doing what you want it to.

FIGURE 13-4 In auto mode, the camera selects a shutter speed that is too fast to showcase the ambient light.

FIGURE 13-5
Changing flash settings, shutter speed, and/or ISO gives us a well-exposed subject and ambient light in the background.

Figures 13-4 and 13-5 show this problem. In Figure 13-4, the subject is brightly lit with flash against a dark background. There is a hint of something in the background, but you can't really see what it is. In Figure 13-5, on the other hand, we see the image we wanted to make—a well-exposed subject and ambient light in the background. In Figure 13-4, the camera was in auto mode with a fast shutter speed, while in Figure 13-5 I moved to manual mode, decreased the shutter speed, increased the ISO, and turned the flash power down.

We saw in that same section of Chapter 11 the challenges of having well-lit subjects in front of a sunset. At times, flash is necessary to light the subject and preserve the sunset. We see an example of how to do this a little later in the chapter in Figures 13-9 and 13-10

In semi-auto and manual modes, the flash does not pop up automatically, so you must enable it yourself. Most cameras have a button adjacent to the flash that allows you to turn on your flash (see Figure 13-6). The exact location may differ from camera to camera, but the button is recognizable by its flash symbol.

As with the exposure triangle, there are times when what your camera thinks the best flash exposure is and what you are looking for will differ. When the pop-up flash is enabled in semi-auto or manual modes, you actually have some control over the amount of light output.

We have talked about exposure compensation several times so far and how you are able to override the camera in semi-auto modes via this feature. With the exposure compensation feature you are able to over or underexposure your image and, therefore, gain greater control of your exposure decisions.

FIGURE 13-6 Manually enable your pop-up flash via a button like this one.

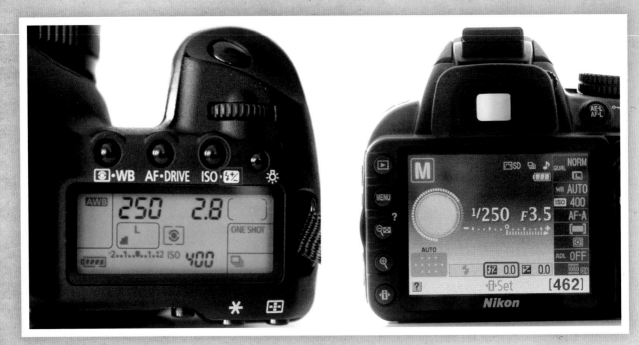

FIGURE 13-7 Use flash compensation to control flash exposure manually.

There is something called flash compensation that works the same way for flash exposure. Locate a button that looks like the one circled in red on the camera on the left in Figure 13-7. If you don't see this on the top of your camera, check the back buttons or back display menu.

FIGURE 13-8 The flash compensation bar.

When you push the button down, you see an exposure bar like Figure 13-8. Increase flash output by moving the indicator toward the plus sign and decrease flash output by moving toward the minus sign. As with exposure compensation, it's possible your camera has the plus and minus reversed, so we have shown both options in Figure 13-8. Your camera will only have one set of +/-, not the two you see in the figure.

It is likely you won't need to use this feature often, but if you find the flash is too bright or too dark, knowing how to correct that will enhance your already well-exposed imagery. Flash compensation would have solved the problem of bright subjects and a black background that we talked about in Chapter 11 and saw earlier in this chapter with Figure 13-4. One reason the background went dark in 13-4 was because the light

of the flash was so overpowering it essentially replaced all the light in the scene, rather than simply filling in what was needed. Turning down the flash compensation like we did in Figure 13-5 can result in a balanced exposure with a well-lit subject and ambient light.

USING FLASH IN REAL-LIFE SITUATIONS

The best way to understand how flash works is to use it. We talked about different places to make portraits in Chapter 11 and different types of light in Chapter 7. While we found ways to make images using available light, there are times when using flash is advantageous and necessary.

Sunsets and Other Interesting Backdrops

There are many scenes that offer unique challenges. Photographing people at sunset, for example, offers a scenario where the background (sunset) is filled with stunning colors and light, but the foreground is significantly darker. To balance this scene without flash means your subjects are either very underexposed, if not a silhouette, or your subjects are exposed, but the sunset looks washed out and flat (refer to Figures 13-2 and 13-3).

The same problems occur in other environments where you want to include background light in your image. A great example for this is photographing people in front of a Christmas tree or on a street at night. To make these types of scenes work, you want to expose for the background and then use the pop-up flash to light your subject.

We say "expose for the background," but what does that mean? In this exercise, expose for the sunset image you want to create like

FIGURE 13-9 When making images in front of a sunset, expose for your background first.

FIGURE 13-10 After choosing the correct exposure for your background, use flash to light your subjects.

in Figure 13-9 (we learned more about this in Chapter 12). Before bringing your subjects into the frame, make an image of the sunset, fine-tuning your exposure until you achieve the look you want. In Figure 13-9, the settings are ISO 100, shutter speed 1/160, and aperture f/9. This is slightly underexposed to ensure that the colors are saturated.

Now that you have your background well exposed, bring your subjects into the frame and consider how to light them. Leave your ISO, shutter speed, and aperture settings exactly the same as when you made the sunset image. Place your subjects close enough to you that the flash will deliver the light you need, and then focus on their faces. As you push down the shutter button, your camera is determining the flash exposure and fires once the shutter is open. You will likely see a flash of light before the photo is taken (the pre-flash).

Take a look at your image. If your subjects are well lit and the background is also well exposed (like in Figure 13-10), your camera made the correct flash exposure. If, however, their faces are too bright or they are very dark, it's time to use the flash

compensation feature. If the flash was too bright, move the indicator in the minus direction; if the flash was too dark, move the indicator in the plus direction.

You may have to make more than one adjustment to get the look you want, so be patient and take the time to get it right. Once you have the setting you want, you can make a series of images without changing the settings further.

Sunshine

Although we typically think of using flash in a darker setting, it can also be very effective in a brighter scene. Figure 13-11 is a portrait of a child on a bright day. The entire scene is fairly well exposed, except for his face, which is shadowed.

This is the perfect time for a little fill flash. Your subject is relatively close to the camera and you only need a "kiss of light" to fill in the shadows (see Figure 13-12). Fill flash is just what it sounds like: a little bit of light to "fill in" the shadows.

FIGURE 13-11 Without fill flash, the subject's face is in shadow.

FIGURE 13-12 When flash is added, the subject's face is evenly lit.

251

ADDING A CAMERA-MOUNTED FLASH

If you upgrade your camera to prosumer or professional quality, there will no longer be a pop-up flash built into the body. Your camera will have something called a hot shoe mount where you will attach a separate flash unit, often referred to as a speedlite (Canon) or speedlight (Nikon). Even if your camera does have a pop-up flash, there will still be a hot shoe you can use for a camera-mounted flash.

Much like the pop-up flash, newer camera and flash systems use E-TTL metering to help determine flash exposure. E-TTL is a Canon designation, while with Nikon it is referred to as iTTL. Both do effectively the same thing despite the different names. A camera-mounted flash is larger and more powerful than a pop-up flash and it also recycles faster, which means it is ready to fire again more quickly than the pop-up unit.

Obviously, if your camera body doesn't have a pop-up flash, and you need a flash unit, investing in a speedlite is important. That said, even if your camera does have

FIGURE 13-13 An external flash is mounted to the camera via the hot shoe.

FIGURE 13-14 A speedlite allows you to bounce your flash, thereby creating a more subtle lighting scenario.

a pop-up flash and you find yourself in low-light situations, the speedlite is the better option for a flash given its versatility and power. Upgrading your flash unit is one of the first choices I recommend after purchasing better lenses. This is especially true if you find yourself using flash frequently.

One of the biggest advantages of a speedlite is the ability to "bounce" the flash. Basically, this means you change the angle of the flash, as in Figure 13-14, and point it at a surface you can use to bounce the light off of.

Let's try this. Find an object to work with. In my example, I'm using a candle holder sitting on a mantle (Figure 13-15). Without flash, my exposure is ISO 1600, shutter speed 1/40, and aperture f4, and my image is underexposed. I don't want to slow down my shutter speed or increase my ISO, so I need to add flash. Find your exposure in manual mode, choosing to

FIGURE 13-15 The initial exposure is slightly underexposed with shadows from the room (ambient) light.

FIGURE 13-16 Using direct flash can result in unflattering light and shadows.

FIGURE 13-17 By bouncing my flash, I avoided unflattering light and harsh shadows.

be at an even exposure or slightly underexposed. Photograph the scene with direct flash, then turn your flash and bounce off an available surface.

In Figure 13-16 I used direct flash—the flash was pointed directly at the subject in the same way a pop-up flash would be. Using manual mode and E-TTL flash exposure, the direct flash resulted in harsh lighting and shadows behind the subject. The shadows are more evident because the subject was fairly close to the background.

Figure 13-17, on the other hand, uses the same settings but the flash unit was angled up toward the white ceiling. The light is coming out of the flash, hitting the ceiling, and bouncing back into the frame to light the subject. Notice the light is more

subtle and there are almost no shadows at all. This is a time you might want to increase your flash output because the light is traveling a larger distance and, therefore, is not as bright when it hits the subject. Try increasing your flash exposure to see how that affects your image. In Figure 13-17, my flash exposure was increased by one and one-third stops.

When you start experimenting with bounce flash, the angle of the bounce as well as the distance from the surface you are bouncing from become important. Trying to bounce fill flash off a dark 16-foot ceiling will be much less effective than using a neutral colored wall just a few feet away. The color of the surface you use is important, as the light from your flash will take on a color cast of whatever surface you are using. A bright green wall, for example, will create a green color cast across your image.

When you decide to add a speedlite (or speedlight), to your arsenal, there are a number of excellent books written on the subject. I strongly suggest reading one of them if you want to learn more about how to get the most out of your flash unit.

Here are two titles I recommend: *Canon Speedlite Digital Field Guide, 3rd Edition*, and *Nikon Creative Lighting System*.

ADDING OTHER GEAR

As you move forward with photography and start to purchase new equipment, it's easy to get caught up in all the options available to you. There are dozens of lenses to choose from, different accessories like battery grips, and a variety of stabilizers, just to name a few categories. It's tempting to start acquiring gear just for the sake of having more.

Before purchasing any new equipment ask yourself why you need that new gear. If you are primarily photographing sporting events, for example, your gear requirements will be different than someone interested in landscape photography or portraits. Consider what is currently limiting your ability to make the images you want: Do you need lenses with a wider aperture (we call this "fast glass") or do you need a way to hold your camera steady? Perhaps you simply need a zoom lens that can do a little more than the one that came with the camera. Or perhaps you don't need anything at all—you simply need to make different exposure choices.

Lenses

If you could upgrade only one thing, I almost always suggest investing in a better lens (or "glass," as the professionals say). With analog cameras, photographers used the same bodies for years, upgrading their lenses along the way. With digital cameras and the changing technology that goes into them, people are upgrading their bodies more often. Without the right lenses, however, the photographer is still limited in what he can do.

Lenses affect more than aperture and depth of field—they affect the color and clarity of your images as well. The more expensive a lens, the better quality the glass, which means better color, clarity, and contrast in your images. Less expensive glass handles light differently than expensive glass, sometimes creating a vignette effect, or offering less contrast in the frame. As one of our goals is to make the best images possible, better lenses make that goal more achievable.

Which lens to buy depends on what you are photographing. If you often find yourself photographing your children in arenas or at recitals, for example, investing in a zoom lens with a maximum aperture of f/2.8 makes sense. If, on the other hand, you prefer to photograph landscapes, you would look for a wide-angle lens like the Canon 17-40mm f/4 L.

Good lenses are expensive, so take your time when choosing what lens to purchase. You don't always need the priciest option for the images you want to make and the conditions you are making them in. And while it is very nice to have fast glass, paying an additional sum of money to move from a maximum aperture of f/1.8 to f/1.2 likely won't make a lot of sense for you. Fast glass is not just pricey, it can also be much heavier than the lenses you are accustomed to, and that can impact your ability to hand hold your camera at slower shutter speeds.

One other thing to consider when purchasing a lens is whether it is a full frame lens or a lens designed for only one kind of sensor body. Many digital cameras have something called a cropped sensor. Basically, with SLR or 35mm film cameras, the rectangle the image was captured on was one size and universal across all camera bodies. With digital, we still use the 35mm film as a standard of measure. A full frame camera covers the same area of the rectangle as that 35mm camera. A camera with a cropped sensor, on the other hand, records a

smaller amount of the rectangle, effectively cropping into the middle and leaving out the edges. This is called the crop factor.

Why does this matter in a discussion about lenses? Well, some lenses are designed specifically to work with a particular crop factor and will not work on camera bodies with different crop factors. The only lenses that work on all camera bodies are those designed for full frame sensors. For Nikon users, full frame is referred to as FX and the 1.5 crop is referred to as DX. Lenses designed for the DX sensor will not work on an FX camera. The same holds true for Canon. The EF-S lenses from Canon, made specifically for cameras with a 1.3 or 1.6 crop factor, will not work on a full frame (EF) camera body.

When you are investing in lenses, consider the long-term use of that equipment. Purchasing an EF-S or DX specific lens might work while you own one of those cameras, but if you choose to move to a full frame camera body, these lenses are no longer usable. I would suggest investing in lenses that can be used on all camera bodies.

Lenses can be used for years without being replaced, so buying something with long-term goals in mind makes sense.

Stabilizers

Being able to keep your camera still while using a very slow shutter speed requires a stabilizer. As with all other gear categories, there are a number of stabilizers available for purchase, from the standard tripods and monopods to smaller, mini stabilizers.

In reality, the only stabilizer you need is a tripod—at least at this point. And you only really need a tripod if you are working with settings that require a slow shutter speed. The images of the moving water in Chapter 12, for example, were all made using a tripod. Tripods don't need to be relegated to use only during times requiring slow shutter speeds, though.

Documenting daily life is a great way to practice photography while making interesting images: Try setting your camera on a tripod and focus on a regular activity in your family's life. Maybe it's making pizza together, playing board games, or something else that happens in a stationary space. Make an image every minute or so and you will have a series of relaxed and natural photographs. The consistent framing and perspective from one frame to the next give the illusion of movement through the frames, while capturing the everyday moments of life.

There are a few smaller items to consider investing in: things like camera bags, card wallets, and more. As with lenses and stabilizers, consider what your needs are when making these purchases.

Camera Bags

Choose something comfortable when buying a camera bag. If, like me, you like to leave a lens on your camera at all times, you need a bag that accommodates that plus another lens or two. There are options that look utilitarian and options that look more like a woman's purse. The most important consideration is whether you will take it with you, in my opinion, so I have a bag that doubles as a purse, negating the need to carry two things.

Digital Media Cards

With digital cameras, we use digital media (most commonly CF or SD cards) to capture our images rather than film. Some cameras use one type of card, while other cameras use more than one. Ensure you always have at least one back-up card, in case you fill your first one. The smallest card I would suggest is the 4GB option—image files can be quite large and you don't want to fill your card too quickly, especially if you don't carry many cards with you. I typically use 8GB or 16GB cards in my cameras.

Card Wallets

Digital media cards are quite small—much smaller than a canister of film—so ensuring you keep them safe is important. A card wallet is simply a place to store your cards while they are not in your camera. I keep my card wallet with my cameras, and many camera bags come with a built-place for your cards. Keeping the cards organized can be challenging, so I turn my cards upside down when they have been used and right side up when they are ready to be used. This ensures I don't accidentally delete images I haven't yet backed up to my computer.

Card Readers

Choose a card reader based on the medium your camera uses. A reader with multiple options for digital media is a great choice. Many cameras allow you to download directly from camera to computer, which might work for you—for now. Thinking ahead, however, if you are using multiple cards or your camera-to-computer speed is slow, having a card reader makes downloading images convenient.

Filters

In Chapter 12 we talked about a neutral density (ND) filter. There are dozens of options when it comes to filters, all of which do something different. Some make the sky appear bluer (a polarizing filter) while others darken the sky (a graduated ND filter). The only filter I use, albeit not regularly, is the ND filter, but that is, in part, because of what and how I photograph. Whether you use filters or not will depend on what you are interested in photographing. If you love landscapes, having the polarizing and graduated ND filters will be important, while photographing people rarely requires a filter. ❖

BEYOND AUTO MODE
GLOSSARY

The terminology and phrasing associated with photography can be confusing and even off-putting. As tempting as it was for me to use different words to describe terms like aperture or exposure value, doing so would not help you understand how to better use your camera or make better images. When I was learning the technical aspect of image making, I needed to read or hear the language of my craft over and over again until one day it all started to make sense.

All the terms and phrases that might give you pause or be hard to remember are gathered here for quick reference. Although I try to define each term more than once through this book, there will be times you need more. You'll find basic definitions and explanations laid out in this section for you in an easy-to-find format.

Aperture:	The size of the lens opening, which allows light to reach the sensor. A large aperture means there is a wide lens opening while a small aperture means a small lens opening. Typically expressed as an f/number, aperture is one point of the exposure triangle. Aperture also controls depth of field.
Aperture priority mode:	A semi-auto mode. The photographer chooses aperture and ISO, and the camera determines shutter speed based on its internal light meter.
Auto white balance (AWB):	A setting on the camera that makes color adjustments to an image, to try to make the image look natural, based on the temperature of the light source.

Center weighted metering:	The internal light meter reading on a camera, where the bulk of the information is taken from the center focal point and ranges outwards from that point.
Depth of field (DOF):	Controlled by aperture, DOF refers to how in or out of focus the foreground and background are in an image. A shallow DOF has less of the foreground and background in focus, while an extended or deeper DOF has more in focus. For example, a shallow DOF is found when using an aperture like f/2.8, while an extended DOF uses an aperture like f/16.
Dynamic range:	The ratio between the lightest and darkest areas in an image and how much of those can be discerned. It is the amount of detail your camera can record between the lightest area (highlights) and the darkest area (shadows).
Equivalent exposure:	Multiple exposure combinations that result in the same exposure triangle.
Evaluative metering:	The camera light meter evaluates all the light in the scene and averages it to choose what it thinks is the best exposure.
Exposing for the background:	You do this when making exposure decisions based off the background of the image. A sunset is an example of this: Make exposure decisions based on how you want the sunset background to look in the frame.
Exposing for the subject:	You do this when making exposure decisions based on the subject's face. The exposure of the background is of less concern with this. An example of this is in a backlit setting where the highlights are blown (overexposed) while the subject's skin is well exposed.
Exposure bar:	Tells you what the camera thinks of the exposure settings, indicating if your image will be over, under, or correctly exposed based on the camera's preset exposure formula and the built-in light meter mode and reading.

Exposure compensation: In semi-auto modes, this feature is used to override the setting chosen by the camera. Using the exposure bar, one increases the amount of light by moving toward the plus end of the scale or decreases the amount of light by moving toward the minus side.

Exposure triangle: The three elements required to make an exposure: ISO, shutter speed, and aperture.

Exposure value: All combinations of aperture, shutter speed, and ISO settings that give the same exposure. Also referred to as equivalent exposure.

F/stop: Used to express aperture value, it is simply the expression of the f/number: a ratio of the focal length of the lens to the diameter of the lens. In other words, it's a math equation of focal length over lens opening.

Fill flash: The flash is used to supplement the ambient light in the scene to light a subject that would otherwise be in shadow relative to the rest of the scene.

Fixed aperture lens: A lens with a constant maximum aperture across all focal lengths.

Flash compensation: Also known as flash exposure compensation (FEC), this feature is used to override flash settings controlled by the camera. Using the FEC bar, add more flash power (light) by moving to the plus side of the bar, and less by moving to the minus side.

Flash sync speed: The fastest shutter speed at which the sensor (film) can receive enough light from a flash.

Focal length: The zoom of a lens. A 24-105mm lens has focal lengths that range from 24mm to 105mm, while a 50mm lens has only one focal length (50mm).

Focus-recompose: A technique whereby you press the shutter button down halfway while using the center focus for your subject. Once your focus is locked (you will probably hear a beep), keep the shutter button depressed halfway and move your subject within the frame, and then press the shutter button the rest of way to make the picture.

Highlight control or highlight enable/alert:	A feature on digital cameras that shows overexposed (very bright) areas with blinking or flashing lights.
Inverse square law:	The further a subject is from the flash, the less light is available to light the subject. See also light falloff.
ISO:	The sensitivity of the digital sensor (also known as film speed). It also determines the amount of noise (grain) in an image.
Light falloff:	As light travels from the source, it "falls off" or diminishes until it is no longer visible. An example of this is a car's headlights: Objects close to the light are well lit, while objects some distance away are completely dark.
Maximum aperture value:	This value, shown as the f/value, is the widest the opening of a lens can get.
Motion blur:	An effect where moving objects appear blurred.
Neutral density (ND) filter:	A filter that reduces the amount of light available for making an exposure.
Noise:	Random artifacts or color specks where there should be none, typically the result of a high ISO in digital cameras. Also referred to as grain.
Overexposure:	An image is overexposed when too much light has been let in and there is a loss of highlight detail. In other words, the highlights are "blown" and the image itself looks overly bright. In extreme cases the image is all white.
Rim light:	This happens when there is a light source behind the subject, creating almost a ribbon of light that highlights the edges of the subject.
Rule of thirds:	This rule divides the image frame into three equal parts— horizontally and vertically

264

Shutter priority mode:	A semi-auto mode. The photographer chooses shutter speed and ISO, and the camera determines aperture based on its internal light meter.
Shutter speed:	Controls how long the shutter is open, allowing light to reach the sensor. Measured in seconds and expressed as a fraction, an example of a fast shutter speed is 1/1000 second while a slow shutter speed is 1/30 second. Shutter speed also controls motion blur.
Spot metering:	The internal light meter uses a "spot" or very small area, determined by you, to determine exposure.
Stop:	A relative change in the brightness or darkness of light. Specifically, a stop measures the doubling or halving of light.
Stopping down:	The amount of light is halved (decreased by a stop).
Stopping up:	The amount of light is doubled (increased by a stop).
Sunny 16 rule:	Also referred to as basic daylight exposure, this states that the ISO and shutter are always the same when the aperture is set at f/16 on a bright sunny day.
Underexposure:	An image in underexposed when there is not enough light and there is a loss of shadow detail. Often referred to as "blocked-up shadows" or "crushed blacks," this means the image is too dark and looks muddy as a result. In extreme cases the image is all black.
Variable aperture lens:	The maximum aperture of the lens changes depending on the focal length (zoom) of the lens. For example, 1:3.5–5.6
White balance:	Adjusts for the color temperature of the light source in a scene to make white objects appear white. The camera measures the amount of red, green, and blue light being reflected on its sensor, thus determining white balance. The camera adjusts for this via auto white balance (AWB), but the user can also adjust for this via preset or manual white balance selections.

WHERE

In a shaded area between trees. It was an overcast day, almost chilly. We were looking for interesting light, which was hard given that the sun was hiding behind the clouds. Because we were in the mountains, it was almost foggy in many of the places I wanted to work.

WHEN

Early evening, the first day of summer.

WHY

The location became secondary to the moment I was seeing between Jill and Ryan. I asked them to lean into each other and relax. The expression on her face is so peaceful and serene, which is something I don't see often during a wedding shoot. For me, this sums up the complexity (and simplicity) of two people in love, and transcends their wedding day.

HOW

Made in AV mode, with an 85mm 1.8 lens. ISO 250, aperture f/2, shutter speed 1/250, and exposure compensation of +1 stop. This is an example of the rule of thirds as well as simple backgrounds.

WHERE
In a small area of our studio, a corner really, with just enough depth to use a 50mm lens.

WHY
In a determined effort to make more images of our children (that is Ethan reaching out and Logan in the chair), I combined a lighting experiment with a character study. (See "How" for the lighting setup.) The goal was simple: capture natural expressions and actions that conveyed the personalities of our children. I wanted a stripped down, simple setting where the only thing in the frame was the subject. Photographing your own children can be a challenge, as they don't always follow direction as well as a client's child does, but my patience paid off as Ethan and Logan relaxed into the session and let their personalities shine through.

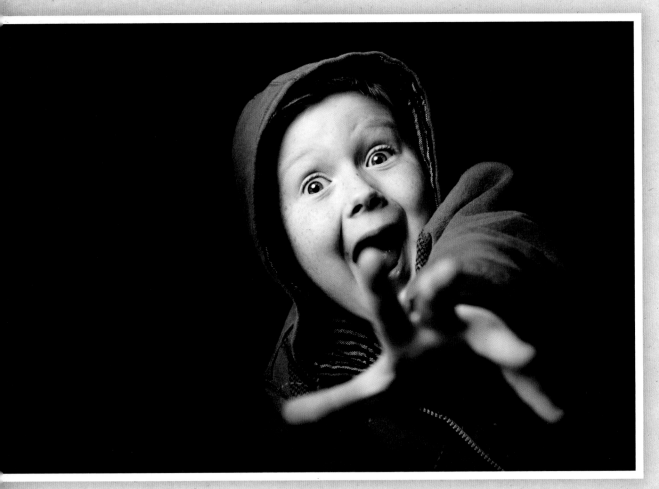

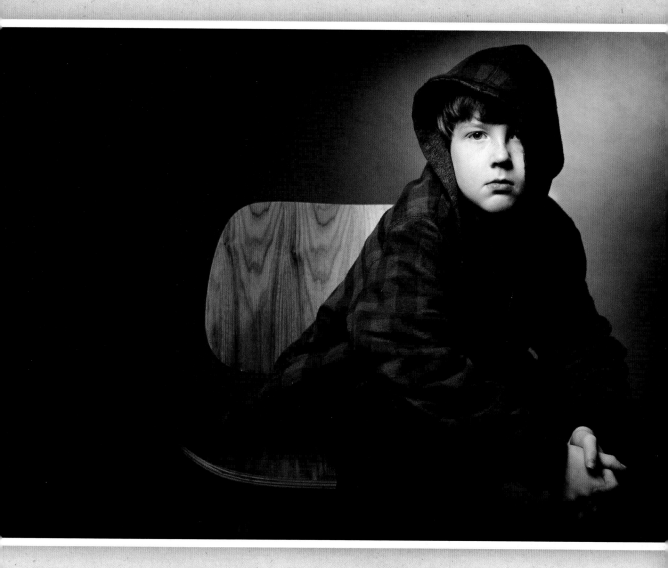

HOW

Made in M mode, with a 50mm 1.2 lens. ISO 125, aperture f/5.6, shutter speed 1/160. The lighting was simple—a single studio light. The light is a strobe, which means it fires when the shutter button is pressed, but this can also be done with a constant light source. These images offer examples of the rule of thirds and simple backgrounds.

WHERE

With the idea that light is the location, this image was made in an elevator lobby of a hotel. Over my shoulder is a large window that is lighting Stef with soft frontal light.

WHEN

Late afternoon, summer.

WHY

Much like many wedding days, we were running out of time to get the photo shoot done. Stef and I were on our way downstairs for her to see Jim for the first time. While waiting for the elevator, I noticed the bench and the pattern on the walls and when Stef turned to speak to me, the light on her face was perfect. This was the last moment she would be alone for the rest of the day—the calm before the storm. Stef has a little bit of sass in her, so when she sat down all I had to say was "Look at me like you look at Jim." A little bit sweet and a little bit sassy was the result.

HOW

Made in AV mode, with a 45mm f2.8 TSE lens. ISO 640, aperture f/2.8, shutter speed 1/100, exposure compensation +0.7. The "TSE" refers to a tilt-shift lens, which shifts (or tilts) the plane of focus in an image. You can see the result of this in the left side of the frame where the table is blurred. Typically used in architectural photography, the TSE is something we sometimes use for portraits as well. It is a fully manual lens, which makes it challenging to use. The lighting in this elevator lobby is from a window over my shoulder. I crouched down low to give a different perspective and to be out of the way of the light. In this image, you can see the rule of thirds as well as balance at work.

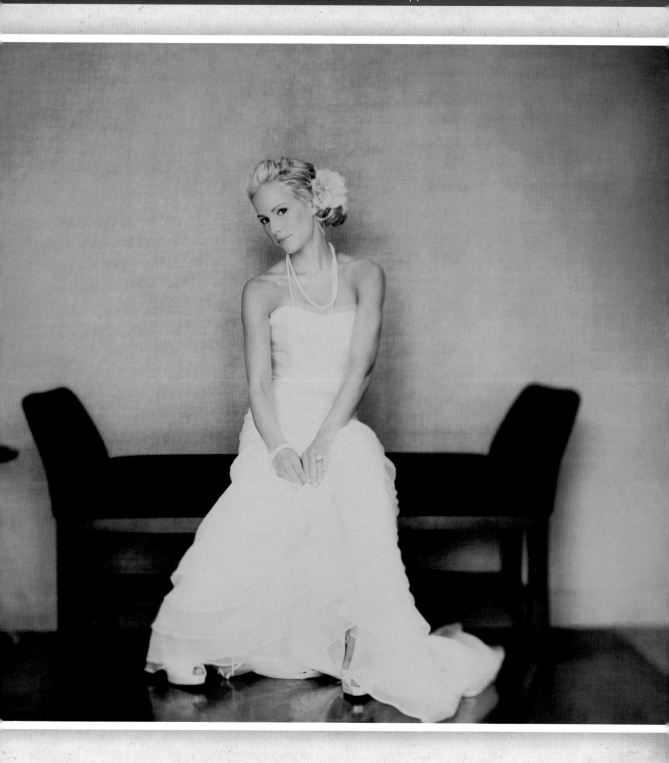

WHERE
A local beach.

WHEN
Late afternoon, spring.

WHY
This is a romantic image of a couple walking off into the sunset together. Photography is extremely important to these two: They love the play of light and shadow as well as relaxed settings and poses. As the sun was setting the light hit the sand as it swirled around their feet, creating a beautiful effect. In this image you see everything that matters to them: a relaxed but obvious connection, a location they love, and the movement of light and shadow.

HOW
Made in M mode, with a 135mm 2.0 lens. ISO 160, aperture f/2, shutter speed 1600. The sun is setting and the light is low in the sky. The couple is backlit, and we have an "almost silhouette" in this image. The compositional rule at play in this image is the rule of thirds.

WHERE
Middle Beach Lodge, Tofino, BC.

WHEN
Early summer.

WHY
Our couple had chosen Tofino for their wedding as it is one of their favorite places to visit. Both surf and they travel to the area frequently. There were only a handful of people at the wedding, including us, and the location was like another guest, with something wonderful around every corner. Ensuring we made images that showcased the spirit of their carefully chosen location was important. This organization of objects that spoke perfectly to the place was sitting just outside the wing of the lodge where all the guests were staying. To me, this image sums up the spirit of the lodge.

HOW
Made in AV mode, with a 135mm 2.0 lens. ISO 250, aperture f/2, shutter speed 1/500. The light is flat—it's overcast, as it typical for Tofino, so I used the color and composition to create an interesting image. I used the rule of thirds in this composition.

WHERE
Banff, Alberta, Canada.

WHEN
Late afternoon, summer.

WHY
As we traveled from the ceremony to the photo session, the road offered an incredible view of the mountains that surround Banff. Sandy and Mark are riding in the classic car ahead of our own vehicle and I'm struck with how small they look against the backdrop. For a moment we are almost alone on this busy highway, so I grab my camera and make this image. I wanted to show context as well as the symbolism of a journey just begun.

HOW
Made in AV mode, with a 17-40mm 4.0 lens. ISO 250, aperture f/4, shutter speed 1/1000, exposure compensation +0.7. The sun was hidden behind the clouds and our light was flat, almost dull, at that moment. I used the contrast of the trees lining the roadway, as well as the road itself, as leading lines in the frame while giving the most interesting feature—the mountains and sky—two thirds of the composition.

WHERE
Banff, Alberta, Canada.

WHEN
Early afternoon, summer.

WHY
I've always believed a bride's shoes say a lot about her. Often the shoes reflect her personality, whether she realizes it or not. I listen to the bridesmaids talk about the shoes and I'm struck by how often I hear the phrase "those are so *you.*" Nancy's shoes are understated, but elegant. They are classic, but interesting. The red soles mark them as a particular brand, but the subtle white on white lets us know she's not bragging about them. In other words, they reflect Nancy perfectly. To me, shoes that say this much deserve a grand tableau, which is why I set them on this window frame and surrounded them with stunning light.

HOW
Made in M mode, with a 17-40mm 4.0 lens. ISO 640, aperture f/4, shutter speed 1/160. Obviously backlit, my goal was to effectively blow the highlights around most of the composition, but leave the lines of the window and near drapes intact. The shoes themselves offer balance compositionally, as do the square window panes and drapes on either side of the shoes. The window sill falls along the bottom one third of the frame, leaving the rest of the frame filled with light.

WHERE
Tofino, BC.

WHEN
Late evening, summer.

WHY
My husband Steve and I don't take a lot of opportunities for personal work—it seems like we are always on assignment. On this night, the day before Anita and Sam's Tofino wedding, Steve went for a walk on the beach alone. Perched on the edge of the Pacific Ocean, Tofino offers incredible vistas of nothing but sand and sky. But it was the play of reflections on sand and water that caught Steve's eye. We photograph so many events and literal images, the opportunity to create something more abstract could not be passed up. He knows I love the ocean in all its moods and so he made a series of images for me. This is one of my favorites—the colors and the softness draw me in.

HOW
Made in AV mode, with a 135mm 2.0 lens. ISO 200, aperture f/2, shutter speed 1/800. Late in the day, the sun is already low in the sky as the colors of sunset show. Focusing on an area of water where the trees and sky are reflected, Steve uses the rule of thirds as well as diagonal lines in his composition. You can also see how the trees act as complimentary or symmetrical elements in the frame, providing balance. ❖